The Speed Art Museum
Highlights from the Collection

D1516691

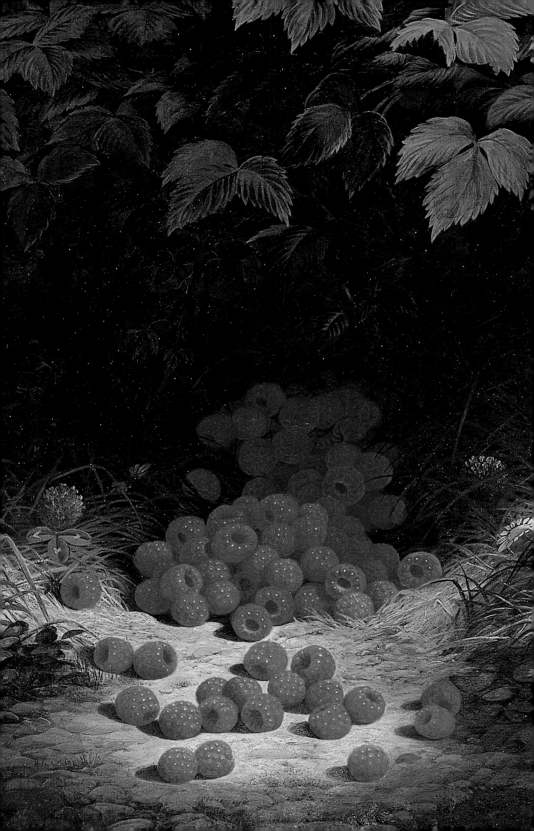

The Speed Art Museum
Highlights from the Collection

The **Speed**
Art Museum

MERRELL
LONDON · NEW YORK

First published 2007 by Merrell Publishers Limited

Head office:
81 Southwark Street
London SE1 0HX

New York office:
740 Broadway, Suite 1202
New York, NY 10003

merrellpublishers.com

The Speed Art Museum
2035 South Third Street
Louisville, KY 40208

speedmuseum.org

British Library Cataloguing-in-Publication Data:
The Speed Art Museum : highlights from the collection
1. J.B. Speed Art Museum – Catalogs 2. Art – Kentucky –
Louisville – Catalogs
I. Cloudman, Ruth H.
708.9′769

ISBN-13: 978-1-8589-4409-8
ISBN-10: 1-8589-4409-0

Produced by Merrell Publishers Limited
Designed by Dennis Bailey
Copy-edited by Matthew Taylor
Proof-read by Elizabeth Tatham
Indexed by Hilary Bird

Printed and bound in China

Front cover:
Paul Cézanne, *Two Apples on a Table*,
about 1895–1900 (detail; see page 166)

Back cover:
Yinka Shonibare, MBE, *Three Graces*,
2001 (see page 219)
© Yinka Shonibare, MBE; courtesy the
artist and Stephen Friedman Gallery,
London

Frontispiece:
William Mason Brown, *Raspberries*,
about 1870 (detail; see page 146)

This project is made possible in part by
a grant from the U.S. Institute of Museum
and Library Services

INSTITUTE *of*
Museum and **Library**
SERVICES

This project is also supported in part by
an award from the National Endowment
for the Arts

NATIONAL
ENDOWMENT
FOR THE ARTS

A great nation
deserves great art.

The Kentucky Arts Council, a state agency
in the Commerce Cabinet, provides
operational support funding for the Speed
Art Museum with state tax dollars and
federal funding from the National
Endowment for the Arts, which believes
that a great nation deserves great art.

Kentucky
UNBRIDLED SPIRIT

THE KENTUCKY ARTS COUNCIL

Contents

Foreword

The first-time visitor, the experienced docent, and the reader from afar will find much to discover in these pages. Just as a visitor to the Speed Art Museum can count on enjoyable and sometimes unexpected encounters with the diverse works of art in the collection, almost everyone will find fresh insights and new information in this volume. This informative companion provides signposts to fuller encounters with the rewarding pleasures of the museum's wide-ranging collection.

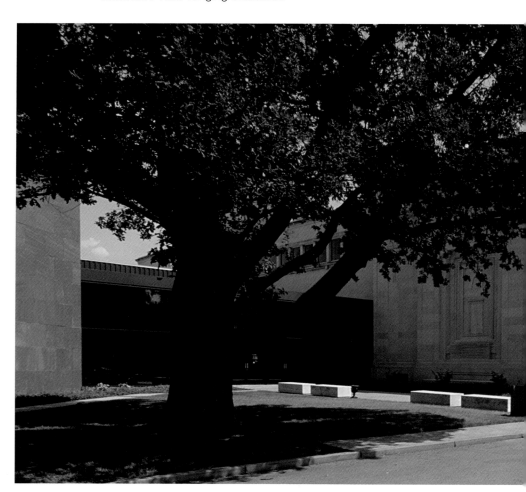

The Speed Art Museum: Highlights from the Collection is the first collection handbook for the Speed Art Museum in nearly twenty-five years. The collection has grown dramatically since 1983, the date of the previous handbook, and today contains nearly four thousand more works of art. Among our newer acquisitions are signal works by Ruisdael, Cézanne, Picasso, and Chagall. The museum has also acquired important Dutch and French Old Master paintings, early twentieth-century art, American sculpture, and distinguished works to enhance the decorative-arts and contemporary-art collections. Significant donations have included major collections of contemporary glass art, Matthew Boulton silver, Whistler lithographs, contemporary British prints, and the arts of Kentucky. These acquisitions and many more demonstrate the museum's consistent pursuit of excellence. A new publication has long been needed to take account of the collection's felicitous transformations.

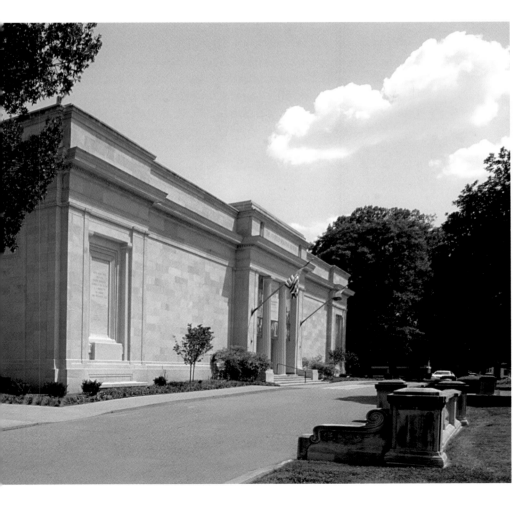

The talents of many people throughout the museum contributed to the success of this endeavor. Ruth Cloudman, the Speed Art Museum's Chief Curator and Mary and Barry Bingham, Sr., Curator of European and American Art, deserves the lion's share of credit for initiating this project, for advocating a fresh approach, and for writing a history of the collection as well as many of the entries. The texts have benefited greatly from her editing skills, painstaking regard for precision, and judicious restraint. Associate Curator Kimberly Spence, Curator of Decorative Arts and Design Scott Erbes, and Curator of Contemporary Art Julien Robson, along with Ruth Cloudman, proposed works of art for inclusion and took the lead in writing the texts. The Speed Art Museum was also fortunate to draw upon the knowledge of outside scholars and curators, who helped in innumerable ways: their names are listed, with sincere appreciation, in the Acknowledgments.

Finally, we are profoundly indebted to each and every one of the donors to the collection, whose gifts and contributions fill the galleries. Our thanks go as well to all those who supported this publication. Special mention needs to be given to Mr. and Mrs. Robert E. Kulp, Jr.; Mr. and Mrs. Ian Y. Henderson; an anonymous donor; Mr. and Mrs. James B. Speed II; Dr. Gregory Bays Brown; Mr. and Mrs. S. Gordon Dabney; Adele and Leonard Leight; Dr. and Mrs. Condict Moore; Paradis Foundation Inc.; Ms. Helen Powell; The Reverend and Mrs. Alfred R. Shands III; Mr. and Mrs. James E. Breece III; Mr. John S. Speed; the U.S. Institute of Museum and Library Services; the National Endowment for the Arts; and the Henry Luce Foundation.

It belabors the obvious to say that the operative word in the term "art museum" is the word art. The collection gives the museum its personality, establishes its place in the ranks of art collections worldwide, and forms the basis for most of the museum's other activities: exhibition, education, and preservation. The permanent collection is the currency of our business: the greater its quality, depth, breadth, and pertinence, the stronger our position in seeking loans for our own special exhibitions, obtaining desirable exhibitions organized by other institutions, or recruiting new staff of a quality comparable to that of our present gifted team.

Since 1927 the Speed Art Museum has been fortunate in attracting successive generations of collectors and contributors who understood the need of Louisville and the region for an outstanding art museum with a great permanent collection—and for a museum determined to share its treasures as fully as possible. I hope all readers will join in our pride and pleasure in the Speed Art Museum's collections and its widening community of support.

Peter Morrin, *Director*

Acknowledgments

The Speed Art Museum: Highlights from the Collection is published on the occasion of the eightieth anniversary of the museum's founding. Page after page it demonstrates the generosity of the donors who helped build the museum's art collection. The names of the donors of the works of art featured in this volume are noted alongside the objects they gave, and in some cases are mentioned as well in "A Brief History of the Collection." Additionally, our profound appreciation goes to the individuals and institutions, listed on pages 12–13, whose generous support made this collection handbook possible. I would like to single out Bob and Margaret Kulp, whose generosity from the beginning of this project was essential to its success.

The Speed's curators—Scott Erbes, Julien Robson, Kimberly Spence, and I—decided how best to present the collection in a handbook and selected the works of art to include with the counsel of the museum's director, Peter Morrin, who lent his enthusiastic support throughout the project. To bring further perspective to bear on the collection and its presentation in a handbook, we organized a conference in the summer of 2003, assembling leading scholars and educators from across the country to participate in a dialogue with the Speed's curators and educators. Our sincere thanks go to Marianna Adams, Kenneth Ames, Stephen Aron, Colin Bailey, Elisabeth Cameron, David Park Curry, Erika Doss, Wayne Franits, Jasper Gaunt, Emma Hansen, and Beth Schneider for the informed and stimulating points of view that they contributed. Cecelia Wooden very ably facilitated the wide-ranging discussion. Nana Lampton graciously provided our visitors with an evening of true Kentucky hospitality. As handbook planning progressed, we sought to ensure that the organization and design of the publication would meet the needs of readers, through audience research conducted by Horizon Research International.

The museum's four curators wrote the majority of the entries on individual works of art. I would like to express my admiring appreciation to my colleagues for their excellent texts. In addition to her writing, Kimberly Spence made critical contributions to the project through her research and her remarkable organizational abilities. Sarah Lindgren, the museum's curatorial administrative coordinator, researched and wrote the informative

glossary. For this project we called upon the assistance of several outside writers. Margaret Lind, our handbook project coordinator, authored many entries, in addition to dealing adeptly with the myriad details of such a complex project. Our handbook researcher, Lisa Bessette, not only accomplished much research in a short amount of time, but also wrote a number of entries. Kara Kostiuk contributed several texts on contemporary works of art. We are all grateful to several specialist scholars and curators, namely Bill Carner, Jasper Gaunt, Emma Hansen, and Moyo Okediji, who wrote entries for works of art in their respective fields.

I also wish to express our profound appreciation to the scholars who served as readers for entries in their areas of specialization. They are Hugh Belsey, Virginia Bower, David Park Curry, Larry Feinberg, Wayne Franits, William Gerdts, Mary Tavener Holmes, and Estill Curtis Pennington. Samuel Thomas and Dario Covi brought their knowledge of the museum and its history to bear as readers for "A Brief History of the Collection."

The museum's curators are indebted to the following people, who provided invaluable information and assistance during the research process: Gerald Ackerman, Maryan W. Ainsworth, Clifton Anderson, Annie Barbera, Peter Barnet, Damien Bartoli, Sylvain Bellenger, Alice Binion, Carol Bonura, Miklós Boskovits, Peter Bowron, Celeste Brusati, Susanna Caroselli, Yannick Chastang, Alain Daguerre de Hureaux, Tina Dickey, Elizabeth Einberg, Everett Fahy, Sarah Faunce, Thomas Fusenig, Linda Gigante, Rebecca Ginnings, Amy Golahny, E. Adina Gordon, Michael Greenbaum, Wanda de Guébriant, John Hand, Ursula Härting, Carolus Hartmann, Robert Herbert, Megan Holmes, Jeremy Howarth, Pamela Ivinski, Iris Kalden-Rosenfeld, Pepe Karmel, Jack Kerpestein, Dieter Koepplin, Amy Kurtz Lansing, Riccardo Lattuada, Howard Lay, Melissa Leventon, Charles Little, Robert Lodge, Bruce MacLaren, David Marshall, James McCormick, Fred Meijer, Paul Mitchell, Jennifer Montagu, Edgar Munhall, Alexandra Murphy, Lawrence Nichols, Christina Nielson, Patrick Noon, Ellwood C. Parry III, Craig Peariso, Natalie C. Polzer, Stuart Pyhrr, Marianne Ramsey, Ilka Rasch, Howard Rehs, Nancy E. Rexford, Rebecca Reynolds, Aileen Ribeiro, Stefan Roller, William Sargent, Judith Schaechter, Kerry Schauber, Arlene Palmer Schwind, Michael Simpson, Jeffrey Chipps Smith, Jack Soultanian, Alice Stites, Sophie Guillot de Suduiraut, Christian Theuerkauff, Achim Timmerman, Hans Vlieghe, Susan Vogel, Paul Williamson, Jean C. Wilson, Timothy Wilson, Gail Gilbert and Kathy Moore of the Margaret M. Bridwell Art Library, the Interlibrary Loan staff at the University of Louisville, the staffs of the Interlibrary Loan Department and the Fine Arts Library of the University of Michigan, and the reference librarians at the Frick Art Reference Library.

The entire museum staff directly or indirectly contributed to the completion of this publication. Although not everyone can be named here, I would like to acknowledge the work of administrative director Paula Hale, Bobbie Rafferty, her predecessor Nora Bernhardt, Trish Fleischman, Lori Hagest, Margie Austin, and Lonna Versluys from the development and public information departments. Penny Peavler oversaw audience research and, with the assistance of Carolyn Wilson, the obtaining of photographic rights. Cynthia Moreno, Nancy Renick, Martin Rollins, and Bryan Warren from the education staff offered advice throughout the project. Bill Staley, Ron Davey, Matt Loeser, and his predecessor Dan Pfalzgraf assisted from the preparations department, as did Chuck Pittenger, Julie Thies, and Lisa Parrott Rolfe from the registrar's department, and the museum's librarian, Mary Jane Benedict. From the curatorial department, in addition to Sarah Lindgren, Lynn Reynolds, her predecessor Laura Fiser, and Betty Lyn Parker provided valuable assistance.

Funding for the conservation of works included in this book was generously provided by Mr. and Mrs. William O. Alden, Jr.; The Alliance of the Speed Art Museum; the Marguerite Montgomery Baquie Memorial Trust; Mr. and Mrs. John W. Barr III; the William E. Barth Foundation; Mr. and Mrs. Owsley Brown II; *The Courier-Journal*/Gannett Foundation; Mr. and Mrs. Bruce Farrer; the Frazier Museum; Mr. and Mrs. Gordon B. Ford; Mr. Julius Hegeler; Edith and Jacob Horn, The Horn Foundation; Robert E. Kulp, Jr., and Margaret Barr Kulp; Dr. Charles F. Mahl and Louanne Mahl; Rowland D. and Eleanor B. Miller; Mrs. Nina J. Milner; Mr. and Mrs. Kenneth W. Moore; the staff of Muldoon Memorials; the National Endowment for the Arts, a Federal agency; contributions in memory of Owen S. Ogden, M.D.; J. Royden Peabody, Jr.; Mr. and Mrs. Tommy Smith; Mr. and Mrs. Horace Speed III; Mr. and Mrs. John S. Speed; Mrs. James Ross Todd; and Louise Ross Todd.

Nils Nadeau worked as a contract editor during the draft stages of the text, and his remarkable attention to detail was essential in refining its structure and language. Anne Ogden generously provided proof-reading assistance. Mary Rezny was the project's principal photographer, completing much of the new color photography. Other contributing photographers are listed individually on page 232.

Finally, our special thanks go to the patient and talented staff at Merrell Publishers, particularly Julian Honer, Nicola Bailey, Rosanna Fairhead, and Phil Brown, for so skillfully overseeing the final editing, design, production, and printing of this book.

Ruth Cloudman, *Chief Curator and Mary and Barry Bingham, Sr., Curator of European and American Art*

Donors

The Speed Art Museum: Highlights from the Collection has been made possible through the generous support of the following:

U.S. Institute of Museum and Library Services
Mr. and Mrs. Robert E. Kulp, Jr.
Mr. and Mrs. Ian Y. Henderson
The National Endowment for the Arts

Anonymous
Mr. and Mrs. James B. Speed II in memory of Anne Carter Stewart Speed

Dr. Gregory Bays Brown
Mr. and Mrs. S. Gordon Dabney
Adele and Leonard Leight
The Henry Luce Foundation
Dr. and Mrs. Condict Moore
Paradis Foundation Inc.
Ms. Helen Powell
The Reverend and Mrs. Alfred R. Shands III in honor of Peter Morrin

Mr. and Mrs. James E. Breece III
Mr. John S. Speed in memory of Anne Carter Stewart Speed

Dr. S.P. Auerbach
Matthew and Brooke Barzun
Ms. Merrily Orsini and Mr. Frederick G. Heath
Richard and Heather Whipple

The Kentucky Arts Council

Gifts to *The Speed Art Museum: Highlights from the Collection*
in Tribute and Memoriam:

In Honor of Ruth Cloudman

Maydie and Nolen Allen
Anonymous
Dr. and Mrs. Charles C. Barr
Carolyn Brooks and Peter Morrin
Lee and Beth Davis
Sarah McNeal Few
James R. and Helen Lee Fugitte
Paula Hale
Mrs. John Hardwick
Mr. and Mrs. Spencer E. Harper Jr.
Spencer E. Harper III
Mr. and Mrs. David A. Jones
Mr. and Mrs. Donald F. Kohler
Dr. and Mrs. Joseph E. Kutz
Arthur and Mary Lerman
Mrs. Walter H. Millard, Jr.
Debra and Ronald Murphy
Mr. and Mrs. John David Myles
Mrs. C. Jean Nalley and
 Mr. Chris Nalley
Sarah Jane Schaaf
Mr. and Mrs. J. Baxter Schilling
Pat and John Schrenk
Lindy B. and Bill Street
Ms. Doris Trautwein
Suzanne Whaley

In Memory of
Anne Carter Stewart Speed

Carolyn Brooks and Peter Morrin
Laura Lee Brown and Steve Wilson
Mrs. W.L. Lyons Brown
Ruth H. Cloudman
Mrs. Chenault Conway
Mrs. Anne S. Dorsey
Sarah McNeal Few
Dr. and Mrs. Lawrence F. Jelsma
Mrs. Fairleigh Lussky
Mr. and Mrs. Stanley K. Macdonald
Mr. and Mrs. Douglas H. Owen, Jr.
Mrs. John S. Rankin
Mrs. Charles H. Semple, Jr.
Mr. and Mrs. James W. Stites, Jr.
Mr. and Mrs. Peter P. Thurber

Construction of the original building, 1926

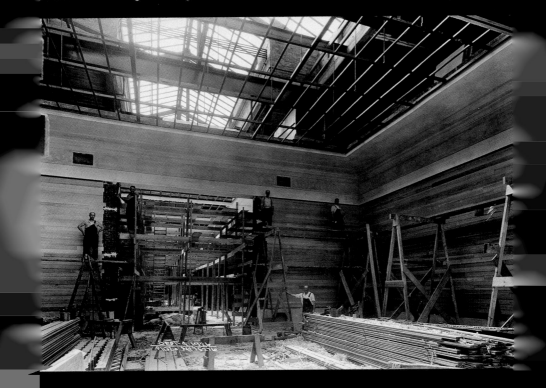

A Brief History of the Collection

Louisvillians opened their morning newspapers on February 8, 1925, to the surprise announcement that Hattie Bishop Speed was to build an art museum in memory of her late husband, James Breckinridge Speed. The museum, placed on the edge of the University of Louisville's new Belknap campus, would benefit equally students of the university and the entire community. Newspaper editorials rejoiced: *The Louisville Times* acknowledged Louisville as "probably the last city of its size and age in America to be without an art gallery," while *The Courier-Journal* declared, "Louisville has long needed such a structure."

Mrs. Speed's awareness of the city's needs undoubtedly guided her as she considered how best to memorialize her husband. Harriett Theresa Bishop (known throughout her life as Hattie) was born in Louisville on February 12, 1858, the last of eight children of William and Jane Fletcher Bishop. Hattie's mother had been born in England, and her father, who had come to Louisville from New Orleans about 1844, was the co-proprietor of the city's elegant Galt House hotel at the time of his death in 1860. Hattie attended private schools in Louisville and Boston and studied piano locally, then in Cincinnati and Boston, before going to Europe in 1886 for nearly six years of piano training in Berlin and Rome. Upon her return to Louisville, she became a piano teacher and performer.

Hattie's husband, James Breckinridge Speed, was born in Boonville, Missouri, on January 4, 1844, the son of Kentucky natives William Pope Speed and Mary Ellen Shallcross Speed and the grandson of John Speed, who had come from Virginia and begun settling the Farmington estate on the outskirts of Louisville in 1809. J.B. Speed's uncle James Speed became United States attorney general under Abraham Lincoln; another uncle, Joshua F. Speed, was Lincoln's closest friend. After graduating from high school in Louisville, J.B. Speed served on the Union side during the Civil War. A self-made man, he began his career as a bank clerk, and rose to control several coal and cement companies, cotton and woolen mills, and Louisville's street railway and telephone company, becoming a driving force in the city's burgeoning commercial and industrial economy. His first marriage, in 1868, to Cora A. Coffin of Cincinnati, produced two surviving children, Olive Speed (Mrs. Frederic M. Sackett) and William Shallcross

Speed. After Cora's death he married forty-eight-year-old Hattie Bishop on March 10, 1905, in Boston. Speed died on July 7, 1912, in Rockland, Maine, at the age of sixty-eight. He had traveled extensively in the United States and abroad and enjoyed collecting paintings and sculptures. According to his obituary, he was "known in art circles as an excellent judge of paintings. He had a large, private collection of oil paintings. This branch of art was considered his hobby." Although no listing or inventory of his collection has been found, his documented purchases of paintings by William Mason Brown, William-Adolphe Bouguereau, and Daniel Ridgway Knight, as well as a marble bust by Hiram Powers, suggest an appreciation of realism and polished technique.

After fourteen years of planning by Mrs. Speed, the J.B. Speed Memorial Museum opened to the public on January 15, 1927. Louisville architect Arthur Loomis's restrained Classical limestone façade, punctuated by a recessed central portico, was apparently based on the Cleveland Museum of Art, built in 1916. Unlike the Cleveland Museum, which is situated in a park setting, the Speed Museum faced Third Street, a main artery stretching from the city's urban core on the Ohio River south toward Churchill Downs, thus ensuring that the museum was easily reachable. Its site, bordering the university's new campus, guaranteed not only its convenience for students but also its place in a growing educational and cultural area of the city.

The museum's handsome Beaux-Arts spaces consisted of a grand foyer, a flower court, and four galleries: two to the north of the foyer and two to the south. In the early years the south galleries showed changing loan exhibitions, while the north galleries housed the museum's collection—Mr. Speed's art, and works acquired subsequently—and a book room that displayed manuscripts and Kentucky portraits.

Like those of other American art museums, the Speed's collection developed a unique character, forged from diverse influences. As the museum's director for the first fifteen years of its existence, Hattie Speed profoundly shaped the museum's early collection through her purchases and cultivation of collectors and donations. She took a broad view in the annual report of 1937 on the museum: "The Speed Museum is not an art gallery—though an art gallery is included—but a museum." This explains the wide range of objects she purchased or accepted for the collection during her directorship, from historical items of local or national interest, particularly Lincoln memorabilia, to nineteenth- and twentieth-century American and Kentucky painting and sculpture. By the museum's tenth anniversary, in 1937, however, the collection contained only some twenty paintings, sculptures, and drawings still considered notable today, none of

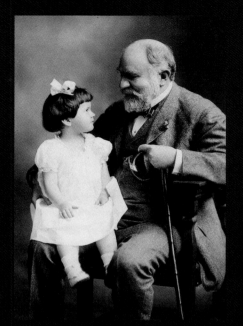

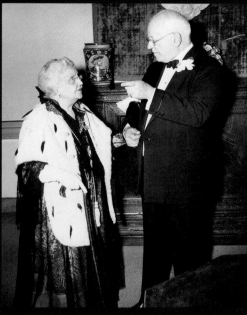

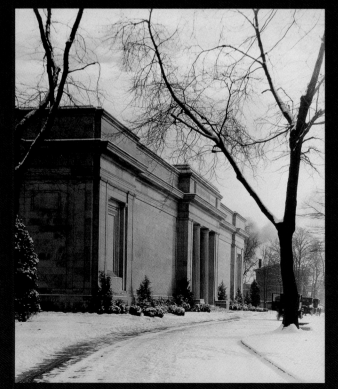

Top left: Alice Speed (Stoll) and her grandfather James Breckinridge Speed, about 1908

Top right: Hattie Bishop Speed and Dr. Preston Pope Satterwhite, November 1, 1941

Left: Exterior view of the J.B. Speed Memorial Museum, January 29, 1928

which dated from before 1800. Yet Mrs. Speed's success in attracting donations soon reshaped the Speed's collection.

Indeed, the generosity of the individuals who have given entire collections or single objects has transformed the museum's collection, determining its distinctive character and taking it in directions unimagined at its founding. Although space forbids the mention here of every important donor to the Speed, those who are included suggest the richness of the collection's heritage.

During its eighty-year history the museum has received many extraordinary gifts of collections. In 1929, just two years after the museum opened, Rogers Clark Ballard Thruston and his sister-in-law, Mrs. S. Thruston Ballard, gave hundreds of funerary artifacts that had been excavated from ancient columbaria in Rome, and which dated from the first century BC to the third century AD. This collection, one of the largest of its kind in the United States with a documented provenance, in turn established the Speed's antiquities collection. Between 1934 and 1937 Frederick Weygold donated his extensive collection of Native American articles from the Plains region, gathered while he lived among Native American peoples in South Dakota, Oklahoma, and Montana during the first decade of the twentieth century.

The character and focus of the museum's holdings took another dramatic turn in 1940, when Mrs. Speed's long-time friend Dr. Preston Pope Satterwhite began giving his collection to the museum. A Louisville native, Dr. Satterwhite practiced medicine in New York, where his marriage in 1908 to heiress Florence Brokaw Martin allowed him to begin collecting on a grand scale. With the advice of Mitchell Samuels of New York's French & Company, he amassed decorative and fine arts of the fourteenth through the eighteenth centuries to furnish the Satterwhite homes in Great Neck (Long Island), Palm Beach, and Manhattan. At his death in 1948, the doctor's bequest completed the gift of his collection and provided funds to build the Speed's Satterwhite Wing to house his gifts. His donations and bequest resulted in the doubling in size of the museum's building, gave the Speed its first Old Master paintings and important pre-1800 European decorative arts, and, most significantly, firmly established the Speed as an art museum. His bequest also provided funds for the purchase of works of art dating from before 1800, and was used by the museum until 1981 to launch an Old Master collection of distinction, with purchases of Dutch and Flemish paintings by David Teniers I, Gerrit Berckheyde, Jacob Duck, Johannes Verspronck, and Anthony van Dyck, and Italian and French paintings by Giovanni Battista Pittoni, Pseudo Granacci, and Laurent de La Hyre. The Satterwhite bequest clearly marked the Speed as a museum

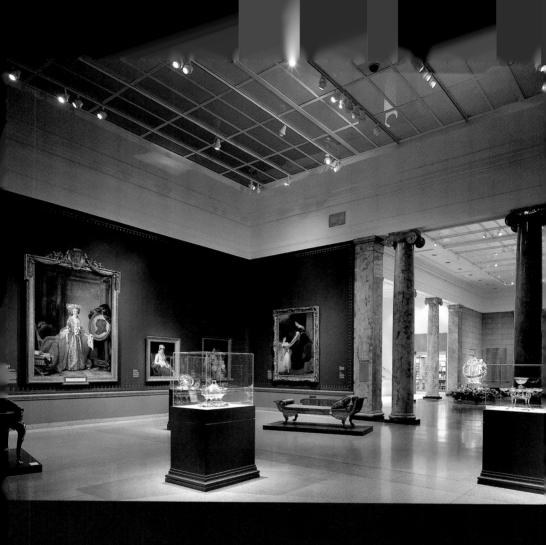
One of the north galleries in the 1927 building, with a view to the foyer

with an interest in European art, a relative rarity among southern art museums at the time.

In 1946 Paul Stewart Harris became the museum's first professional director, succeeding Catherine M. Grey, the museum's long-time executive secretary and member of the board of governors, who had served as acting director following Mrs. Speed's death in 1942. Harris changed the museum's name in 1947 to the J.B. Speed Art Museum, to reflect its new focus on art, and oversaw the construction of the Satterwhite Wing, designed by the Louisville firm of Nevin & Morgan and completed in 1954. Harris's greatest legacy, however, was the guidance and encouragement he provided between 1957 and 1961 to board member Mrs. Blakemore Wheeler in collecting eighteenth- and nineteenth-century French paintings. Her holdings, then known only to a few and ensconced at her home until they were bequeathed to the Speed in 1964, included works by Monet, Cassatt, Degas, Tissot, Seurat, and Courbet. The Wheeler bequest also provided funding that allowed for the purchase of paintings by Corot, Nattier, Largillière, and Boucher. True to her generous and discreet nature, Mrs. Wheeler had also given funds anonymously in 1962 so that the museum's new director, Addison Franklin Page, could purchase the Speed's first Picasso.

Since the 1980s, gifts to the collection have become more diverse in media and period. Henry V. Heuser, Jr., and Harry and Kate Talamini gave the museum rare depth in recent photography with donations of works by Nicholas Nixon, Ralph Eugene Meatyard, and Aaron Siskind. Dr. Leonard Leight and his wife, Adele, have been assembling one of the country's finest collections of contemporary glass, and since 1992 they have given the Speed full or partial ownership of it, as well as of twentieth-century ceramic pieces and furniture. Winchester, Kentucky, native James C. Codell, Jr., and his wife, Carol, assembled the USA's most important and comprehensive collection of metalwork by English entrepreneur Matthew Boulton; this gift came to the museum in part in 1993 and fully in Mr. Codell's bequest of 2004. In 1998 Major General Dillman A. Rash bequeathed a group of important works that he and his wife, Nancy, had collected, among them examples by Picasso, Dubuffet, Chagall, and Matisse, taking the Speed's twentieth-century holdings to new heights. In 2002 Paul Chellgren initiated an ongoing gift of prints by important British and European artists, such as Howard Hodgkin and Mimmo Paladino, in a single stroke making contemporary prints an area of excellence within the collection. In 2004 a partial gift and partial purchase of Steven Block's collection of James Abbott McNeill Whistler lithographs, made possible in part by the generosity of Mrs. W.L. Lyons Brown, established the museum

as a center for the study of Whistler's graphic work. The same year, the family of Joseph and Sylvia Slifka of New York contributed sculptures by Hans Arp and Max Ernst and a painting by André Masson, the first major examples by these artists to enter the collection. Also in 2004, Robinson S. Brown, Jr., presented his collection of more than six hundred American historical flasks and bottles, greatly advancing the museum's goal of developing a historical glass collection. A partial and promised gift from a Louisville collection in 2006 of works by Joseph Stella, Preston Dickinson, Alfred Maurer, William Sommer, and E. Ambrose Webster has brought distinction to the Speed's growing American Modernism collection.

In addition to these remarkably generous donations of large collections and groups of objects, the galleries brim with individual gifts. One of the first of these, the stature of which as a great American portrait only increases with time, is James Peale's *Portrait of Madame Dubocq and Her Children.* Painted in Philadelphia in 1807, it accompanied the Dubocq family to Kentucky in the 1830s, and was presented to the museum in 1932 by Mrs. Aglaé Kent Bixby, the granddaughter of one of the children portrayed. Another gift, startling in its importance, is Constantin Brancusi's bronze masterpiece *Mademoiselle Pogany I*, bequeathed in 1954 by Mrs. Mabel Hussey Degen, who had purchased it while a young art student and painter in Paris in the 1920s. In the mid-1960s Mrs. George W. Norton, Jr., and Mrs. Leonard T. Davidson gave funds for the museum's purchase of an exquisite Rubens oil sketch for the Flemish collection. In 1975 a collector made an anonymous gift of a magnificent oil sketch by Giovanni Battista Tiepolo, setting a similarly high bar for Italian painting. The museum's specialization in Yoruba art from western Africa got its start in 1976 with Mrs. William B. Belknap's donation of the rare late nineteenth-century relief panels.

In 1972, driven in part by the growth of the contemporary collection, the museum built the New Wing, designed by the Chicago firm of Brenner, Danforth, & Rockwell. The wing's Ina Shallenberger Sculpture Court was given by Mrs. W.L. Lyons Brown and her family. Subsequently, Mrs. Brown made possible the museum's acquisition in 1981 of Henry Moore's masterpiece *Reclining Figure: Angles* in memory of her late husband, who had wished to contribute an important piece for the sculpture court. In 1992 Mrs. John Harris Clay gave the museum an eighteenth-century still life by Jan van Os, and her family honored her memory in 2003 with the gift of a marble by John Storrs. Laura Lee Brown and her husband, Steve Wilson, generously made a partial and promised gift of a work by Tony Oursler in 1998, the first video work to enter the collection. Douglas S. Cramer presented the museum with its first screenprint by Andy Warhol in 2002.

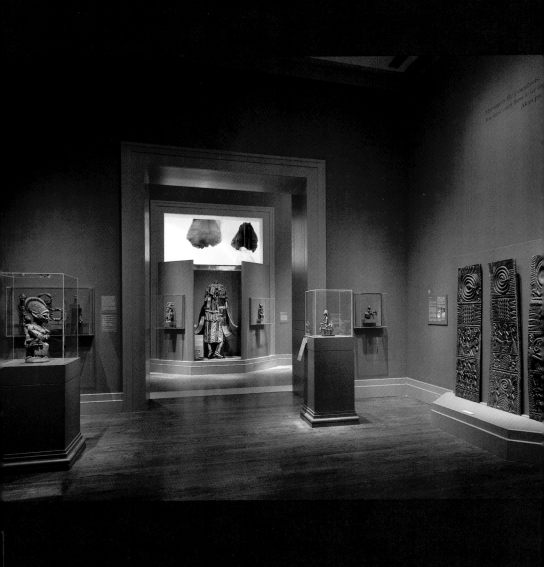

These galleries house the museum's growing African art collection.

Other gifts of signal objects have further enhanced and expanded the collection. In 2000 the Barr family gave funds for the purchase of Randolph Rogers's sculpture *Nydia*, and established a fund for acquisitions of American sculpture in memory of John W. Barr III. The gift from Mr. and Mrs. Owsley Brown II in 2005 of a canvas attributed to Gérard Douffet added a major work to the museum's notable collection of Caravaggesque paintings. The donation by Edith and John Brewer in 2004 of an exceptional early Kentucky inlaid sugar chest is the Speed's first important example of this distinctive American furniture form. All these works set the highest standards for their respective collection areas and continue to attract further gifts and purchases in their wake.

While the collection's many areas of strength and individual high points were born from the generosity of collectors and donors—and could never have been achieved with museum resources alone—the institution's purchases have been another determining influence on the collection, contributing masterworks and adding critical focus and links. In a bold move to raise the profile of the museum and its collection, the Speed purchased Rembrandt's *Portrait of a Forty-Year-Old Woman* in 1977. Since his appointment in 1962, Addison Franklin Page, the museum's second professional director, had been steadily building a representative Dutch collection, and he envisioned the acquisition of a Rembrandt portrait as a fitting way to celebrate the Speed's golden jubilee in 1977. A coalition of corporations, foundations, state government resources, individual donors, and public contributions raised the necessary $1.5 million in five short months. The pressing need for more display space for the Rembrandt and the growing Old Master collection spurred the museum to build another new wing, designed by Robert Geddes of Geddes Brecher Qualls Cunningham of Philadelphia and Princeton, and completed in 1983.

During this period the museum was actively purchasing works of art in other areas as well. With a ready awareness of the contemporary scene, Addison Franklin Page purchased a Robert Rauschenberg screenprint painting in 1964, with funds given by Mr. and Mrs. Charles Horner; a Ben Nicholson in 1966; a Frank Stella in 1967; and, with the support of Henry V. Heuser, Jr., a Sam Gilliam in 1976. During previous decades, as well, the collection benefited greatly from museum purchases. In 1956 the purchase of Kentucky silversmith Asa Blanchard's candlesticks made for Isaac Shelby, the Commonwealth's first governor, announced the Speed's commitment to the finest Kentucky decorative arts. The Speed's collections of paintings and drawings continued to grow, through purchases of English works by Thomas Lawrence and Joseph Wright of Derby, Italian paintings by Sano di Pietro, Giovanni Lanfranco, and Pompeo Batoni, and French

works by Millet, Cabanel, and Tanguy. The Dutch collection also gained further distinction through purchases, among them a pair of Hendrick Goltzius paintings, made possible by the bequest of Jane Morton Norton.

The involvement of the Speed family with the museum has continued since its founding, notably through J.B. Speed's granddaughter Alice Speed Stoll, who served on the board of governors for thirty years and generously funded major purchases (such as portraits by Adélaïde Labille-Guiard and Antoine-Jean Gros) that helped establish French painting as a particular collection strength. Mrs. Stoll's extraordinarily generous bequest in 1996 transformed the collection with the establishment of the Alice Speed Stoll Accessions Trust, providing the museum's only endowed fund for acquisitions since the Satterwhite Trust ceased such support in 1982. The Stoll Trust has enabled the museum to collect more systematically and ambitiously than ever before, and to target works by artists currently not represented in the collection who altered the course of art history, such as a landscape by the seventeenth-century Dutch painter Jacob van Ruisdael and a still life by Paul Cézanne. The fund also makes possible major annual additions to the collection that have ranged from a Sèvres *déjeuner* set to a Yoruba horse-and-rider figure to Yinka Shonibare's *Three Graces*. The thirty-seven works of art that have been purchased to date through the Alice Speed Stoll Accessions Trust are only the beginning of the profound contribution that it will make to the quality of the museum's collection.

Following Addison Franklin Page's retirement in 1983, after twenty-one years as director, Jesse G. Wright became the museum's head in 1984. In 1986 he was succeeded by Peter Morrin, who, like his predecessors, initially served as both director and curator on the museum's small staff. Under Morrin's leadership the museum collection has grown, especially since the addition to the staff of the museum's first full-time professional curators, who include Ruth Cloudman, engaged as Chief Curator and Mary and Barry Bingham, Sr., Curator of European and American Art in 1990, Kimberly Spence as Associate Curator in 1991, Scott Erbes as Curator of Decorative Arts and Design in 1999, and Julien Robson as Curator of Contemporary Art in 2000. Also under Morrin, the museum completed a major renovation and reinstallation of its galleries in 1997, vastly upgrading the presentation of the collection, and completed an addition designed by the Office of Peter Rose of Montreal and Cambridge, providing state-of-the-art storage, art-handling facilities, and new gallery lighting and climate control.

The museum's collection support groups, the membership dues of which support acquisitions, have been the final driving force behind the growth of the Speed's collection. Through their generous support, they

have allowed the museum to collect steadily, even when institutional funds were unavailable, and they have involved hundreds of individuals from the community in building the museum's collection. The first of these groups, the Museum Collectors (subsequently renamed the Charter Collectors), started in 1966 with the support of Addison Franklin Page and under the chairmanship of board member Priscilla Bullitt. For more than forty years Charter's gifts have vitalized galleries throughout the museum with dozens of works, such as the Greek calyx-*krater*, the Gabriel Metsu portraits, Caravaggesque paintings by Nicolas Tournier and Hendrick van Somer, an American genre painting by E.L. Henry, an early painting by Jan Steen, and a landscape by Thomas Gainsborough.

The New Collectors group was formed in 1970, again with Mrs. Bullitt as chairman, to support acquisitions of contemporary art and to engage young collectors, while the Charter group continued to support acquisitions of art dating before 1950. For nearly forty years, the group (its name changed in 2000 to New Art Collectors to reflect its focus on new art) has kept the museum's collections abreast of developments nationally and internationally, with purchases of such works as Realist paintings by William Bailey and Philip Pearlstein in 1972, a Tony Cragg piece in 1986, a work by Kiki Smith in 1995, and, since 2003, pieces by Alfredo Jaar, Ghada Amer, and Berni Searle.

Founded in 2000 under the chairmanship of Sarah McNeal Few, the Decorative Arts Collectors group has already made several major purchases, including ceramic flasks by late nineteenth-century Louisville potter Henry Thomas, a stained-glass lantern attributed to the New York City firm of I.P. Frink, and a chest by the American Arts and Crafts movement artist Madeline Yale Wynne.

The trips that these various groups take to national and international art centers, such as New York, London, Paris, Mexico City, and Stockholm, have resulted in purchases, but have also brought to their attention works subsequently acquired for the museum through other avenues, such as the gift of the Rubens oil sketch by Mrs. Norton and Mrs. Davidson, the donation of the Thomas Addison Richards landscape by Dr. and Mrs. Irvin Abell, Jr., and the Zorach sculpture generously given by Yum! Brands, Inc. Working with directors Addison Franklin Page, Jesse Wright, and Peter Morrin and subsequently with the curators, the collection support groups have added immeasurably to the quality and scope of the Speed's collections.

The growth of the Speed's holdings, from a modest founding collection of 101 objects of various kinds in 1927 to some thirteen thousand works of art spanning six thousand years of human creativity, is a testament to the generosity, knowledge, and enthusiasm of hundreds of donors,

collectors, board members, volunteers, supporters, and staff members. *The Speed Art Museum: Highlights from the Collection*, published on the occasion of the museum's eightieth anniversary, presents some of the museum's finest objects, and reflects the range of what awaits its visitors. We are delighted to offer this volume to help people with planning a visit, walking through the galleries, or recalling their experience. This guide also provides a means to introduce the collection to art lovers everywhere, who in many cases undoubtedly will be pleasantly surprised by the superb and fascinating works of art that have a home in Louisville. We extend to you all a warm welcome to the Speed Art Museum!

Ruth Cloudman, *Chief Curator and Mary and Barry Bingham, Sr., Curator of European and American Art*

How to Use This Book

The works of art included in this guide are divided into five categories: **Art of Ancient Cultures** (ancient Egypt, Greece, Rome, and Asia), **African Art**, **Native American Art**, **European and American Art to 1950**, and **Contemporary Art** (works produced after 1950).

The caption for each object presents the name of the artist or maker, where known, along with his or her nationality and life dates. The date of the work, when known, follows the title. Dimensions are given in inches and centimeters. For two-dimensional works, height precedes width. For works on paper, unless otherwise noted, the size of the sheet is given. For three-dimensional objects, height precedes width, which precedes depth, unless otherwise stated. Sight dimensions refer to the visible portion of a framed or matted work of art.

The last line of the caption contains both the credit line, which tells how the object was acquired (gift, bequest, or purchase), and the object's accession number, which is its cataloguing number, beginning with the year it was acquired. A number starting with an X is an inventory number for an object without an assigned accession number. An object with a PL number, such as PL1943.1, indicates a permanent loan to the museum.

A glossary of selected terms begins on page 230. Sources for direct quotations are listed on pages 234–35.

As its title indicates, this publication features nearly three hundred works considered highlights of the collection. Although the museum endeavors to display as many of these works as possible, not every one can be on view all the time. Textiles, photographs, and other works on paper are highly sensitive to light and can be exhibited for only a limited time. Works in the collection may also be away on loan or undergoing conservation.

Authors

Lisa Bessette (LB)
Handbook Researcher and independent scholar

Bill Carner (BC)
Imaging Services Manager at the University of Louisville Special Collections: Photographic Archives

Ruth Cloudman (RC)
Chief Curator and Mary and Barry Bingham, Sr., Curator of European and American Art

Scott Erbes (SE)
Curator of Decorative Arts and Design

Jasper Gaunt (JG)
Curator of Greek and Roman Art at the Michael C. Carlos Museum of Emory University, Atlanta

Emma Hansen (EH)
Curator of the Plains Indian Museum at the Buffalo Bill Historical Center, Cody, Wyoming

Kara Kostiuk (KK)
Graduate student, Art History Program, University of Louisville

Margaret Lind (ML)
Collection Handbook Project Coordinator

Moyo Okediji (MO)
Associate Professor of Art History, University of Colorado, Denver, and Curator of African and Oceanic Arts, Denver Art Museum

Julien Robson (JR)
Curator of Contemporary Art

Kimberly Spence (KS)
Associate Curator

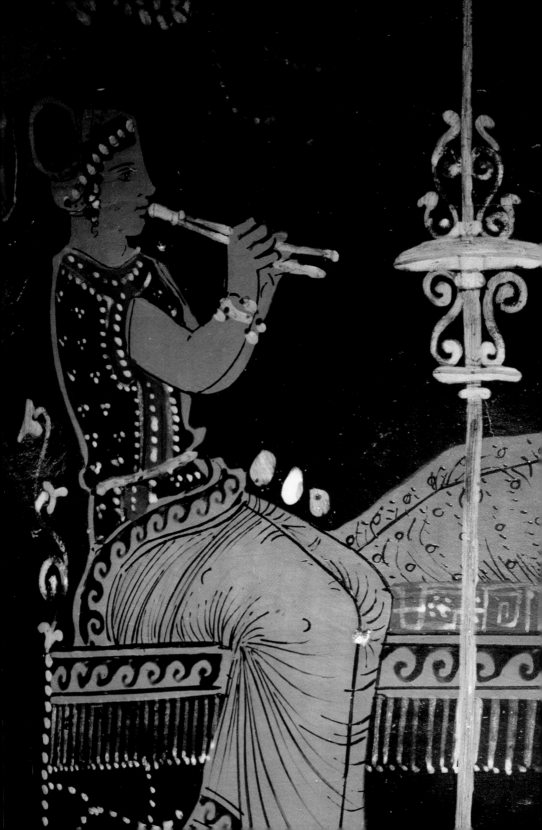

Art of Ancient Cultures

Egyptian, Ptolemaic period
Isis, 332–30 BC
Black granite
$5^5/_8 \times 2^7/_{16} \times 2$ in.
(14.3 × 6.2 × 5.1 cm)
Museum purchase 1996.20.3

▶

The Egyptian goddess Isis was worshipped as
the giver of life. Here she is portrayed with a
traditional wig, supporting the *uraeus* (a spitting
cobra symbolizing divine authority) and an
elaborate headdress of sun disk, horns (now
broken away), and feathers. This relief may
well have shown her together with her consort,
Osiris, the god of life, death, and fertility, and
their child Horus, often depicted seated on
his mother's lap. JG

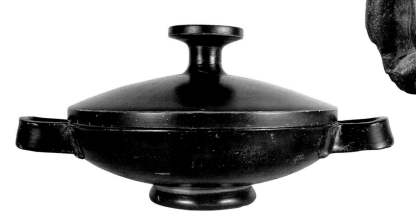

Greek, Athens
Lidded bowl (*lekanis*),
about 430–420 BC
Earthenware
$7^1/_4 \times 15^7/_8 \times 11^1/_4$ in.
(18.4 × 40.3 × 28.6 cm)
Museum purchase 1966.36 a,b

This wide bowl, equipped with long ribbon handles and a
lid, was known in antiquity as a *lekanis*. It was a common
bridal gift, and could be used to store children's toys or
thread. Ancient sources also record that food or spices
might be kept inside. The perfect preservation of this
example suggests that after use, the bowl was finally
consigned to the grave. While Greek pottery was often
decorated, many pieces were glazed black to allow the
refined proportions and sculptural character of the shapes
to emerge more clearly. The glaze itself is not vitreous but
is instead a carefully prepared iron-rich clay slip fired in
oxygen-reducing conditions. JG

The Greeks diluted their wine with water at symposia (drinking parties). Here the god of wine himself, Dionysus, reclines while a female companion, possibly Ariadne, plays the flutes. An old Papposilenos, one of the god's male followers, who is often shown with pointed ears and a goat's tail, fetches a wine jug (*oinochoe*). A table with food, a drinking cup (*kantharos*), and a wine jar (*amphora*) stand before the couch. Dionysus engages in a game of *kottabos*: by spinning his cup, he intends to hurl the dregs so as to dislodge the top from the elaborate stand. The half-length flanking figures are maenads, his female companions; they indicate that the picture is set outside in a hilly landscape that partly obscures them. Dionysus was also the god of theater, hence the two masks that hang above. Python, together with Asteas, was the leading vase painter in Paestum in the fourth century BC. JG

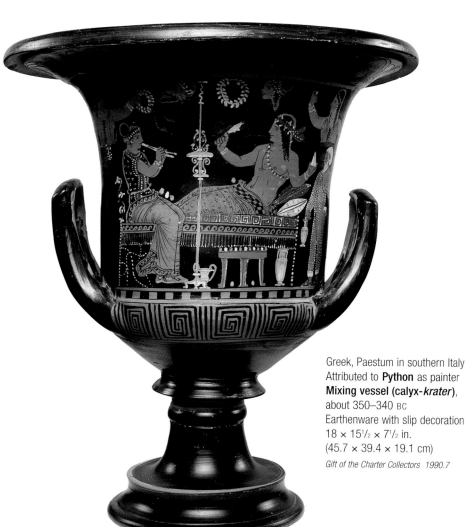

Greek, Paestum in southern Italy
Attributed to **Python** as painter
Mixing vessel (calyx-*krater*),
about 350–340 BC
Earthenware with slip decoration
18 × 15$^1/_2$ × 7$^1/_2$ in.
(45.7 × 39.4 × 19.1 cm)
Gift of the Charter Collectors 1990.7

Roman
Cinerary urn, mid-1st century BC
Marble
$9^{11}/_{16} \times 12^9/_{16} \times 9^7/_8$ in.
(24.6 × 31.9 × 25.1 cm)

Gift of R.C. Ballard Thruston and Mrs. S. Thruston Ballard 1929.17.306 a,b

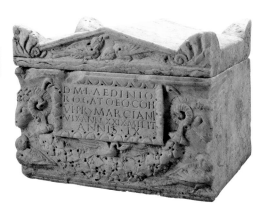

◀ **D**ecorative marble urns were commonly made in the first century BC to contain the ashes of the deceased. Here two rams' heads support with their horns an ivy garland. The pincerlike elements by their horns may be eagles' beaks, joining the two eagles at the lower corners and a third with a snake in its mouth. The pedimental lid, framed by schematic *palmette acroteria* (stylized leaf ornaments), shows two birds feeding. The inscription names the deceased: Lucius Aedinius Rogatus was a member of an elite equestrian family who served in the sixth cohort of the Praetorian Guard. He died at the age of twenty-nine, after nine years of active service. His urn is one of many funerary artifacts recovered from columbaria in Rome to have been preserved in the museum. JG

Roman
Relief with a ram's head,
2nd century AD
Marble
$12^7/_8 \times 15^1/_4 \times 6$ in.
(32.7 × 38.7 × 15.2 cm)

*Gift of Karen Giles Hovey,
Mr. and Mrs. Robert E. Kulp, Jr.,
Mr. William I. Winchester,
Mr. and Mrs. Barry Bingham, Jr.,
Mrs. J. Byron Hilliard,
John and Mary Louise Barr,
Mr. and Mrs. Allen D. Angell,
Dr. Charles and Lisa Barr,
Ms. Anne B. Ogden, and
Mr. and Mrs. Philip Ardery 1993.7*

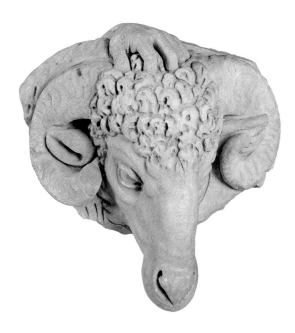

Roman
Sarcophagus, 3rd century AD
Marble
22 × 77 × 21⁹/₁₆ in.
(55.9 × 195.6 × 54.8 cm)

*Bequest from the Preston Pope Satterwhite
Collection 1949.30.266*

▼ **T**he front panel of this sarcophagus shows two swooping *amoretti*, or winged cherubs, who support a shield engraved with the name of the deceased, Gaius Julius Tiberius, who died while on service in Britain. The inscription continues to record that his wife, Calpurnia, commissioned this monument. Below the *amoretti*, at left, lies Oceanus, the god of the river that the ancients believed encircled the world. A *ketos*, or sea-monster, appears beside his feet, while an *amoretto* plays in his lap. On the right, similarly reclining, is Tellus, the female personification of the Earth. Originally she would have held a cornucopia. A bull appears at her feet, while another *amoretto* seeks refuge in her arms. The composition is framed by two groups representing the famous lovers Cupid and Psyche. JG

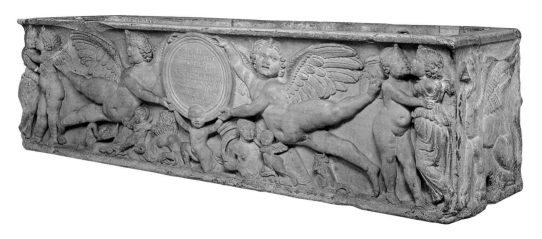

◀ **T**he back of this sensitively wrought sculpture suggests that it was originally in high relief rather than in the round. Although rams' heads often provide decorative corners for Roman sculptural reliefs, whether on cinerary urns, altars, or sarcophagi, the presence of a left hand on top of the animal's head indicates that this fragment was part of a narrative frieze. The narrative may have been mythological in character, or possibly ritual, depicting a sacrificial procession. Its Classicizing style brings to mind the well-known group of Hermes and a prancing ram that, together with Zeus and Hera, decorated the three sides of a candelabrum from the Barberini collection, now in the Vatican. JG

▼ **O**riginally buried in a tomb to serve the deceased, this miniature tower emulates the multistory, timber-framed structures built by wealthy Han-dynasty landowners as part of their fortified rural compounds. This model's archers, figures mounted on horses, and bowl—the latter symbolizing a moat—allude to the Han towers' defensive function. But the towers also offered a place of retreat, providing views over the countryside and relief from the summer heat. Their pleasurable aspects are represented here by flute players, women holding babies, and figures playing a game of *liubo*, here depicted as incorporating a game board and six rods. While the rules of *liubo* are not completely understood, it is known to have been a game of chance that possibly involved fortune-telling. SE

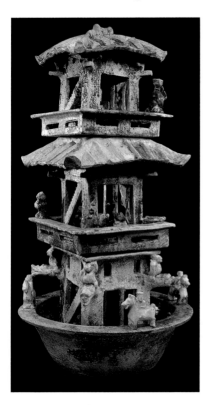

Chinese, Eastern Han dynasty
Tower, AD 25–220
Glazed earthenware
32¼ × 16 in.
(81.9 × 40.6 cm)

*Gift of Mr. and Mrs. Jouett Ross Todd;
Justice and Mrs. Louis Brandeis; bequest
from the Preston Pope Satterwhite Collection;
gift of Dr. Scott W. Cole; Mrs. Dulaney Logan,
in memory of Mr. Logan; Collection of the
Speed Art Museum; gift of the William S.
Kahnweiler Collection, presented by his
wife, Mary Steele Tillman; gift of Miss Fanny
Brandeis; Mr. Cale Young Rice; the estate of
Miss Fanny Brandeis; Miss Jenny L. Robbins;
Miss Mary C. Vance; Miss Anna Schollian;
and Mrs. Clifford L. Alderson, by exchange
2003.13 a–e*

▶ **A**ncient Chinese tomb figures reflected the lifestyle of the person with whom they were buried. This figure's well-modeled face and detailed painted decoration—the products of extensive handwork—suggest that it originally graced the tomb of someone of high rank. There, judging by the position of its hands, it may have served as a groom, holding the reins of a ceramic camel or horse. Natives of central and western Asia, such as this heavily bearded man, often cared for the imported camels and horses used in Tang-dynasty China. The man's ornate headgear, however, differs from the simple turbans and tall hats typically found on most Tang-dynasty groom figures. It instead resembles the headgear worn by some of the foreign dignitaries shown in Tang cave paintings from Dunhuang in northwest China. SE

▶ This fierce, feline-headed beast originally protected the tomb of a person of high rank from grave-robbers and sinister supernatural forces. It would have been partnered with another guardian, which combined a human head with a single horn and very large ears. A pair of armored warriors completed a typical protective entourage. The four figures, usually placed near the tomb entrance, faced outward in order to repel intruders and secure the tomb. As with many glazed Tang-dynasty figures, this example incorporates amber and green glazes. Its blue glaze, however, is relatively rare. Whether owing to scarcity, taste, or a combination of the two, the use of blue glaze during the Tang dynasty is largely limited to the period of about AD 650–750. SE

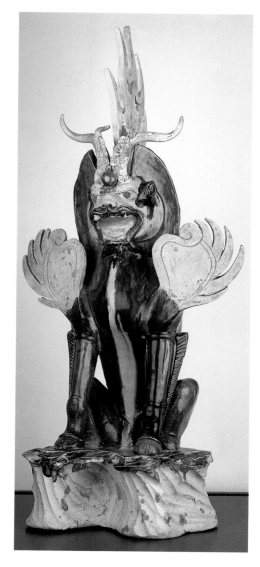

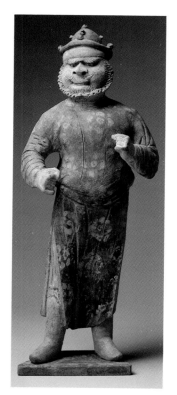

Chinese, Tang dynasty
Foreign man, about AD 700–756
Earthenware, pigment
16¼ × 6 × 5⅜ in.
(41.3 × 15.2 × 13.7 cm)

Gift of the William S. Kahnweiler Collection, presented by his wife, Mary Steele Tillman; bequest from the Preston Pope Satterwhite Collection; bequest of Mrs. Blakemore Wheeler, by exchange; and gift of Abby and Fairleigh Lussky 2001.16

Chinese, Tang dynasty
Tomb guardian, about AD 700–750
Glazed earthenware with traces of pigment
24¾ × 8⅞ × 8⅜ in.
(62.9 × 22.5 × 21.3 cm)

Gift of an anonymous donor and James Breece 1997.6

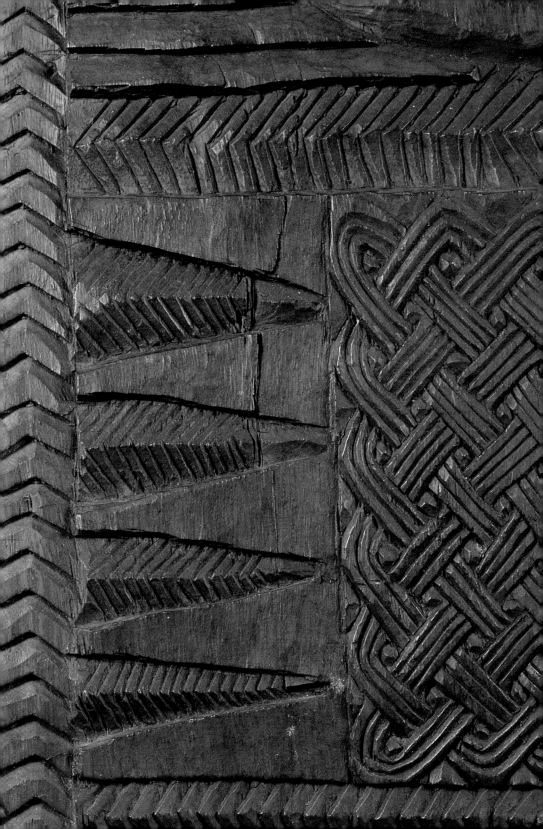

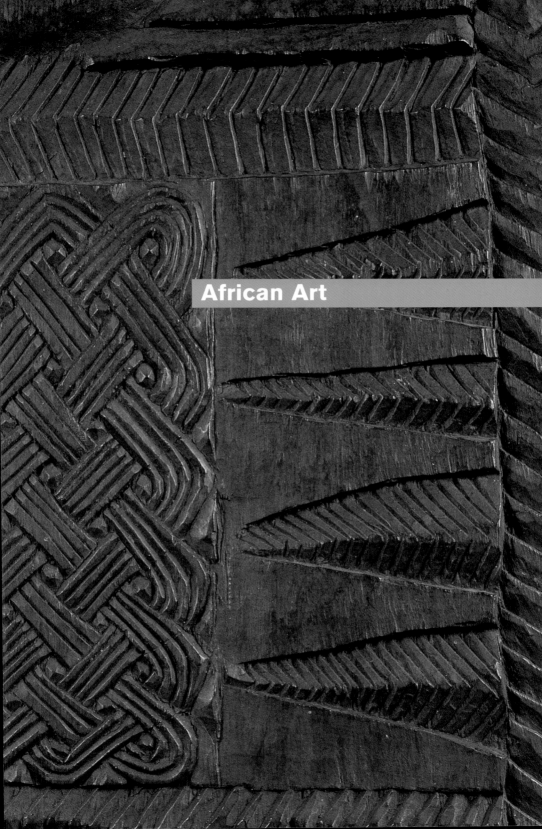

African Art

Edo people, Nigeria, Benin kingdom
Altar of the Hand, 17th century
Brass
10¹/₂ × 11 in.
(26.7 × 27.9 cm)
Museum purchase, Preston Pope Satterwhite Fund 1970.14

◀ **A**mong the Edo-speaking Benin people of southwestern Nigeria are artists renowned for their virtuosity as metalworkers. Benin artists usually cast objects in bronze and brass for the royalty only. This unknown artist represents the increasingly prominent role of Benin women in seventeenth-century political life, when the office of the king's mother became one of the most important sections of Benin bureaucracy. The Benin world, symbolized as a round structure with a roof, is divided into four cardinal points, each marked by a queen beating a gong: an expression of female voice, power, and vigilance. Each queen is ritually dressed in expensive beads, to show the prosperity of a people who had recently developed international trade. The availability of metalcasting materials from Europe encouraged artists to experiment with new forms, such as this ornately decorative royal altar object. The rippling shapes at the women's feet and on the top demonstrate the spiritual connections and mysterious energy among the queens, and allude to Olokun, the Benin water divinity. MO

▶

The northern Yoruba warriors from the kingdom of Oyo who invaded the southern parts of Yorubaland in the seventeenth and eighteenth centuries clearly left an impression on this unknown sculptor, who depicts a mounted invader poised with a javelin. Wearing body armor and a large helmet, this warrior sits straight on his horse as he prepares to attack. Although the sculptural style suggests an origin in the southern Owo region, the face is decorated with lines associated with warriors from the Oyo region. The invader's terrible gaze is intended to strike fear into the hearts of his enemies. The artist uses intricate zigzag patterns to give character and detail to the composition, which was probably commissioned as an altarpiece for the celebration of Ifa, the divination god. MO

Yoruba people, Nigeria, Owo
*Horse and Rider (**Jagunjagun Eleshin**)*, probably 17th–18th century
Wood
8⁵/₈ × 7⁷/₈ × 3¹/₄ in.
(21.9 × 20 × 8.3 cm)
Purchased with funds from the Alice Speed Stoll Accessions Trust 2003.15

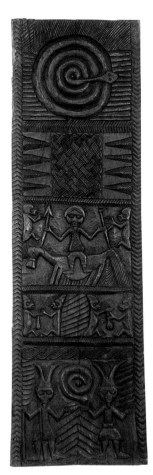
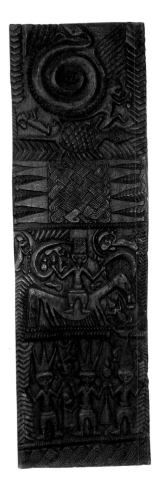

This triptych marks a transitional period in Yoruba history between independent indigenous rule and the colonial era. The unknown sculptor portrays several political players jockeying for power in the wake of a protracted civil war, ironically designing a balanced composition to convey profound social imbalance. The central figure in the triptych is the heraldic equestrian general, wielding a spear and a gun and flanked by his attendants, whereas the king (wearing his conical crown) appears at the bottom of the right panel, surmounted by bird images representing the support of local witches. The location of the king at the margin here suggests the shifting role of royalty in the unstable political structure that emerged at the end of the nineteenth century. To suggest unity, however, the sculptor repeats the "W" motif of linked arms throughout the work. MO

Yoruba people, Nigeria, Ijebu-Ode
Panels, late 19th century
Wood
Left: 70 × 19⁷/₈ × 2¹/₂ in.
(177.8 × 50.5 × 6.4 cm)
Center: 70¹/₈ × 20⁹/₁₆ × 3 in.
(178.1 × 52.2 × 7.6 cm)
Right: 70¹/₄ × 21¹/₈ × 2⁷/₈ in.
(178.4 × 53.7 × 7.3 cm)
Gift of Mrs. William B. Belknap
1976.12.1–.3

▶ **A** devotee of Eshu, the Yoruba god of the crossroads, wears a *buba* tunic over a patterned undergarment, adorns his neck with rows of beads, and intricately braids his hair beneath an arching cap covered with *ado,* or stuffed power gourds. Holding a small *ogo,* or Eshu staff, in one hand and a jar of palm oil in the other, he kneels at a crossroads, shown as the summit of a conical plinth. Here he invokes the *ashe,* or power of Eshu, by pouring the palm oil—the favorite drink of the divinity—on the *ogo.* This piece probably hung on the shoulder of a priest as an insignia of office during performances worshipping Eshu, who was further associated with uncertainty, impulse, and mischief. MO

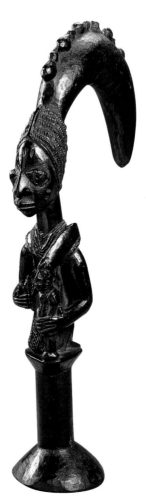

Yoruba people, Nigeria, Oyo
Eshu staff (*Ogo Elegbara*),
late 19th–early 20th century
Wood
20¹/₂ × 3⁷/₈ × 10¹/₄ in.
(52.1 × 9.8 × 26 cm)
*Purchased with funds from the Alice Speed
Stoll Accessions Trust 2004.18*

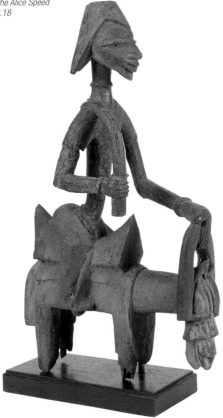

Yoruba people, Nigeria, Ijebu,
probably Ikorodu
***Horse and Rider* (*Babalawo
Eleshin*),** 19th–20th century
Wood, pigment
12⁵/₈ × 3¹/₁₆ × 7³/₈ in.
(32.1 × 7.8 × 18.8 cm)
*Purchased with funds from the Alice Speed
Stoll Accessions Trust 2004.4*

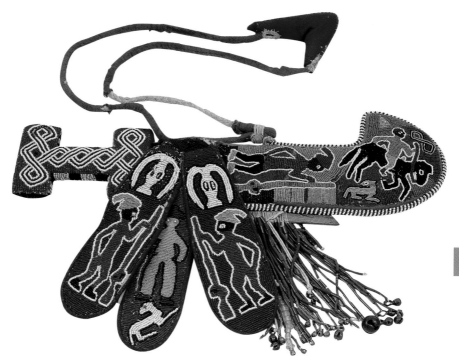

Yoruba people, Nigeria, Owo
**Ceremonial sword (*Udamalore*)
and beaded scabbard (*Ewu*)**,
19th–20th century
Sword: iron, glass beads, cotton,
raffia
Scabbard: glass beads, cotton,
felt, raffia, copper alloy, wood,
animal pelt
Sword: 4¹/₂ × 18¹/₂ × 1¹/₈ in.
(11.4 × 47 × 2.9 cm)
Scabbard: 14¹/₄ × 18 × 1¹/₂ in.
(36.2 × 45.7 × 3.8 cm)
*Purchased with funds from the Alice Speed
Stoll Accessions Trust 2003.7.1 a,b*

▲ The intricately decorated ceremonial beaded sword and
scabbard depict scenes glamorizing military prowess. The
high-ranking chiefs from the Owo kingdom in Yorubaland
who wore these items as costumes were members of
the military elites that ruled and protected this borderland.
Using imported European beads, this unknown artist
presents an Owo warrior on a horse, attended by guards
armed with rifles. The blue-and-white beaded symbol on
the sword's red handle represents the *ibo,* or linkages,
an allusion to the virtues of cooperation in any social
or military enterprise. Also depicted here are the dogs
sacrificed to Ogun, the god of war, and the rams sacrificed
to Shango, the god of lightning and thunder. MO

◀ The majesty of the Ifa priest (*babalawo*) on horseback is the subject of this
figure for Ifa, the divination god. Unlike Ogun priests, who also functioned as
warriors, Ifa priests generally served civil or political functions. The unknown
sculptor uses graceful lines and elongated shapes to convey the benign
demeanor of the priest, who displays the *iroke*, an elongated ivory staff
associated with the divinity of wisdom and knowledge. The center of gravity of
the entire sculpture lies at the intersection of the horizontal thrust of the horse
and the precarious vertical rise of the rider. The stabilizing diagonal arches
of the arms connect the horse to the rider, whose head is treated in broad
geometric shapes that convey intelligence, reflection, and calm. MO

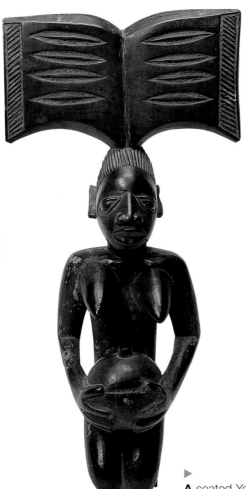

◀ **A** young devotee kneels in submission under the trance of Shango, the Yoruba divinity of lightning and thunder. Her transfixed eyes show that she has become a vehicle to connect the world of mortals visually with the world of spirits. With her hair carefully braided and her youthful body attractively oiled, she presents a gourd containing sacrifices from devotees seeking Shango's protection from malevolent forces. The double-headed axe at the top of the figure is the prominent symbol of *Oshe*, or Shango's wand, which was used by Shango priests to control his stormy attributes. The four parallel flattened ellipses that accent the axe show the Oyo–Yoruba origin of Shango priests, who often wear similar facial designs. MO

Yoruba people, Nigeria, Oyo
Shango dance wand (*Oshe Shango*), late 19th century
Wood
15⅝ × 7⁵/₁₆ × 4³/₁₆ in.
(39.7 × 18.6 × 10.6 cm)
Museum purchase 1972.40

▶

A seated Yoruba mother of twins cradles and feeds her babies as she softly treats them to nursery rhymes. She has rolled up her blouse to enable the twins to suckle comfortably. The elaborate coral beads braided into her finely woven hair suggest that she is a queen, and to enhance her beauty further, she wears facial lines of three vertical designs on each cheek. This sculpture shows the characteristic robust handling of volumes by Adeshina, one of the most eminent sculptors in Yorubaland at the turn of the twentieth century. It is an altarpiece probably commissioned to commemorate the repeated birth of twins in the palace; the Yoruba people are noted for their high rate of twin births. MO

Agbonbiofe Adeshina
Nigerian, died 1945
Mother of Twins (Iya Ibeji),
early 20th century
Wood, pigment
25⁹/₁₆ × 7³/₈ × 7⁷/₈ in.
(64.9 × 18.7 × 20 cm)
*Purchased with funds from the Alice Speed
Stoll Accessions Trust 2003.14*

▼ **G**elede sculptures are part of an elaborate masking performance that combines carving, costume, singing, and dancing into a spectacular annual event celebrating motherhood. The chanted and sung poetry of Gelede, called *Efe,* consists of satires and jests composed to enshrine social values and admonish aberrant behavior. This Gelede sculpture portrays a Yoruba proverb about feminine beauty, *Gele o dun,* which says that the *gele* headgear is not attractive unless it is tied properly and furthermore fits the head, as it does here. The unknown sculptor therefore subtly reminds people about the importance of appropriate behavior in the community. This sculptor also draws upon symmetrical forms to represent the values of balance, simplicity, elegance, and proportion. MO

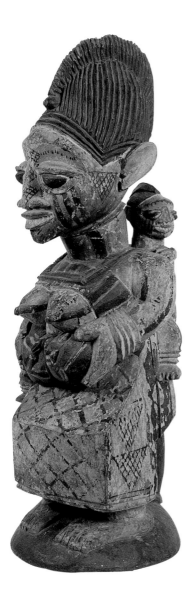

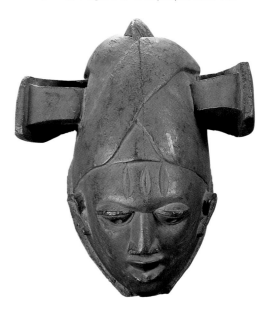

Yoruba people, Nigeria
Gelede mask (Ere Gelede),
mid-20th century
Wood
12⁷/₈ × 11 × 9¹/₄ in.
(32.7 × 27.9 × 23.5 cm)
*Purchased with funds from the Alice Speed
Stoll Accessions Trust 2003.12*

▼ **T**he Kuba people, who live in the southeastern part of the Democratic Republic of Congo (formerly Zaire), are renowned for their impressive raffia textiles. Starting with a plain rectangular canvas typically woven of raffia fiber by a man, this unknown female Kuba artist has produced an exquisite work of embroidery worthy of a royal commission. The repetition of a simple rectangular shape produces a complicated effect of interlocking lines that break and reconnect at measured intervals. Using a variety of embroidery stitches to produce different patterns, textures, and shapes, the artist has limited her colors to two shades of brown, thus harmonizing the entire composition. The concentric shapes that frame the work turn the entire cloth into an aerial landscape of round dwellings surrounding a cultivated field, with the dark dots symbolizing people. Probably made as an undergarment for a queen or princess, the apron has lost its section with attachment strings. The Reverend William H. Sheppard, one of the first African–Americans to serve as a Christian missionary to the Congo region, reportedly received this cloth as a gift from the Kuba king. MO

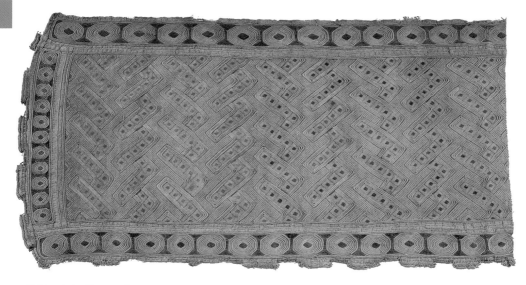

Kuba people, Democratic
Republic of Congo
Cloth, 19th century
Raffia, dyes
15³/₈ × 27 in.
(39.1 × 68.6 cm)
Gift of Mrs. W.H. Sheppard 1934.9.3

Songye people, Democratic
Republic of Congo
Ceremonial axes, 19th–20th
century
Copper hammered over wood,
wrought iron
Each, approx.: 16¹/₈ × 11 × 2¹/₂ in.
(41 × 27.9 × 6.4 cm)
Gift of Mrs. William B. Belknap
976.12.8–.9

► The Fang people, who inhabit the dense rainforests of central Africa, organize their societies around close-knit family units claiming common ancestry. Fang sculptors represent the spiritual connections between the people and their ancestors. With a sparing use of shapes and symmetrical volumes, this unknown Fang artist presents an expressive funerary sculpture that typically attaches to the basket containing the cherished remains of deceased ancestors. Symbolizing the metaphysical intersection of the living and the dead, the sitting figure captures nostalgia, recollection, grieving, and healing within its exaggerated facial expression and controlled body language. Its segmentation into three sections (head, torso, and limbs) enables the sculptor to abbreviate some anatomical features in order to emphasize adjacent forms. For instance, the reduction of the jaw enables the artist to exaggerate the forehead and give prominence to the eyes, evoking wisdom, metaphysical vision, and mystery. The solidity of the male figure suggests dependability and stability, which are always valued in times of grieving. MO

Fang people, Gabon
Reliquary figure,
19th–20th century
Wood, metal
15^{1}/$_{8}$ × 4 × 3^{7}/$_{8}$ in.
(38.4 × 10.2 × 9.8 cm)
Collection of the Speed Art Museum X.1

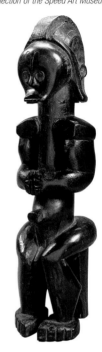

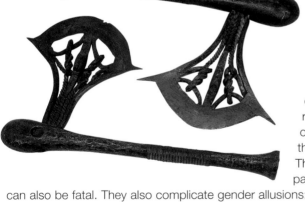

◄
The Songye people, whose kingdom dates from the sixteenth century, inhabit the southeastern region of the Democratic Republic of Congo and are renowned for their exquisite work in iron forging. These ceremonial axes suggest the paradox that something beautiful can also be fatal. They also complicate gender allusions: the convoluted uterine shape of the metal blade penetrates the simple phallic head of the wooden stem, while the "female" part is forged of hard iron and the "male" part is sculpted out of wood. The reference within the blade to the uterus is likewise ambivalent, because the small, sculpted head at the center can refer to a victim of execution as well as an emerging infant at childbirth. The knotted twines within the blades suggest newly forming human lives but also hint at death by hanging. In form and function, then, these objects, proclaiming their bearer's authority and decision-making capacity, are evocative, even contradictory, symbols of life and death. A golden-and-rust-brown patina covers both metal and wood, softening the geometric differences between the linear handle and the arching blade. MO

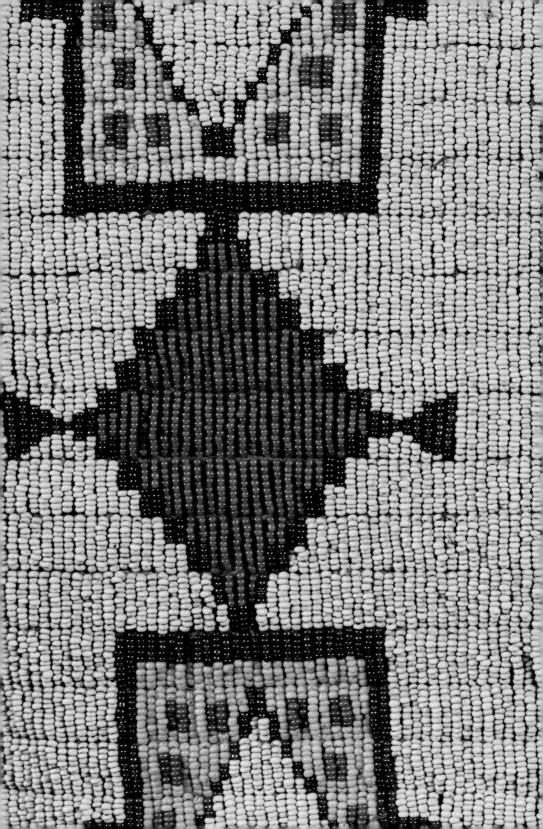

Native American Art

▼ **W**ithin Plains Native societies, specialized clothing, regalia, and insignia denoted the honors, abilities, and status of their owners. For ceremonies and sometimes during battle, honored warriors wore shirts made of deer, elk, or antelope hides decorated with strips of dyed porcupine quillwork or beadwork sewn on to the shoulders and sleeves. Some war shirts exhibited paintings illustrating deeds done in battle: coups counted, horses captured, or enemies defeated. The dark painted hand on this Lakota shirt possibly signifies that the wearer had defeated an adversary in hand-to-hand combat. The red hand may indicate further that he had killed the man in such a conflict, although the act of touching an enemy in battle without killing him earned the highest honor of all. EH

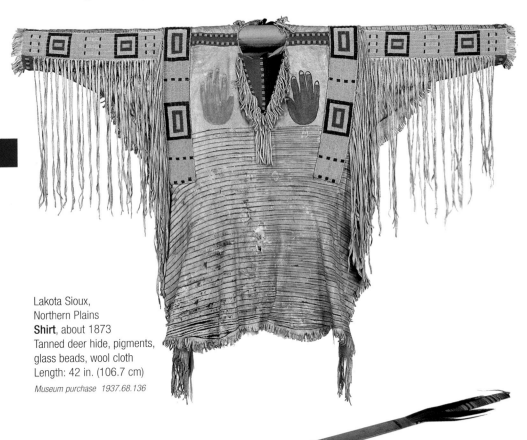

Lakota Sioux,
Northern Plains
Shirt, about 1873
Tanned deer hide, pigments,
glass beads, wool cloth
Length: 42 in. (106.7 cm)
Museum purchase 1937.68.136

Sac and Fox, Iowa
Pipe bowl and stem, about 1832
Pipestone (catlinite), lead, wood,
dyed porcupine quills, horsehair
Bowl: 4⁵/₈ × 2 × 9¹/₁₆ in.
(11.7 × 5.1 × 23 cm)
Stem: 37¹/₂ × 2 × ¾ in.
(95.3 × 5.1 × 1.9 cm)
Museum purchase 1937.68.112 a,b

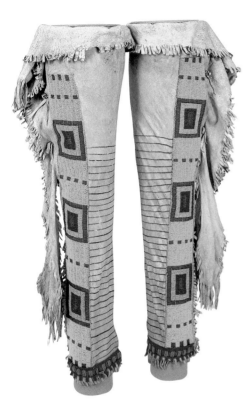

◀ **L**akota men carried their finest decorated war shirts and leggings when traveling on war expeditions, and wore them during battle to attract supernatural protection and ensure success. This pair of leggings is part of a set of dress clothes that includes the war shirt opposite as well as moccasins, a pipe bag, a bow case and quiver, and a quirt (riding whip), all decorated in coordinating beadwork designs. The horizontal stripes of the leggings and shirt possibly symbolize the wearer's war honors or the number of expeditions he had undertaken. Such beautifully decorated outfits were also worn during ceremonial occasions to represent their owners' fortitude, valor, and leadership abilities. Lieutenant Lee Alexander of the Seventh Cavalry acquired this outfit at Fort Rice, North Dakota, around 1873. EH

Lakota Sioux, Northern Plains
Leggings, about 1873
Tanned deer hide, pigments, glass beads, wool cloth
Each, length: 33 in.
(83.8 cm)
Museum purchase 1937.68.137 a,b

◀ **N**ative American men smoked ceremonial pipes during times both of war and of peace. War expedition leaders carried pipes as symbols of their position and sought protection, success, and guidance through ceremonial smoking. Men also held pipe ceremonies to establish alliances among peoples, and in councils before important deliberations. An elegant lead inlay design enhances the bowl of this catlinite pipe, while porcupine quillwork and horsehair embellish the stem. The pipe is said to have been collected in 1832 by Lieutenant Thomas Alexander from the renowned Sac and Fox leader Black Hawk, as Alexander escorted him as a prisoner to Washington, D.C., at the conclusion of the Black Hawk War, an unsuccessful attempt to regain tribal homelands east of the Mississippi. EH

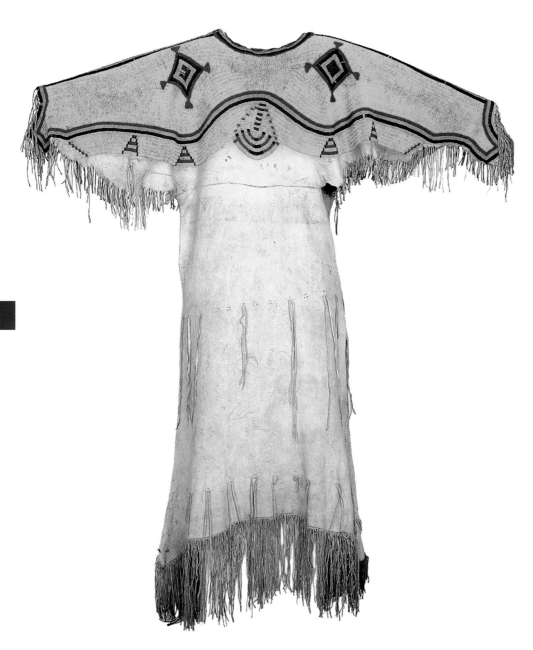

Lakota Sioux, South Dakota
Dress, about 1880–90
Tanned deer hide, glass beads
Length: 59 in. (149.9 cm)
Museum purchase 1937.68.10

◀ During the early reservation period, 1880–1920, an unexpected and remarkable flowering of Plains Native arts transpired, with the creation of beautiful works in hide, beadwork, and porcupine quillwork. Using their skills in producing soft, white, tanned hides and delicate beadwork, Lakota women created elegant dresses for ceremonies, dances, parades, and other formal occasions. Lakota beadworkers favored blue beads as the backgrounds for reservation-era dresses such as this one, which features a fully beaded bodice with geometric designs that include two multicolored diamond shapes. The characteristic central design of the lower bodice is said to represent a turtle rising from the water. For the Lakota, the turtle is symbolically associated with women, childbirth, and infancy. EH

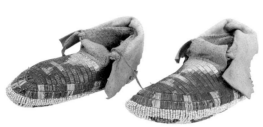

Lakota Sioux, Pine Ridge Reservation, South Dakota
Child's moccasins, about 1890
Tanned hide, dyed porcupine quills, glass beads
Each: 3 × 2³/₄ × 6 in.
(7.6 × 7 × 15.2 cm)
*Frederick Weygold Collection
1937.68.122 a,b*

◀
Plains Indian women were respected for their traditional roles of nurturing children and caring for their families. A significant part of both roles, and one that became even more important during the difficult early reservation period, was the creation of beautifully designed and well-crafted clothing and moccasins for family members to wear for ceremonial occasions and rites of passage. Lakota and Cheyenne women produced moccasins such as this pair with tops entirely covered in quillwork or beading as well as fully beaded soles. Sometimes referred to as "spirit moccasins," they could be buried with beloved family members. The moccasins were also made for family members to wear during ceremonies as they sat with outstretched legs so that others might appreciate the artistry—and devotion—of their female relatives. EH

▼
Native American people believed that tobacco was a gift from the supernatural powers to men, and the act of smoking a ceremonial pipe was a message or prayer to the heavens. They smoked to give thanks, to establish new relationships and seal agreements, to mark significant passages of ceremonial life, and to begin important expeditions. Pipe bowls and stems were sometimes carved in the shape of human or animal figures; in this one an eagle claw cradles the bowl, and the form of a fish serves as the stem. In the early 1890s, Eastern Sioux carvers began sculpting catlinite pipes in this design for sale at the Pipestone National Monument in eastern Minnesota, where this stone was quarried. EH

Dakota Eastern Sioux, Minnesota
Pipe bowl and stem,
about 1890–1900
Pipestone (catlinite), wood
Bowl: 2⁷/₈ × 1¹/₈ × 2 in.
(7.3 × 2.9 × 5.1 cm)
Stem: 7¹/₂ × 1¹/₄ × ⁵/₈ in.
(19.1 × 3.2 × 1.6 cm)
*Frederick Weygold Collection
1937.68.117 a,b*

▼ **P**lains Native women made parfleches for storing food, clothing, and household goods. They were commonly shaped as envelopes, made from an oblong section of buffalo rawhide with the long sides folded inward and the short sides folded to meet in the middle. Women painted the vibrant geometric designs of the parfleches when the hides were staked out to dry before being cut. Made in sets of two, parfleches were hung by hide loops in lodges or packed on horses or dogs for travel. After buffalo became scarce and the tribes were settled on reservations in the late nineteenth century, women made parfleches from the hides of domestic cattle. By this time manufactured containers were available for daily life, so parfleches were primarily made for gift-giving. EH

Lakota Sioux, South Dakota
Parfleche, about 1900
Rawhide, pigment, tanned hide strips
13¹/₄ × 26¹/₂ × 1¹/₂ in.
(33.7 × 67.3 × 3.8 cm)
Frederick Weygold Collection 1937.68.68

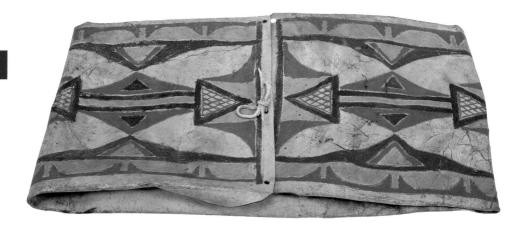

▶
Plains warriors and leaders wore eagle-feather bonnets, created from the bird's tail feathers and often elaborated by magnificent flowing trailers of many more feathers, as symbols of their own personal acts of bravery or of the combined war honors of many men in their tribe. Men also wore them in battle to inspire bravery, to remind other men of past war honors, and to summon supernatural powers to defeat their enemies. The Lakota considered that the feathers of the bonnet held the protective power of the eagle, which prevented men from being hit by arrows or bullets. After tribes were settled on reservations, distinguished men continued to wear eagle-feather bonnets to represent their achievements and to remind people of their tribal histories. EH

Lakota Sioux, South Dakota
Eagle-feather bonnet,
about 1925
Tanned deer hide, eagle feathers,
glass beads, horsehair, ermine,
wool cloth
Installed: 72 × 31¹⁄₂ × 19 in.
(182.9 × 80 × 48.3 cm)
Museum purchase 1937.68.1

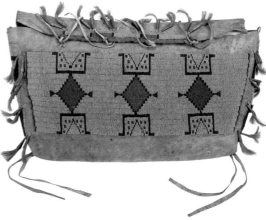

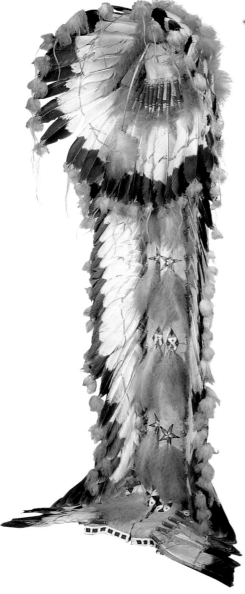

Northern Arapaho, Wyoming
Bag, about 1880–90
Tanned deer hide, glass beads,
metal, horsehair, cotton cloth
12 × 20³⁄₄ × 2³⁄₄ in.
(30.5 × 52.7 × 7 cm)
Frederick Weygold Collection 1937.68.67

▲

Plains Native women took great care
and pride in furnishing their lodges with
functional and transportable, yet often finely
decorated, objects. Such bags as this
Arapaho example were sometimes called
"possible bags," because they were used
to store every possible thing. Made in pairs
from soft tanned hide, they were decorated
with painting, beadwork, or porcupine
quillwork in culturally specific designs.
These bags were also considered
decorative and were deliberately hung or
placed around lodges or tied on saddles.
By the start of the early reservation period
in 1880, Lakota, Cheyenne, and Arapaho
women were embellishing entire fronts of
storage bags in beadwork and creating
innovative designs by combining beading
with the fabrics, tin cones, and other
metals that were available through trading
posts and stores. EH

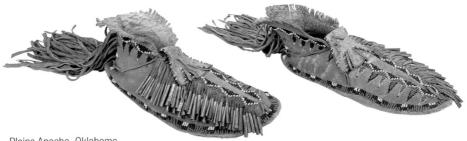

Plains Apache, Oklahoma
Moccasins, about 1890
Tanned hide, rawhide, glass
beads, pigment, metal
Each, approx.: 3⁷/₈ × 4 × 10¹/₄ in.
(9.8 × 10.2 × 26 cm)
Frederick Weygold Collection
1937.68.129 a,b

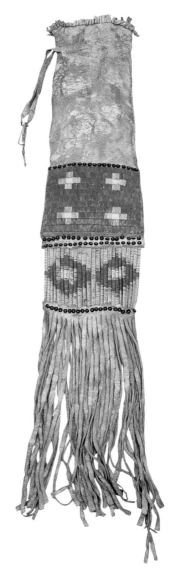

▶

Porcupine quillwork is an ancient tradition among Native
American people of the Plains. Women used this art to
decorate lodge robes and furnishings, clothing, moccasins,
and pipe bags with geometric and floral designs, which
they created by flattening and dyeing the quills with natural
pigments before sewing or wrapping them on to hide.
Later, Plains women created more vibrant colors by boiling
quills with strips of brightly dyed blankets and aniline dyes
obtained from trading posts. As small glass beads became
widely available, by the middle of the nineteenth century,
beadwork largely replaced quillwork, except among the
Lakota and the Mandan, Arikara, and Hidatsa, who
continued to produce it into the twentieth century. The
latter group particularly favored the vivid red, yellow,
orange, and violet dyes they obtained from Fort Berthold
Reservation traders. EH

Hidatsa, Fort Berthold Reservation,
North Dakota
Pipe bag, about 1900
Tanned deer hide, dyed porcupine
quills, metal disks
34¹/₂ × 5³/₄ × 1 in.
(87.6 × 14.6 × 2.5 cm)
Frederick Weygold Collection 1937.68.191

◀ **U**sing their skills in tanning the hides of deer and other animals, and their artistry in painting, quillwork, and beadwork, Plains Indian women produced functional yet beautiful and culturally meaningful items for everyday use as well as special ceremonial occasions. Dresses, leggings, shirts, and moccasins created by the Plains Apache (Kiowa Apache), Kiowa, and Comanche women of the Southern Plains were examples of simple elegance, with modest beadwork designs centered on single motifs or narrow bands highlighted by painting and long fringes. These moccasins show the use of yellow pigment, long fringes, and sparsely applied beadwork bands and designs, all characteristic of Southern Plains decoration. The long fringes embellish the backs of the heels, while tin cones enhance the fringes on the tops of the moccasins. EH

Southern Cheyenne, Oklahoma
Cradle, about 1900
Cotton cloth, glass beads, wood, metal, brass bells and tacks, tanned hide
47$^1/_2$ × 13$^1/_2$ × 10$^1/_2$ in.
(120.7 × 34.3 × 26.7 cm)
Frederick Weygold Collection 1937.68.29

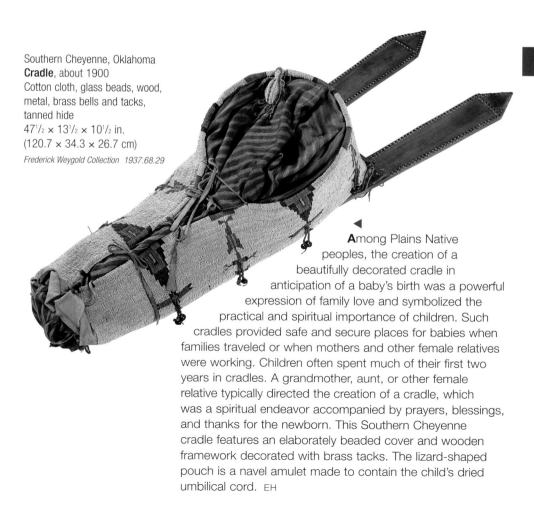

▲

Among Plains Native peoples, the creation of a beautifully decorated cradle in anticipation of a baby's birth was a powerful expression of family love and symbolized the practical and spiritual importance of children. Such cradles provided safe and secure places for babies when families traveled or when mothers and other female relatives were working. Children often spent much of their first two years in cradles. A grandmother, aunt, or other female relative typically directed the creation of a cradle, which was a spiritual endeavor accompanied by prayers, blessings, and thanks for the newborn. This Southern Cheyenne cradle features an elaborately beaded cover and wooden framework decorated with brass tacks. The lizard-shaped pouch is a navel amulet made to contain the child's dried umbilical cord. EH

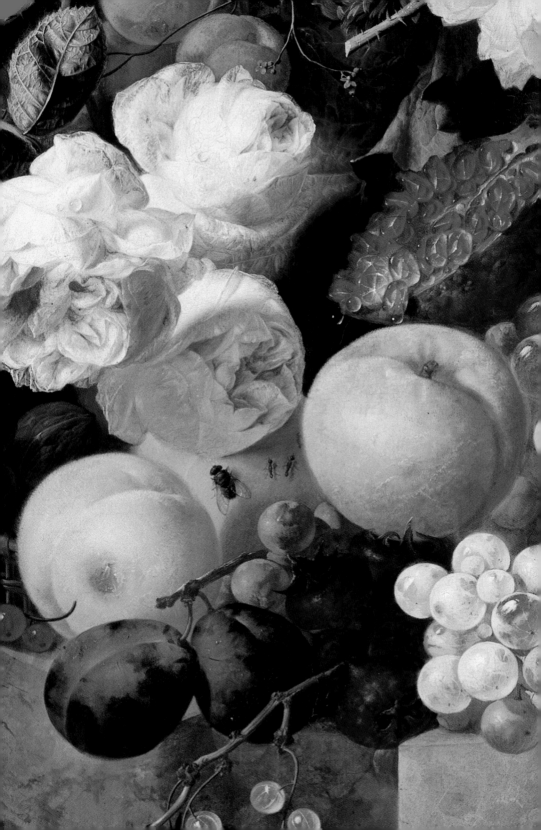

European and American Art to 1950

▼ These paintings once formed part of a multipaneled altarpiece. Positioned on the right, they flanked a central image of an enthroned Madonna and Child and were mirrored on the left by other saints. Saint Catherine holds a martyr's palm (symbolizing her spiritual victory over death) and stands near the spiked wheel used by Emperor Maxentius in an attempt to kill her. Saint James the Major, one of Christ's apostles and the brother of John the Evangelist, holds a pilgrim's staff that recalls his missionary journey to Spain. Daddi operated one of the busiest workshops in Florence during the first half of the fourteenth century. Adopting the revolutionary innovations of his teacher, Giotto, Daddi used shading to give his figures mass and weight, infusing them with a sense of naturalism and three-dimensionality that heralds the Renaissance. ᴋs

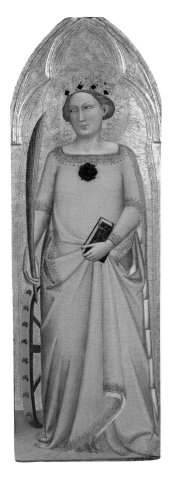
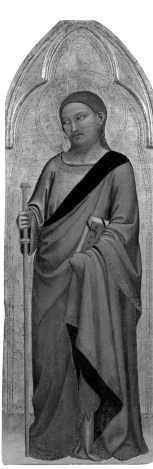

Bernardo Daddi
Italian, active about 1280–1348
Saint Catherine of Alexandria,
mid-1340s
Tempera and gold leaf on panel
37⁷/₁₆ × 12¹/₄ in.
(95.1 × 31.1 cm)
Gift from the Preston Pope Satterwhite Collection 1941.106

Bernardo Daddi
Italian, active about 1280–1348
Saint James the Major,
mid-1340s
Tempera and gold leaf on panel
37⁷/₁₆ × 12⁷/₁₆ in.
(95.1 × 31.6 cm)
Gift from the Preston Pope Satterwhite Collection 1941.105

◀ **T**his manuscript page originally formed part of an antiphonary, or liturgical music book, that was commissioned for the hospital of Santa Maria della Scala in Siena. The page features a response sung by the choir for the feast of the Annunciation on March 25 ("The angel Gabriel was sent to the Virgin Mary . . ."). Sano's rich colors and elegant figures earned him numerous prestigious commissions to decorate manuscripts, but his true genius lies in the creative way he stages his narratives within the shapes of the ornamented initials. Here the letter M forms architectural arches and columns that separate the Virgin Mary from the archangel Gabriel, who announces that Mary will bear a child. KS

Sano di Pietro
Italian, 1405–1481
The Initial M, with the Annunciation (page from an antiphonary), about 1470–73
Tempera and gold leaf on vellum
$21^{13}/_{16} \times 15^{1}/_{2}$ in.
(55.4 × 39.4 cm)
Purchase, Museum Art Fund 1963.9

▶

Pseudo Granacci is the name given to a Florentine artist whose work has sometimes been confused with that of Francesco Granacci; both painters worked in the circle of the conservative master Domenico Ghirlandaio. The tondo (round) format was especially popular in fifteenth-century Tuscany, and was often used for paintings intended for domestic settings; the Madonna and Child were frequently the subject of tondi. In this rendition of the *Maria lactans,* or lactating Virgin, Mary pulls aside her dress and the infant Christ prepares to nurse, looking toward the viewer to draw attention to his act. The Incarnation of God was an important theme in Renaissance art, one repeatedly explored, as here, in scenes of Christ's infancy. The Virgin's bared breast and tender look are intended to remind the viewer that she sustained the Son of God in his infancy and has a standing in heaven that allows her to intercede on behalf of sinners. LB

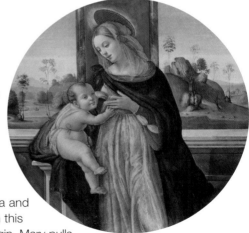

Pseudo Granacci
Italian, active about 1490–1525
Madonna and Child
Tempera on panel
Diameter: $34^{7}/_{8}$ in. (88.6 cm)
Museum purchase, Preston Pope Satterwhite Fund 1972.35

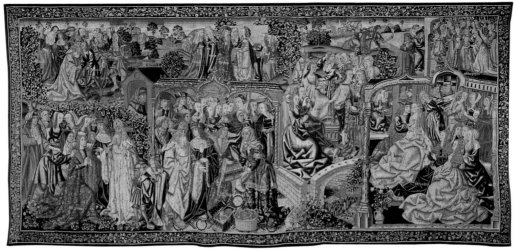

 In this grand late medieval tapestry, densely packed figures, often enclosed within late Gothic archways, provide a theatrical account of the New Testament parable of the Prodigal Son and his story of sin, redemption, and salvation. Although influenced by the period's morality plays, this tapestry's anonymous designer also drew upon other sources, such as easel paintings and a centuries-old vocabulary of allegorical figures. Representing vices and virtues, these allegorical characters insert themselves throughout the tapestry. Here the final scene shows the Prodigal Son stripped of his finery and last few coins. His story concludes on a second tapestry, now owned by the Walters Art Museum in Baltimore. SE

Flemish
Scenes from the Parable of the Prodigal Son, 1500–20
Wool, silk
167³/₄ × 333¹/₂ in.
(426.1 × 847.1 cm)
Bequest from the Preston Pope Satterwhite Collection 1949.30.89

▶

Saint Eustace stands out as one of Dürer's most ambitious engravings, in terms of both scale and execution. The artist fills the composition, his largest intaglio, with details to delight the eye and to demonstrate his acute ability to depict nature. In this print Dürer fully realizes the painterly potential of engraving, achieving subtle gradations of tone through dashes, lines, and hatching.

Dürer's technical virtuosity in this print nearly overshadows its subject. Amid the rocks, crags, and foliage one finds the miraculous vision that has brought the saint to his knees. While hunting, the Roman soldier Placidus (later baptized Eustace) encounters a stag with a crucifix between its antlers. Upon hearing the voice of Christ emanate from the stag, Placidus falls to the ground and professes his faith. KS

▶ **M**ary and Joseph kneel in solemn adoration before the newly born Christ child, a subject based on a vision of the Nativity experienced by Saint Bridget of Sweden (about 1303–1373) and known throughout Renaissance Italy. Together with a *Crucifixion* by Fra Bartolommeo now in a private collection, this small painted panel may originally have formed a portable diptych used for private devotion. Together the panels illustrated the two most important dates on the Christian calendar, Christmas and Easter, and encouraged the contemplation of the miraculous life and redemptive death of Christ. A native of Florence, Fra Bartolommeo entered the Dominican monastery in 1500 and briefly abandoned painting to devote himself to his religious calling. He probably created this panel some time after taking up the brush again in 1504. KS

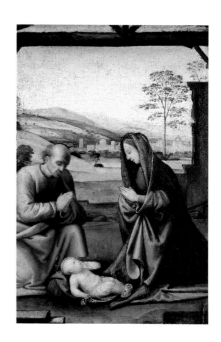

Fra Bartolommeo
Italian, 1472–1517
Adoration of the Christ Child,
about 1506–07
Oil on panel
5⁹/₁₆ × 3⁵/₈ in.
(14.1 × 9.2 cm)
*Museum purchase with additional funds
from Friends 1976.31*

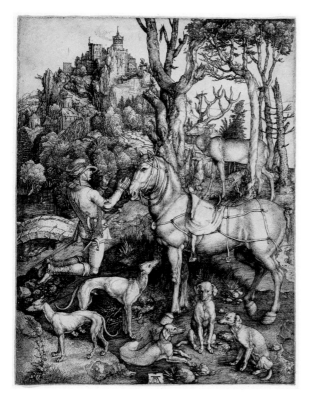

Albrecht Dürer
German, 1471–1528
Saint Eustace, about 1501
Engraving on paper
14¹/₈ × 10¹/₄ in.
(35.9 × 26 cm)
Gift of the Museum Collectors 1968.27

▼ According to legend, Mary Magdalene withdrew to France following Christ's Crucifixion. She lived in penitent isolation in a mountain grotto for the last thirty years of her life, sustained only by angels who carried her daily to heaven, where she feasted on the glorious music of celestial choirs. Here the Magdalene reclines on a hillside overlooking a vast, stylized landscape. With the perfume jar she used to anoint Christ's feet and a crucifix nearby, she piously reads from a religious text. The partially clothed, recumbent figure may derive from a devotional statue of the saint that adorned a cave at La Sainte-Baume in Provence, thought to be the original site of Mary Magdalene's retreat. KS

▼ Religion became an increasingly personal experience for Christians during the late Middle Ages. In Flanders, highly detailed and expressive paintings depicting the Passion of Christ encouraged viewers to imagine themselves as eyewitnesses to the events portrayed and to participate in the suffering of Christ and the saints. This Lamentation by a follower of Bernaert van Orley, a prominent painter and tapestry designer in Brussels, movingly conveys the sorrow of Christ's companions after his death. Tears stain the faces of the Virgin and John the Evangelist as they cradle Christ's rigid body, while Mary Magdalene wrings her hands in grief. The Lamentation, which is not described in the Gospels, gained widespread popularity through mystical writings that provided additional narrative details of the life and death of Christ. KS

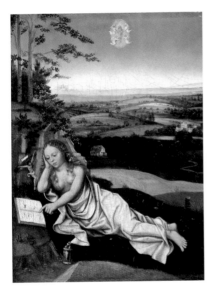

Flemish, Bruges
The Penitent Magdalene,
about 1520–40
Oil on panel
9¹⁄₈ × 6³⁄₁₆ in.
(23.2 × 15.7 cm)
Gift of Mrs. Berry V. Stoll 1967.22

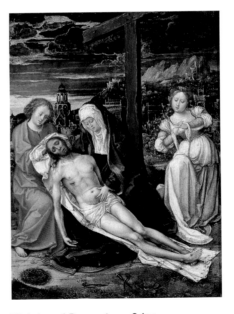

Workshop of **Bernaert van Orley**
Flemish, about 1491/92–1542
The Lamentation, possibly 1520s
Oil on panel
10 × 7¹⁄₄ in.
(25.4 × 18.4 cm)
Museum purchase 1967.23

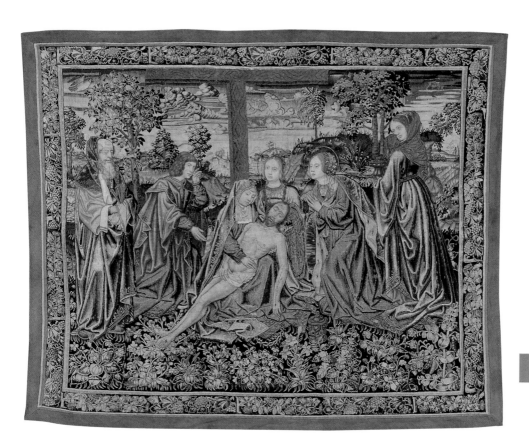

Flemish
The Lamentation, 1500–20
Wool, silk, silver- and gilt-metal-
wrapped threads
71⁷/₈ × 82¹¹/₁₆ in.
(182.6 × 210 cm)
*Bequest from the Preston Pope Satterwhite
Collection 1949.30.88*

▲ **S**cenes of the Lamentation convey the anguish felt by
Mary and by Christ's followers after the Crucifixion. In this
tapestry, Joseph of Arimathea looks on as Mary holds
Christ on her lap. John the Evangelist and Mary Magdalene,
shown at the far right holding a jar of ointment, both wipe
away their tears. The figures' faces, poses, and sumptuous
clothing, typical of Flemish tapestries of the period, were
greatly influenced by Flemish paintings. The design of
the tapestry, however, is not unique, as similarly rendered
figures of Mary Magdalene and other elements also appear
in other tapestries. The repeated use of design elements
was a common practice of the day. SE

▶ **B**orrowing a scene from Homer's *Iliad*, this dish depicts the fabled Achilles arming himself for battle against the mythical Trojan commander Hector, who had slain Achilles' friend Patroclus. Such heroic subjects were favorites of Renaissance artists and patrons. The Italian painter, printmaker, and designer Battista Franco created this particular scene around 1548, one of many produced by the artist for Guidobaldo II, Duke of Urbino. Franco's designs remained in production for several decades, though modifications were sometimes made. In this plate, for example, made about 1560 in the Fontana family workshop, the border differs from Franco's original scheme. SE

Workshop of **Guido Durantino**
(Italian, died about 1576), Urbino, Italy
Basin, 1550–60
Maiolica
8⁷/₈ × 19 × 20¹/₄ in.
(22.5 × 48.3 × 51.4 cm)
Gift of Miss Susan Barr Satterwhite
1941.51

▼ **T**he finest Italian Renaissance maiolica combines intricate designs with brilliant colors, reflecting the Renaissance patron's vibrant tastes. This massive basin provided an especially broad canvas for its skilled decorator. Perhaps working from a specially commissioned drawing, he depicted masses of troops facing one another during the Second Punic War. Fought between 218 and 201 BC, the war pitted Hannibal and the Carthaginians against the Romans; whether historical, mythological, or biblical, violent scenes often found their way on to Renaissance maiolica. Among other functions, basins of this sort could be filled with cold water and used to cool drinking glasses. This example, however, shows few signs of use. SE

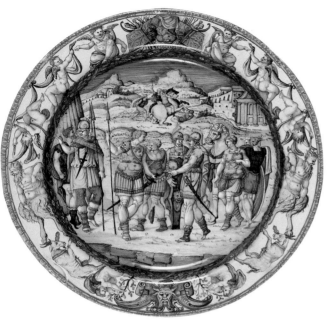

Workshop of the **Fontana family**,
Urbino, Italy
Dish, about 1560
After designs by Battista Franco
(Italian, about 1510–1561)
Maiolica
Diameter: 17$^7/_{16}$ in. (44.3 cm)

Bequest from the Preston Pope Satterwhite Collection 1949.30.244

▶

This fine bronze probably once graced the desk
or dining-table of a wealthy collector. Fitted with a
glass insert (now missing), it may have served as an
inkstand or a container for spices or sweets. The
cover depicts Virtue conquering Vice. Her foot set
triumphantly on the torso of her nemesis, Virtue
draws back her arm to strike the writhing figure of
Vice. In contrast to the youthful beauty of Virtue,
Vice appears as an old hag with snake-like hair,
sagging breasts, and a howling open mouth. Three
sphinxes, mythical creatures with the head and
breasts of a woman and the winged body of a lion,
form the base. Scholars have attempted to attribute
Virtue Overcoming Vice to various artists, including
Benvenuto Cellini and Giovanni Francesco Rustici,
but the identity of the maker remains elusive. KS

Italian, Rome
Virtue Overcoming Vice,
1550–1600
Bronze
16$^3/_{16}$ × 7 × 7 in.
(41.1 × 17.8 × 17.8 cm)
Bequest from the Preston Pope Satterwhite Collection 1949.30.55

▼ Courteys, a French enamelist, here gives visual form to Christ's genealogy. At the bottom of the plaque, the family tree rises out of Jesse's body in a literal rendering of Isaiah 11:1: "There shall come forth a shoot from the stump of Jesse." David, Jesse's son, and Christ's other forebears—both well known and obscure—fill the tree. A popular subject during the Middle Ages, the Tree of Jesse also lingered into the Renaissance. Courteys's version, ripe with rippling muscles and Roman-style costumes, falls into the latter period. During his career Courteys produced small caskets (boxes), plates, and other forms in addition to large oval plaques such as this example. His patrons included the French kings François I and Henri II. SE

Attributed to **Pierre Courteys**
French, about 1520–before 1591
The Tree of Jesse, about 1560
Enamel on copper
17³/₈ × 13 in.
(44.1 × 33 cm)
Gift of the Charter Collectors 1986.24

▶

Beginning in the Middle Ages, clerical garments worn at Mass became increasingly sumptuous celebrations of God's glory, in this case combining costly silk velvet with intricately embroidered bands executed in silk and metal-wrapped threads. The bands on the chasuble (priest's outer garment) depict God the Father, the Madonna and Child, and Saints Peter, Paul, John the Evangelist, and John the Baptist. While the embroiderers' sources remain unknown, the last saint does resemble a drawing, perhaps from Valencia, at Spain's national library. The chasuble's delicately embroidered tracery also connects it to at least two other surviving vestments (one of which is at the Victoria and Albert Museum in London), suggesting that all three may once have been part of the same set. SE

Spanish
Chasuble, 1550–1600
Silk velvet, embroidery in silk,
silver-wrapped threads, gilt-metal-
wrapped threads, gilt-metal-
wrapped cord
Length: 51½ in. (130.8 cm)
Bequest from the Preston Pope Satterwhite
Collection 1949.30.111

▼ **A** native of Flanders, Giambologna (or
Jean Boulogne) traveled to Italy in 1550 to
study ancient and Renaissance sculpture.
After settling in Florence, he attracted the
patronage of the Medici grand dukes and
became one of the most influential sculptors
of the sixteenth century, regarded during
his lifetime as second only to Michelangelo.
To meet the enormous demand for his
artworks, Giambologna employed a
workshop of highly skilled assistants who
produced bronzes from his original wax
models, including several crucifix figures
such as this. Christ's idealized body, with
its carefully articulated musculature and
well-defined ribcage, displays no gaping
wounds or physical distortions to suggest
the suffering associated with crucifixion.
Even in death, his face remains serene,
serving as a tranquil focal point for pious
contemplation. KS

Workshop of **Giambologna**
Flemish, 1529–1608
Christ Crucified,
probably after 1590
Bronze
12½ × 9⅞ × 2½ in.
(31.8 × 25.1 × 6.4 cm)
Gift of Mrs. John Harris Clay in memory of her
sister, Margaret Norton Davidson 1972.2.1

▶

Goltzius was already a renowned engraver when he took up oil painting in 1600. The Speed's paintings, which date to 1607, are Goltzius's first pendants and his only known paintings in the tondo (round) format. Their circular shape and the absence of setting create an intense focus on Christ and Mary that is especially conducive to meditation. Christ rests his left hand on top of an orb surmounted by a cross, which identifies him as *Salvator Mundi*, or Savior of the World, and makes a gesture of blessing with his right hand, as he gazes intently at the viewer. In the companion painting, Mary turns slightly toward Christ with her eyes cast down and her hands held to her chest in a gesture of supplication, presenting a model of submission and devotion to her son. LB

Hendrick Goltzius
Dutch, 1558–1617
Christ as Salvator Mundi, 1607
Oil on panel
19⁵/₁₆ × 19 in.
(49.1 × 48.3 cm)
Bequest of Jane Morton Norton 1989.14.1

Hendrick Goltzius
Dutch, 1558–1617
The Virgin in Supplication, 1607
Oil on panel
19¹/₄ × 18⁷/₈ in.
(48.9 × 47.9 cm)
Bequest of Jane Morton Norton 1989.14.2

▶

Like many Netherlandish artists, Tetrode was drawn to Italy by the chance to study ancient Roman and Italian Renaissance sculpture and by the promise of abundant artistic patronage. He spent more than twenty years there, collaborating on the pedestal for Benvenuto Cellini's celebrated *Perseus* and on the Neptune fountain in Florence, and producing bronze replicas of antique sculpture in Rome. Tetrode's *Warrior on Horseback* appears to have been inspired by an ancient Roman equestrian statue in the collection of Cardinal Alessandro Farnese. Although its precise subject is unclear, Tetrode's figural group may represent Marcus Curtius, a heroic warrior who sacrificed himself to save Rome by jumping, on horseback, into a fiery chasm. KS

Attributed to **Willem Danielsz. van Tetrode**
Netherlandish,
about 1525–after 1575
Warrior on Horseback,
about 1562–65
Bronze
16 × 17³/₈ × 11¹/₁₆ in.
(40.6 × 44.1 × 28.1 cm)
Bequest from the Preston Pope Satterwhite Collection 1949.30.2

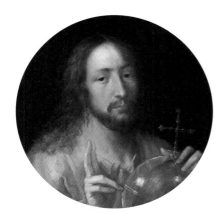
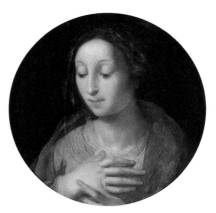

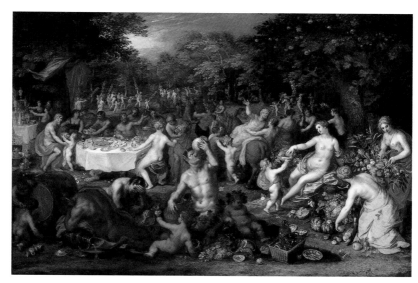

Jan Brueghel the Elder
Flemish, 1568–1625
Hendrik van Balen I
Flemish, 1575–1632
A Bacchanal, about 1608–16
Oil on panel
23⁵/₁₆ × 32¹/₂ in.
(59.2 × 82.6 cm)
Museum purchase 1967.24

▲ **T**wo of Antwerp's most highly regarded artists, Jan Brueghel and Hendrik van Balen, joined forces to create this spirited and meticulously detailed portrayal of a feast of the gods. Such collaborations, in which two or more specialized artists contributed different elements of a single painting, were popular with seventeenth-century collectors. Brueghel, primarily a landscape and still-life painter, probably supplied the forest setting and the abundant fruit, shellfish, and luxury vessels set out for the feast, while Van Balen painted the figures. In this bacchanal (named for Bacchus, the Roman god of wine and fertility), nymphs, satyrs, gods, and goddesses drink and feast upon the bounty of the harvest. Followers of Bacchus, each carrying a *thyrsus*, or leafy wand, proceed toward a temple in the distance. KS

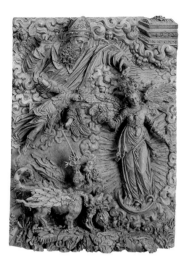

◀ **T**he subject of this carved relief derives from the New Testament book of Revelation, also known as the Apocalypse, which foretells the end of the world. The book describes a woman crowned with twelve stars and clothed in the sun, with the moon under her feet. A seven-headed dragon plagues the woman, waiting to devour her unborn child, but it is defeated by the archangel Michael. Christian theologians interpreted this woman as a symbol of the Virgin Mary, her child as Jesus, and the beast as Satan. In the late seventeenth and eighteenth centuries, the image of the Apocalyptic Woman came to symbolize the doctrine of the Immaculate Conception, the belief that Mary was born free from original sin. This remarkable sculpture, reminiscent of Albrecht Dürer's woodcut of the same subject, was likely made for a sophisticated collector who could appreciate the exquisite craftsmanship and understand its complex subject. KS

South German, probably Lake Constance area
A Scene from the Apocalypse,
about 1600–25
Pear wood
9³/₄ × 6¹/₂ × 1¹/₂ in.
(24.8 × 16.5 × 3.8 cm)
Gift of Mrs. Berry V. Stoll 1968.29

▶

As a prefiguration of Christ's resurrection, the story of the raising of Lazarus (John 11:1–44) has had special appeal to artists and their patrons throughout Christian history. When Christ learned that his friend Lazarus, the brother of Martha and Mary Magdalene, had died, he went to the tomb and cried out, "Lazarus, come forth." To the astonishment of the sisters and those who had come to console them, Lazarus arose, still bound with grave clothes. Teniers emphasizes the human drama by showing the participants variously responding with awe, surprise, and even dismay (on the part of those who will report the miracle to the Pharisees). As was customary at the time, Teniers dresses his figures in fancifully anachronistic costumes to evoke the distant biblical era. RC

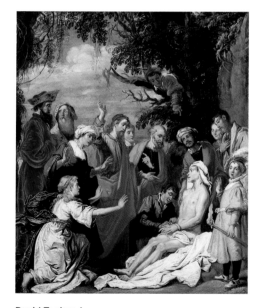

David Teniers I
Flemish, 1582–1649
The Raising of Lazarus,
1630s or later
Oil on canvas
28⁹/₁₆ × 23³/₈ in. (72.5 × 59.4 cm)
Museum purchase, Preston Pope Satterwhite Fund 1981.14

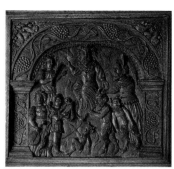

English, Devon, Broadhembury
Paneling, about 1619
Oak, other woods
Overall room:
148¹/₂ × 216³/₄ × 523 in.
(377.2 × 550.5 × 1328.4 cm)
Door:
97⁷/₈ × 48³/₄ in.
(248.6 × 123.8 cm)

Gift of Preston Pope Satterwhite in memory of Hattie Bishop Speed 1944.31

▲ **S**ir Thomas Drewe completed his fine country house, known as Grange, around 1619. Although Grange still stands, the paneling of its parlor was removed in the 1920s and eventually installed at the Speed in 1944 with some changes to its arrangement. The room's primary door, shown here, depicts mythological scenes from Ovid's *Metamorphoses*, an ancient Roman work of poetry that enjoyed renewed popularity from the Middle Ages through the mid-1700s. The imagery on the door was copied from a German edition first published in 1563 and illustrated by Virgil Solis. The other carved elements of the paneling were similarly influenced by Continental prints, including the Classically inspired ornamental designs of Dutch artist Hans Vredeman de Vries. SE

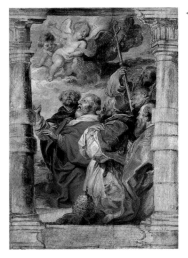

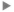

◄ **O**ne of the greatest painters of the seventeenth century, Rubens painted this brilliant oil sketch as a *modello* for a tapestry in a cycle representing the Triumph of the Eucharist. A daughter of Philip II of Spain commissioned Rubens to design the tapestries for a convent in Madrid, where they remain today. This oil sketch depicts the church hierarchy, including a pope kneeling with the papal tiara beside him, a bishop in a gold cope, a cardinal holding a tasseled hat, and a Dominican monk with his arms raised in prayer. In the sky, two cherubs gesture toward the Eucharist, which would have been depicted in a separate panel. Throughout his distinguished career, Rubens made these sketches to resolve aesthetic problems, to serve as *modelli* for his assistants, and to show patrons what a finished work of art would look like. RC

Peter Paul Rubens
Flemish, 1577–1640
The Princes of the Church Adoring the Eucharist,
about 1626–27
Oil on panel
26¼ × 18⁵⁄₁₆ in.
(66.7 × 46.5 cm)

Gift in memory of George W. Norton IV, by his mother, Mrs. George W. Norton, Jr., and his aunt, Mrs. Leonard T. Davidson 1966.16

►

Van Dyck, already a celebrated portraitist on the Continent when he arrived in London in 1632 at the invitation of King Charles I, endowed his works with an elegance and authority that transformed the English portrait tradition.

When the Speed purchased this portrait in 1971, the sitter was identified as Rachel, Countess of Southampton (1603–1640). Although it is an inexact resemblance, the sitter shares certain features and an ample figure with this daughter of a French nobleman, "a Lady of a goodly Personage, somewhat taller than ordinarily *French* Women are, excellent Eyes, black Hair, and of a most sweet and affable Nature." For unknown reasons, Van Dyck completed the head and pearl earrings here but left the necklace, dress, and hand partly unfinished, offering a rare glimpse into his working method. RC

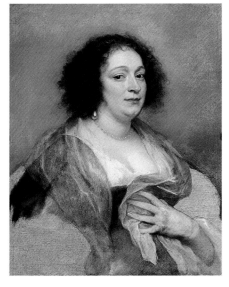

Anthony van Dyck
Flemish, 1599–1641
Portrait of a Woman, about 1635
Oil on canvas
29½ × 23 in.
(74.9 × 58.4 cm)

Museum purchase, Preston Pope Satterwhite Fund 1971.18

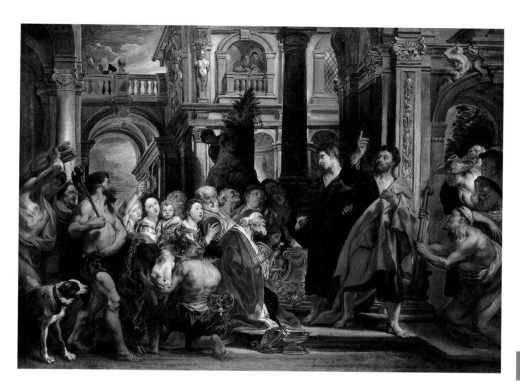

Jacob Jordaens the Elder
Flemish, 1593–1678
Paul and Barnabas at Lystra,
about 1640
Oil on canvas
54 × 71³⁄₄ in.
(137.2 × 182.2 cm)
Gift of the Museum Collectors 1967.36

▲ **W**ith his painterly brushwork, robust figures, and theatrical compositions, Jordaens emerged as the leading artist in Antwerp following the death of Rubens in 1640. Throughout his long career, Jordaens returned repeatedly to the theme of Paul and Barnabas at Lystra, a relatively rare subject in seventeenth-century painting. The story, told in the New Testament book of the Acts of the Apostles (14:8–18), describes Christ's disciples preaching in the town of Lystra, in modern-day Turkey. After Paul healed a crippled man, the town's citizens mistook the two for the Roman gods Jupiter and Mercury and brought them garlands and oxen as sacrifices. Distraught by the pagan display, Paul urged the people to turn their attention heavenward, to the true source of the miracle. Evident in this painting are numerous *pentimenti*, or changes, which Jordaens made as he developed his composition. KS

▼ *E*cce Homo ("Behold the Man") were the words uttered by the Roman governor of Judea, Pontius Pilate, as he presented Christ to the populace after his crowning with thorns. With its intense raking light, this depiction of the event focuses on Christ, Pilate, and a servant who places a purple robe around Christ's shoulders, as three soldiers behind them emerge from the inky darkness of the background. The dramatic lighting and life-size figures pushed to the foreground create a powerful impression of Christ's isolation and suffering.

Douffet, a Flemish painter from Liège, was in Rome from 1620 to 1622, and the strong modeling and expressive handling of light and shadow of the Italian followers of Caravaggio became a lasting influence on his work. RC

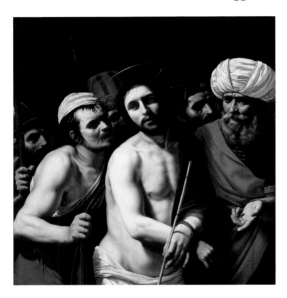

Attributed to **Gérard Douffet**
Flemish, 1594–1660
Ecce Homo, about 1623
Oil on canvas
49¼ × 46 in.
(125.1 × 116.8 cm)

Gift of Mr. and Mrs. Owsley Brown II
2005.4

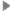

Saint Jerome (AD 343–420), interrupted in his writing, looks up with an intense gaze and entreating gesture. This compelling portrayal depicts the aged, though still vigorous, saint as a hermit in the Syrian desert, where he retreated for four years to meditate, study Hebrew, and translate the Bible into Latin (known as the "Vulgate" version). His meager possessions include his well-thumbed texts, his writing implements, a simple red cloak, and a skull, a reminder of mortality.

The identity of the artist who initialed this remarkable painting is only now emerging. Hendrick van Somer, known also as Enrico Fiammingo (Hendrick the Fleming), appears to have been of Flemish birth, and is documented in Naples from 1624 to 1652. The tactile rendering of the saint's expressive face and aging body, and the dramatic contrasts of light and shadow, suggest that the artist was influenced by the Caravaggesque naturalism of a famous Spanish artist who likewise resided in Naples: Jusepe de Ribera. RC

Nicolas Tournier
French, 1590–about 1660
Dice Players, about
1619–26/27
Oil on canvas
47⁵/₁₆ × 67¹/₂ in.
(120.2 × 171.5 cm)
Gift of the Charter Collectors
1987.12

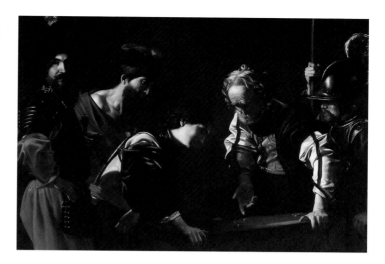

▲ **B**orn in Montbéliard, France, Tournier was in Rome from 1619 to 1626, where Caravaggio's striking naturalism and dramatic lighting profoundly influenced his style. This work, one of his most intriguing nocturnal scenes, presents mercenary soldiers betting on a game of dice at a time when gambling was considered sinful. In the flickering light there is an undertone of tension as the men gather around the table to observe the game. Owing to ongoing warfare, Rome was full of soldiers who often engaged in crude behavior as they idled around the city. For a contemporary audience, they represented the dangers of corruption. Tournier depicts the figure at left gazing directly at the viewer, demanding consideration of the scene's moral significance. ML

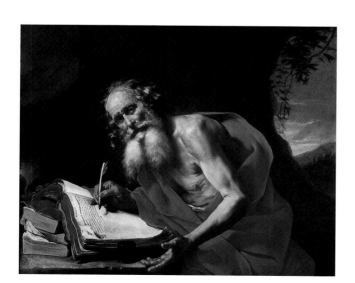

Hendrick van Somer
Flemish, born about 1607,
active Naples, 1624–1652
Saint Jerome, 1651
Oil on canvas
39³/₄ × 49¹/₂ in.
(101 × 125.7 cm)
Gift of the Charter Collectors with funds
from the Bequest of Jane Morton Norton
1991.21

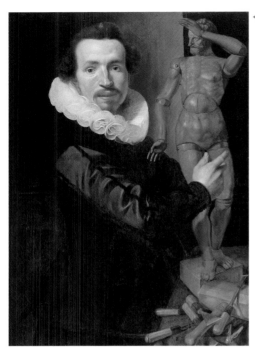

◀ This engaging portrait by Werner van den Valckert is dated 1624, which makes it a late work by the artist. The polished paint surface and the subject's smoothly modeled face, with its lustrous highlights, are characteristic of Van den Valckert's technique. Because the sitter points to a large, elaborately articulated lay figure, or artist's mannequin, it has been suggested that he is a sculptor or teacher. However, evidence that woodworkers produced these lay figures makes it more likely that the sitter is just such a craftsman, gesturing proudly toward a figure that he has made with the woodworking tools on the workbench before him. RC

Werner Jacobsz. van den Valckert
Dutch, about 1580–about 1627
Portrait of a Man with a Lay Figure, 1624
Oil on panel
32³/₈ × 22⁹/₁₆ in.
(82.2 × 57.3 cm)
Purchase, Museum Art Fund 1963.29

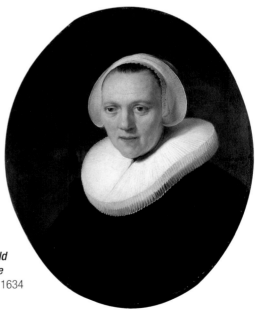

Rembrandt van Rijn
Dutch, 1606–1669
Portrait of a Forty-Year-Old Woman, possibly Marretje Cornelisdr. van Grotewal, 1634
Oil on panel
27⁷/₁₆ × 22 in.
(69.7 × 55.9 cm)

Purchased with funds contributed by individuals, corporations, and the entire community of Louisville, as well as the Commonwealth of Kentucky 1977.16

▼ Verspronck, a native of Haarlem, achieved some success painting portraits of the town's well-to-do Catholic and Calvinist citizens. Although the compositions of fellow Haarlem painter Frans Hals may have influenced him, Verspronck developed his own restrained style, employing a limited palette and a comparatively meticulous technique. This three-quarter-length portrayal of an unidentified man is one of his largest and most impressive portraits. Its soft backlighting gives the black-clad figure a bold silhouette and an imposing presence. Verspronck places particular emphasis on the man's gentle, luminous face, lace collar and cuff, and green-gloved hand. The artist's companion portrait of the sitter's wife, dated 1642, is in a private collection. RC

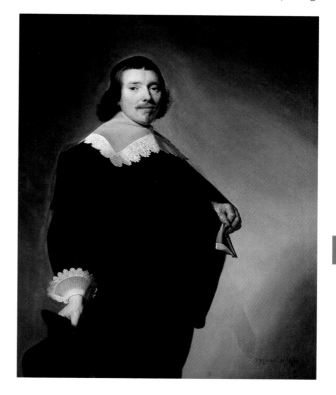

Johannes Cornelisz. Verspronck
Dutch, about 1600/03–1662
Portrait of a Man, 1641
Oil on canvas
46⁷⁄₈ × 37⁵⁄₈ in.
(119.1 × 95.6 cm)
Museum purchase, Preston Pope Satterwhite Fund 1980.21

◀ When Rembrandt moved from his native Leiden to Amsterdam in late 1631, he began one of the most prosperous and productive periods of his career. He brought to portraiture a creative vitality that quickly made him one of the most sought-after portraitists in the city. The Speed's portrait of a forty-year-old woman, unidentified for many years, may depict Marretje Cornelisdr. van Grotewal, the Mennonite wife of Amsterdam businessman Pieter Sijen. Through carefully observed details and a sensitive handling of paint, Rembrandt creates a likeness infused with character and expression. The Speed's painting is remarkably well preserved, retaining the complex array of layers of opaque pigment built up with deft, feathery brushwork and translucent glazes that characterize Rembrandt's paintings from this relatively early period in his career. The pendant to the Speed's panel, a portrait of a bearded man in a wide-brimmed hat, tentatively identified as Marretje's husband, is in the collection of the Norton Simon Art Foundation in Pasadena, California. KS

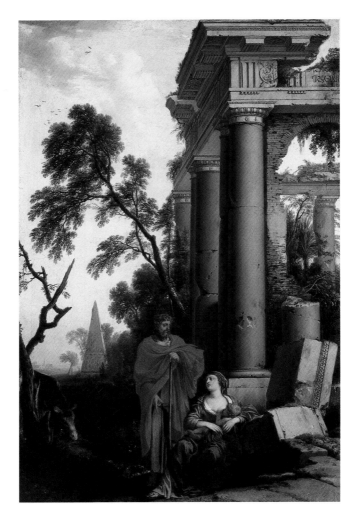

Laurent de La Hyre
French, 1606–1656
Rest on the Flight into Egypt,
1648
Oil on canvas
38³/₄ × 25¹/₄ in.
(98.4 × 64.1 cm)

*Museum purchase, Preston Pope
Satterwhite Fund 1963.10*

▲ La Hyre became one of the founding professors of
France's Royal Academy of Painting and Sculpture in the
same year he painted this work. He depicts Joseph, Mary,
and the infant Jesus before the ruins of an ancient temple,
on their flight from Bethlehem to Egypt to escape King
Herod's planned massacre of all infant boys. Joseph points
to the ground, indicating where his family will rest for the
night. Unlike many artists of his time, La Hyre never saw
the ancient ruins of Italy at first hand. Instead, he borrowed
nearly every detail of the temple from a manual titled
The Five Orders of Architecture, published in 1562 by
Jacopo Barozzi da Vignola. This decaying structure
may symbolize the pagan beliefs that Christ's teachings
eventually displaced. ML

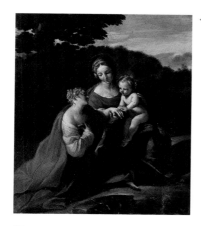

Giovanni Lanfranco
Italian, 1582–1647
The Mystic Marriage of Saint Catherine, about 1646–47
Oil on copper
9 × 7⁹/₁₆ in.
(22.9 × 19.2 cm)
Museum Members purchase 1966.45

◀ **H**ighly regarded for his illusionistic ceiling paintings, Lanfranco also produced a small number of highly finished cabinet pictures for private collectors, such as this gemlike *Mystic Marriage of Saint Catherine*. According to legend, Catherine experienced a vision in which she became the spiritual bride of Christ. Here the Virgin Mary presents Catherine's hand to the baby Jesus, who places a ring on her finger. In the foreground lies a fragment of the spiked wheel (the saint's traditional attribute) with which the Roman emperor Maxentius later tried to kill Catherine after she rebuffed his advances. This panel served as a pendant to another painting on copper by Lanfranco, depicting Christ appearing to Mary Magdalene following the Crucifixion. Both works once belonged to members of the Farnese family, distinguished and influential art patrons of the Renaissance and Baroque periods. ᴋs

▶
Flower painting—ranging from restrained compositions, such as *Flowers in a Glass Vase*, to elaborate bouquets and garlands encircling devotional images of the Madonna and Child—flourished in The Netherlands during the seventeenth century. Many flowers were expensive, and tulips, originally imported from Turkey, were so desirable that they provoked a market frenzy during the 1620s and 1630s that became known as "tulip mania." Although the market collapsed in 1637, and prices fell dramatically, tulips continued to be admired for their beauty, especially the "flaming" red-and-white variety featured here. Antwerp painter Jan van den Hecke, who also produced portraits and landscapes, specialized in floral still lifes, which were prized by important collectors, such as Archduke Leopold Wilhelm of Austria, governor of the Spanish Netherlands. ᴋs

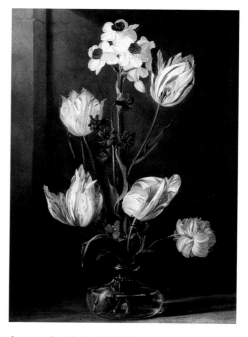

Jan van den Hecke the Elder
Flemish, 1620–1684
Flowers in a Glass Vase,
about 1650
Oil on canvas
17¹³/₁₆ × 12¹⁵/₁₆ in. (45.2 × 32.9 cm)
Bequest of Alice Speed Stoll 1998.6.3

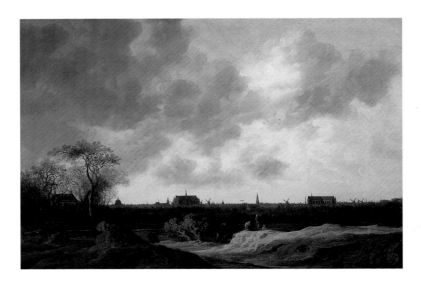

▲

During the seventeenth century Dutch artists pioneered a new form of naturalistic landscape that captured the distinctive appearance of their native countryside, often including the skylines of individual Dutch towns set against the horizon. Here the churches of St. Peter and St. Pancras, as well as the octagonal dome of the Marekerk (consecrated in 1649, the date of this painting), identify this as a view of Leiden. While municipal leaders occasionally commissioned landscapes with town views, artists painted most on speculation, in hopes of selling them to local residents, whose personal prosperity depended on the vitality of their towns and the flourishing economy of the new Dutch Republic. KS

Anthonie Jansz. van der Croos
Dutch, about 1606–1662/63
View of Leiden, 1649
Oil on panel
25⁷/₈ × 37¹¹/₁₆ in.
(65.8 × 95.8 cm)
Bequest of Jane Morton Norton 1989.13

▶

Steen, admired for his satirical genre paintings, was a gifted storyteller. His imaginative use of costume, gesture, and details from everyday life enlivened his narratives and made them readily accessible to his audience. In this early painting Steen depicts John the Baptist (standing on the right and holding a cruciform staff) preaching to the multitude (Luke 3:1–18). Some listen with rapt attention, brought to tears by his call for repentance, while others seem unmoved. Many figures wear simple Dutch attire, while the exotic costume of the couple in the center serves to evoke a setting in the Holy Land. Many Dutch Protestants considered John the predecessor of sixteenth- and early seventeenth-century "hedge preachers," unordained ministers who preached the scripture at clandestine gatherings in the countryside when The Netherlands was still under the repressive rule of Catholic Spain. KS

▼ The preeminent Dutch landscape painter of the seventeenth century, Ruisdael introduced a new expressiveness and grandeur to the depiction of nature. This relatively early work, dated 1653, features the rugged terrain and distinctive half-timbered houses that the artist encountered during a trip to the Dutch–German border about 1650. The patched roof and walls of the cottage, in whose doorway a woman stands watching a man play with a dog, reflect the effects of time and weather. Similarly, the magnificent blasted willow, huge sawn logs, and stately oak with its dead "stag horn" branches catalogue nature's changes, as do the sunlight momentarily piercing the heavy gray clouds and the swiftly moving stream and waterfall. RC

Jacob van Ruisdael
Dutch, 1628/29–1682
Landscape with a Half-Timbered House and a Blasted Tree, 1653
Oil on canvas
26⁵/₈ × 32³/₈ in.
(67.6 × 82.2 cm)
Museum purchase 1998.3

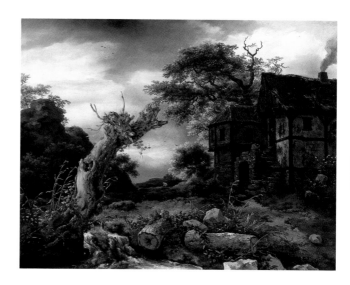

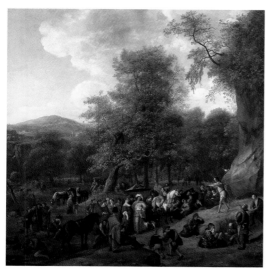

Jan Steen
Dutch, about 1626–1679
John the Baptist Preaching in the Wilderness, about 1648–51
Oil on panel
31¹/₈ × 30³/₈ in.
(79.1 × 77.2 cm)
Gift of the Charter Collectors 2003.16

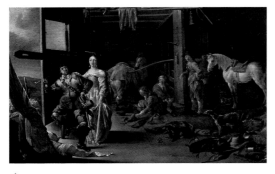

Jacob Duck
Dutch, about 1600–1667
Interior of a Stable with Figures, about 1635–40
Oil on panel
21¹/₈ × 34 in.
(53.7 × 86.4 cm)

Museum purchase, Preston Pope Satterwhite Fund 1965.18

▲

Utrecht native Jacob Duck specialized in paintings showing the leisure activities of soldiers in guardrooms or other interiors, a subject that became popular during the final decades of the northern Netherlands' prolonged struggle for independence from Spain (1568–1648). Much of the fighting during this period occurred along the southern and eastern boundaries of The Netherlands, but prospective buyers of these artworks, despite largely residing in the heavily urbanized western provinces, had some familiarity with troops through pamphlets and illustrated broadsides commenting on the war and its progress. Such paintings as Duck's, while not representing an actual barracks, nevertheless generally recall the spaces inhabited by soldiers, who would while away the hours battling nothing more than sheer tedium. In this panel Duck seems to contrast the diligence of the men in the center, who don their gear in preparation for duty, with the ensign on the left, who is distracted by what were widely perceived to be typical soldierly vices: tobacco and women. KS

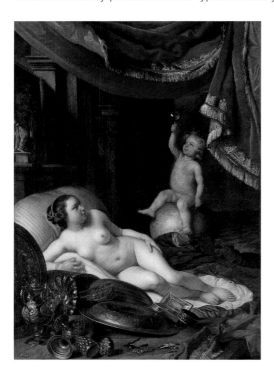

Jacob van Loo
Dutch, 1614–1670
An Allegory of Venus and Cupid, 1654
Oil on canvas
47⁷/₈ × 34¹/₂ in.
(121.6 × 87.6 cm)

Gift of the Charter Collectors and gift of Mrs. Hattie Bishop Speed; George E. Gage; The Art Center Association; Signora Agnese Buzzi; Mrs. Margaret Bridwell; Sallie Underhill Kemper, in honor of Evelina Shreve Underhill; Robert A. Hendrickson; Jean de Botton; Caroline Cooper; Mrs. Credo Harris; John Greenebaum; Miss Mary Elizabeth Michel; and bequest of Mrs. Blakemore Wheeler, by exchange 1993.16

▼ **A**bout 1650, artists in Delft painted some of the most visually arresting realistic church interiors in seventeenth-century Dutch art. The subject's popularity remained such that in the 1660s and 1670s De Man, an established Delft portraitist, found it worth his while to paint a number of these architectural portraits. The New Church in Delft, with its imposing tomb of William the Silent, a George Washington-like figure in the history of the United Netherlands, was a potent religious and patriotic symbol for the nation and, not surprisingly, a favorite subject for painters. This view of the church, reprising a composition used by other Delft painters, shows the rear of the ambulatory and William's tomb from the back. Despite a seventeenth-century writer's claim that De Man "flourished in perspective," the artist's precariously tilted column bases and lopsided capitals reveal his uncertain grasp of complex perspective. Nevertheless, with his characteristically bright white columns and walls and festive touches of color, De Man creates a lively and appealing image of the historic interior. RC

Cornelis de Man
Dutch, 1621–1706
New Church in Delft with the Tomb of William the Silent,
1660s
Oil on canvas
49 × 42¹/₁₆ in.
(124.5 × 106.8 cm)
Gift of the Charter Collectors 1985.8

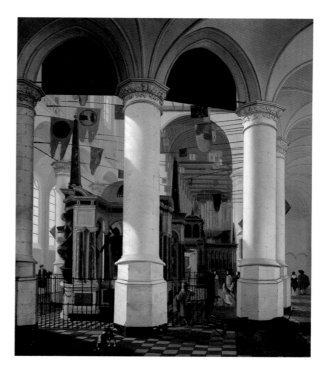

◀ **I**n this allegory of the vanity of earthly pleasures, Venus, the sensuous goddess of love, reclines on a bed and turns to gaze at her son Cupid, who sits astride a globe. He holds a soap bubble, recalling the Latin proverb *homo bulla* ("man is like a bubble"), which alludes to the brevity of human life. Amid the jewelry and luxurious silver and gilt objects in disarray in the foreground lies an overturned lute. Van Loo seems to be suggesting that, like a bubble that quickly bursts or music that rapidly fades, the pleasures of love and worldly possessions are temporary. The shadowy draped sculpture in the background may represent Pudicitia, the Roman goddess of modesty and chastity, who offers the viewer a positive alternative to a life of vanity. KS

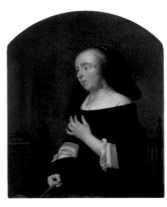

Gabriel Metsu
Dutch, 1629–1667
Self-Portrait, about 1658
Oil on panel
8⁹/₁₆ × 6⁷/₈ in. (21.7 × 17.5 cm)
Gift of the Charter Collectors 1970.56.1

Gabriel Metsu
Dutch, 1629–1667
*Portrait of the Artist's Wife
(Isabella de Wolff)*, about 1658
Oil on panel
8¹/₂ × 6⁷/₈ in. (21.6 × 17.4 cm)
Museum purchase 1970.56.2

▲

These diminutive pendant portraits belong to a small group of works
that can be confidently attributed to Metsu, a painter celebrated for his
intimate domestic genre scenes and precise, exquisitely finished surfaces.
They depict the artist and his wife, Isabella de Wolff, who were married
in Amsterdam in 1658. Following portrait conventions, Isabella appears
on the right, gazing toward her husband. She places one hand over her
heart in a gesture of devotion and holds a closed fan, likely symbolic
of feminine modesty. Her upright, formal posture contrasts with her
husband's more casual demeanor, a distinction that is common in Dutch
marriage portraiture. ML

Pieter Cornelisz. van Slingeland
Dutch, 1640–1691
The Interior of a Kitchen,
about 1659
Oil on panel
17⁵/₁₆ × 14⁹/₁₆ in.
(44 × 37 cm)

*Gift of the Charter Collectors and
Mrs. Blakemore Wheeler,
Mr. and Mrs. Barry Bingham, Sr.,
Mrs. Hattie Bishop Speed,
Mrs. E. Gary Sutcliffe,
Mrs. Margaret Bridwell,
Mrs. Oscar Fenley, and
Mr. and Mrs. Klaus G. Perls,
by exchange 1992.23*

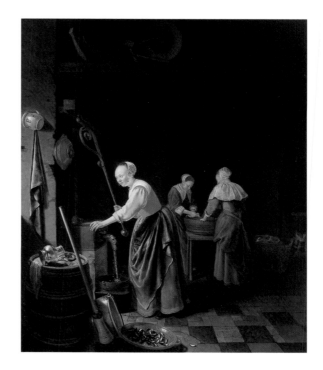

▼ This handsome portrait depicts the artist and his first wife, Maria van Hees, in the guise of Ulysses and Penelope from Homer's *Odyssey*. Such *portraits historiés*, or historicized portraits, were popular in the Dutch Republic because they endowed sitters with the virtues of religious, mythological, or historical figures—in this case a husband and wife renowned for their marital fidelity. De Bray represents the moment of Ulysses' return to his faithful wife twenty years after leaving for the Trojan War. Penelope had cleverly put off her numerous suitors by promising that she would remarry once she had woven a shroud for her father-in-law, and then she secretly unraveled each day's work at night. Maria holds Penelope's loom and places her hand over her heart as a gesture of devotion, while De Bray, dressed in the Classical garb of Ulysses, is joyfully recognized by his loyal dog. The way the two lean inward, with their eyes meeting, clearly expresses their unbroken bond. ML

Jan de Bray
Dutch, about 1627–1697
***A Couple Represented
as Ulysses and
Penelope***, 1668
Oil on canvas
43⁷⁄₈ × 65³⁄₄ in.
(111.4 × 167 cm)
*Gift of the Charter Collectors
1975.24*

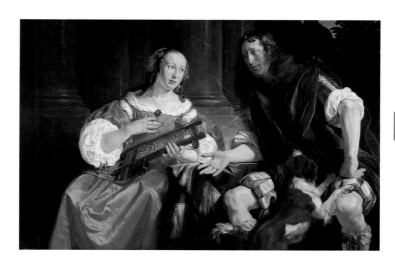

◀ Since the home was the microcosm of the Dutch nation, its order and cleanliness carried special moral significance, and depictions of domestic virtue—as well as the opposite, mocking representations of disorderly households—found great favor with collectors. A group of painters active in Leiden, known as *fijnschilders* (fine painters), Slingeland among them, was quick to seize on such domestic themes. These artists' small, exquisitely detailed, and highly finished paintings commanded enormous prices. In this kitchen scene three housemaids do laundry. Bright light from a window just out of view illuminates a pretty, colorfully dressed servant girl, who draws water from a pump as water boils over a fire in the darkened interior and two maids wash laundry in a tub. The artist observes closely the kitchen's numerous objects, from the overturned pewter tankard, reflecting the girl's dress, to the gleaming mussel shells and copper pot. RC

Ludolf Backhuysen I
Dutch, 1630–1708
A Frigate and Other Vessels on a Rough Sea, 1681
Oil on canvas
21¼ × 27³/₁₆ in.
(53.9 × 69 cm)
Gift of the Charter Collectors 1995.14

▼ In this painting, Backhuysen, the leading Dutch marine painter of the last quarter of the seventeenth century, focuses on a group of ships belonging to the Dutch East India Company's merchant fleet, whose dominance of sea trade brought the Dutch Republic unrivaled prosperity. The frigate in the center, at anchor with its sails set out to dry, flies a long tricolor flag, indicating that the commander is on board. To its left a rowboat ferries a dignitary to a finely carved yacht bearing the initials of the trading company, VOC (Vereenigde Oostindische Compagnie), and its Amsterdam chamber or branch. As the yacht fires a salute, fishermen in a small rowboat in the foreground watch with curiosity. Anthony Bierens, a wealthy Amsterdam collector, probably commissioned this painting and its pendant (location unknown) of ships in calm waters. RC

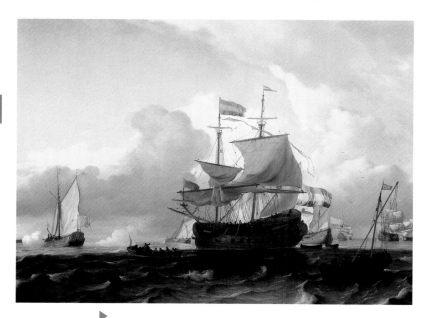

▶ Composed of two parts, the hilt and the blade, this smallsword records the meeting of East and West in the eighteenth century. Made in Japan for export, the hilt was one of many luxury products known as *sawasa* (copper alloy wares decorated with lacquer and gilding). The primary buyers were the Dutch, who enjoyed access to Japanese goods through the Dutch East India Company. While *sawasa* hilts came from Japan, the steel blades were made in Europe. This sword, for example, bears the mark of Amsterdam's Peter Loos. The sword's components probably came together in either the Dutch trading settlement of Batavia (now Jakarta, Indonesia) or The Netherlands. Either way, it was the perfect functional accessory for a fashionable and wealthy Dutchman. SE

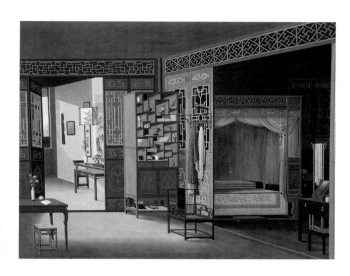

Chinese
View of a Bedchamber,
about 1790
Gouache and watercolor on
wove paper
17 × 22¼ in.
(43.2 × 56.5 cm)

*Gift of Mrs. Martha M. Davis and Family
1979.2.3*

▲ **M**eticulously detailed and brilliantly colored, this view of a Chinese bedchamber is one of twenty related images of rooms and buildings from a single, luxuriously appointed residential compound. From costume details and other visual clues, the compound appears to be that of a civil servant living in southern China. But was it an actual place? The sheer number of views, the repeated visual and written references to civil service, and other elements suggest that it probably was. The Chinese-made renderings are bound together in an English-made folio that also contains depictions of tea, rice, and silk cultivation. Three further folios from the same set include images of boats and religious rituals. All the set's pictures were probably made for export to the West, providing glimpses of a far-off and mysterious land. SE

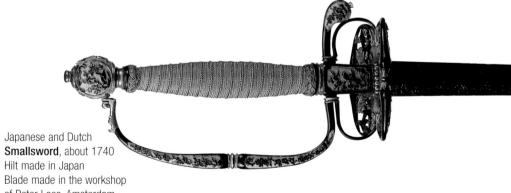

Japanese and Dutch
Smallsword, about 1740
Hilt made in Japan
Blade made in the workshop
of Peter Loos, Amsterdam
Lacquered and gilded *sawasa*
(copper alloyed with silver, gold,
and arsenic), gold wire, steel
34½ × 3 × 2¼ in.
(87.6 × 7.6 × 5.7 cm)

*Gift and bequest from the
Preston Pope Satterwhite Collection,
by exchange 2001.21*

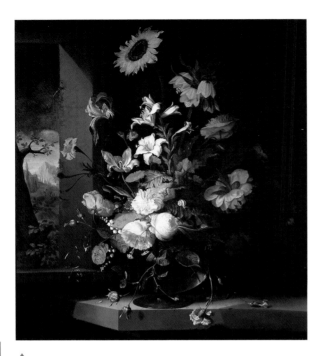

Jacob van Walscapelle
Dutch, 1644–1727
Floral Still Life, 1681
Oil on canvas
40¼ × 35³/₁₆ in.
(102.2 × 89.3 cm)

*Gift of Eleanor Bingham Miller and
Barry Bingham, Sr., in honor of
Mary Caperton Bingham 1987.1*

▲

Elaborate floral still lifes held great appeal for late seventeenth-century art collectors. Their exquisitely rendered details delighted the eye, while the profusion of blossoms celebrated nature's abundance. Despite its naturalism, however, Van Walscapelle's still life presents a curious combination of real and imaginary elements. The artist depicts a fictional mountain landscape through the window on the left, while reflecting in the glass vase the actual town view he observed through his studio window. Similarly, the bouquet contains flowers that never bloom simultaneously, such as the springtime iris and the sunflower of late summer. This stunning yet botanically impossible bouquet demonstrates the artist's triumph over the vagaries of nature and time. The ability of the still-life specialist to conquer fleeting nature by rendering it in permanent, immutable paint was praised by seventeenth-century connoisseurs. KS

▶

Born in Amsterdam, Valckenburg was the last major Dutch specialist in animal and bird painting. He was trained by Jan Weenix and often, as here, borrowed his teacher's format of game depicted in a park with a Classical urn and an elegant country estate in the distance. Valckenburg enlivens this traditional game piece with a spirited confrontation between a cat and a dog over a dead fowl. The painting, gracefully signed and dated 1717 on the stone plinth, demonstrates his superb handling of textures, from the cat's bristling fur and the lapdog's silky coat to the oozing, overripe fruit and the fly crawling on the fuzz-covered peach. Because hunting was a privileged pastime restricted to the aristocracy, such works appealed to the aspirations of wealthy collectors. RC

Gerrit Adriaensz. Berckheyde
Dutch, 1638–1698
View of the Mauritshuis,
The Hague, about 1690
Oil on canvas
21¹/₂ × 25¹/₂ in.
(54.6 × 64.8 cm)

Museum purchase, Preston Pope
Satterwhite Fund 1979.21

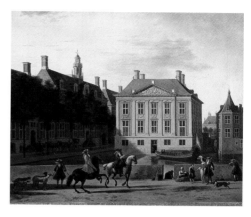

▶

Berckheyde specialized in painting townscapes. During the late 1680s and 1690s he painted many views of The Hague, capitalizing on its reputation as one of Europe's most beautiful cities and on the popularity of the House of Orange-Nassau, following the assumption to the English throne in 1689 by William III of Orange and his wife, Mary Stuart. This townscape is essentially a portrait of a building, the Mauritshuis, the former residence of Johan Maurits, Count of Nassau-Siegen. Designed by Jacob van Campen and begun in 1633, it was the epitome of Dutch Classical architecture and one of the handsomest buildings in the city. The Mauritshuis, its façade bathed in warm sunlight, stands on the far side of the Hofvijver, or court pond. In the foreground, horsemen, dogs, an elegant couple, and other assorted pedestrians enliven the view. RC

Dirk Valckenburg
Dutch, 1675–1721
A Cat Protecting Spoils from
a Dog, 1717
Oil on canvas
39⁷/₈ × 31³/₄ in.
(101.3 × 80.6 cm)

Museum purchase with funds from the
estate of Alice Speed Stoll and anonymous
donors 2005.18

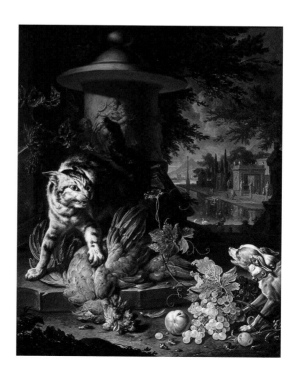

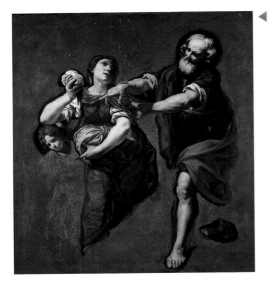

Attributed to
Cristoforo Savolini
Italian, 1639–1677
The Expulsion of Hagar,
possibly 1670s
Oil on canvas
40 × 37 in.
(101.6 × 94 cm)
Gift of Mrs. Baylor O. Hickman 1970.43

◄ **T**his painting, which remained unfinished at the time of Savolini's accidental death, provides a unique opportunity to observe his working process. He began with the figures, orchestrating the relationships among them and fully realizing their faces before turning to the setting. The biblical story is told through gesture and expression. Savolini depicts the moment when Abraham drives into the desert Hagar (a maid sent to him by his barren wife, Sarah, to produce an heir) and her son Ishmael. Though his face is sad, Abraham plants his foot firmly as he points the way to Hagar with his right hand and pushes her with his left. She looks at him beseechingly, as the youthful Ishmael, taking shelter beneath her arm, looks out to the viewer. The setting would probably have been the threshold of Abraham's house, perhaps with the aged Sarah and the new heir, Isaac, in the background. LB

**Giovanni Battista Pittoni
the Younger**
Italian, 1687–1767
The Sacrifice of Isaac,
about 1713–15
Oil on canvas
32⅝ × 38¼ in.
(82.9 × 97.2 cm)
*Museum purchase, Preston Pope
Satterwhite Fund 1965.19*

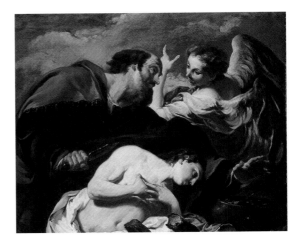

▶

In the biblical Book of Genesis, God tests Abraham's faith and obedience by ordering him to sacrifice his son Isaac. Just as Abraham prepares to slay the boy, God sends an angel to halt the sacrifice and accepts instead a ram as an offering. Christian theologians have interpreted Abraham's willingness to sacrifice his son as a prefiguration of God's sacrifice of his own son, Jesus. The story became a favorite of Italian Baroque artists, who emphasized its emotional aspects. Pittoni, in this early work, focuses on the tense interaction of these figures by thrusting them into the constricted foreground space. KS

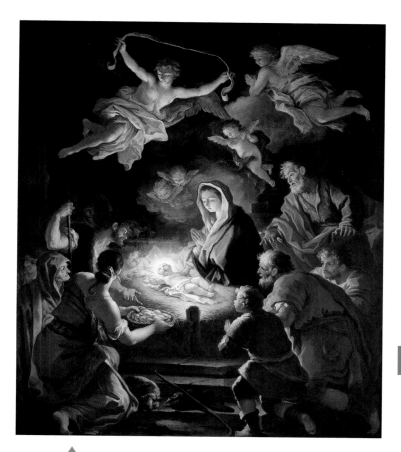

Paolo de' Matteis
Italian, 1662–1728
*The Adoration of the
Shepherds*, about 1710–15
Oil on canvas
60 × 50 in.
(152.4 × 127 cm)
Gift of the Charter Collectors 1971.42.1

This depiction of one of the most popular Christian subjects—the shepherds, led by angels, paying homage to the newborn Jesus—presents the scene in an especially intimate manner, which welcomes the viewer as another adoring visitor. Only the miraculous light emanating from the infant Christ shines through the darkness, illuminating expressions of wonder and joy on the faces of those kneeling around him. The circle includes Mary, Joseph, and the shepherds with their families: figures representing every stage of life. The shepherds wear humble clothing and bring simple gifts, including a lamb and eggs, symbols of redemption and rebirth. Although the artist, Paolo de' Matteis, was primarily active in Naples, he had an international reputation and traveled to Rome, Spain, France, Austria, and England to complete commissions. ML

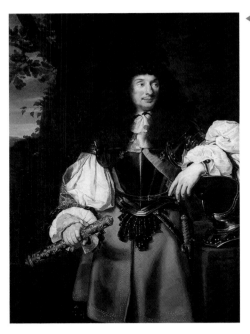

◀ **M**ignard achieved great success as a portrait painter in the court circles of Paris, producing ten portraits of Louis XIV over the course of his career. This portrait, which exhibits Mignard's signature smooth finish and rich colors, may represent François-Henri de Montmorency-Bouteville (1628–1695), a celebrated French general. The sitter grasps a baton decorated with *fleurs-de-lis*, indicating his distinction as a Marshal of France, an honor conferred by the king for military service to the crown. The Maltese Cross in his left hand, hanging from a blue ribbon, symbolizes membership of the chivalric Order of the Holy Spirit. Mignard poses the sitter in a relaxed and confident manner, a quality that set his portraiture apart from the formal stiffness of that of many of his peers and appealed to his prominent clientele. ML

Pierre Mignard I
French, 1612–1695
Portrait of a Marshal of France,
possibly *François-Henri de Montmorency-Bouteville, Duke of Luxembourg*,
probably after 1688
Oil on canvas
57⁵/₈ × 41¹/₂ in.
(146.4 × 105.4 cm)
Preston Pope Satterwhite Collection, by exchange 1958.8.2

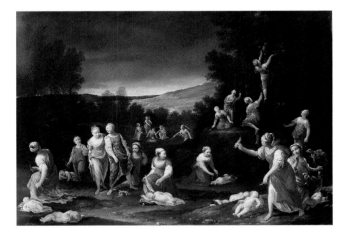

Giuseppe Maria Crespi
Italian, 1665–1747
Sleeping Cupids Disarmed by Nymphs, about 1730
Oil on copper
20¹³/₁₆ × 29⁷/₁₆ in.
(52.8 × 74.8 cm)
Gift of the Charter Collectors 2000.22

▼ **D**uring his reign, Louis XIV assumed an almost god-like persona, a propaganda effort aided by countless idealized images of the king. Here the sumptuously attired Louis heroically directs the siege of Doesburg, one of the battles of the Dutch War of 1672–78, the first major campaign of the king's reign. This view of Doesburg is one of a larger series of Dutch War designs; these were woven in some quantity beginning around 1700. The Speed's collection, for example, includes another tapestry from the same series, depicting the conquest of Dole (today a French town near the Swiss border). The designs of both tapestries relate to engravings by Sébastien Le Clerc. SE

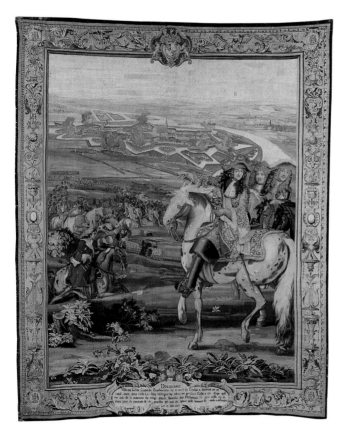

Probably woven at the **Beauvais Tapestry Manufactory**, Beauvais, France,
or possibly at the **Béhagle family workshop**, Paris, France
The Siege of Doesburg,
1692–1722
Probably made under the direction of Philippe Béhagle (French, 1641–1705), 1692–1705,
or under the direction of his widow and son, 1705–22
Wool, silk, silver- and gilt-metal-wrapped threads
185¼ × 121 in.
(470.5 × 307.3 cm)

Gift from the Preston Pope Satterwhite Collection 1947.25

◀ **A**dmired today as an innovative painter of naturalistic genre subjects, the versatile Crespi also produced works filled with wit and whimsy. In this lighthearted allegory of the triumph of Chastity over Love, Crespi depicts a playful battle between the nymphs of the chaste goddess Diana and the cupids of the amorous Venus. Mischievous nymphs bind the cupids' wings, steal their bows, and burn their arrows in a fire. One nymph irreverently urinates on a cornucopia, an emblem of fertility and virility, while her companion presses a finger to her lips to silence the ensuing laughter. Immobilized and robbed of their weapons, the cherubs are rendered powerless, unable to shoot their arrows into unsuspecting hearts. Crespi painted at least nine versions of this innocuous conflict—including three in which Love takes the upper hand and the cupids tease sleeping nymphs—attesting to the theme's popularity. KS

▶ De Troy was inducted into the Académie Royale in 1708 and quickly earned a reputation as one of France's preeminent history painters. His work included such intimate paintings as this, intended for the private collector, featuring enticing, sensuous figures. With lush colors and a smooth finish, he depicts Adam and Eve in the Garden of Eden, as described in the Book of Genesis. The dragon-like serpent rising in the background has persuaded Eve to taste God's forbidden fruit from the Tree of Knowledge. She tempts Adam to do the same, although he momentarily resists, pointing upward to indicate God's authority. Examples of the many animals that God had asked Adam to name surround the couple. The animals coexist peacefully, symbolic of the idyllic harmony preceding Adam and Eve's fall from grace. ML

▼ During the early eighteenth century Largillière was the preeminent portraitist of the wealthy Parisian middle class. Although French by birth, he spent his youth in Antwerp, and his lustrous colors and textures reflect Flemish influence. Here he depicts the celebrated actress Marie-Anne de Châteauneuf, called Mademoiselle Duclos, in the role of Ariadne from the Thomas Corneille play of the same name. Corneille based the drama on the Greek myth in which Ariadne helps her lover, Theseus, defeat the monstrous Minotaur, only to be abandoned by him later on the island of Naxos. Depicted at this climactic moment, she throws open her arms in grief as Theseus' ship sails away into the distance. The Greek

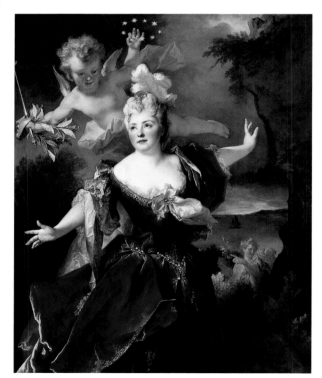

god Dionysus, who will soon marry her, approaches with his retinue. Carrying a poet's crown of laurels and a mask of drama, a putto crowns Ariadne with a circle of stars, a reference to the constellation Dionysus will create in her honor. ML

Nicolas de Largillière
French, 1656–1746
Portrait of Mademoiselle Duclos in the Role of Ariadne, about 1712
Oil on canvas
64¼ × 51½ in.
(163.2 × 130.8 cm)
Museum purchase, Mrs. Blakemore Wheeler Fund 1966.15

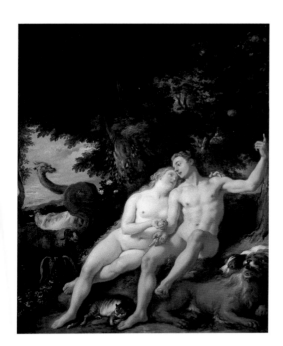

Jean François de Troy
French, 1679–1752
Adam and Eve, 1730
Oil on canvas
32¼ × 25⅝ in.
(81.9 × 65.1 cm)
Gift of Dr. and Mrs. Irvin Abell, Jr. 1977.21

After a design by **Jan van Orley**
Flemish, 1665–1735
Psyche Worshipped as Venus,
1710–52
Possibly made in the workshop
of Peter van den Hecke (Flemish,
about 1675–1752), Brussels
Wool, silk
144¼ × 345¾ in.
(366.4 × 878.2 cm)
*Bequest from the Preston Pope Satterwhite
Collection 1949.30.221*

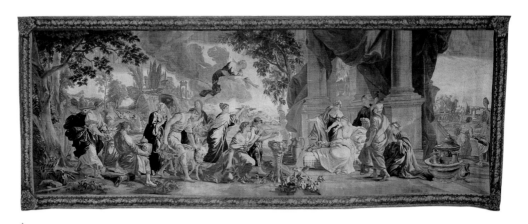

This tapestry was originally the first in a series of seven devoted to the story of Psyche, a tale first told by the Roman author Lucius Apuleius. According to Apuleius, the young Psyche, a mortal, was so ravishing that people confused her with Venus, the goddess of love and beauty. In their delusion people paid Psyche homage as if she were, indeed, a goddess. Here a procession of worshippers brings her animals, garlands of flowers, incense, and other offerings. From the clouds above, Venus looks on with increasing envy. The painter Jan van Orley designed this theatrical vision of the story, perhaps assisted by fellow artist Augustin Coppens. SE

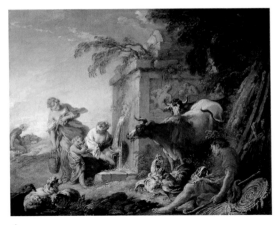

François Boucher
French, 1703–1770
The Fountain (La Fontaine),
about 1730
Oil on canvas
21¹¹/₁₆ × 25¹⁵/₁₆ in.
(55.1 × 65.9 cm)

*Museum purchase,
Mrs. Blakemore Wheeler Fund 1969.12*

Boucher was one of the most influential artists in eighteenth-century France, and set the trend for the delicate ornamentation and erotic playfulness of the Rococo style. In this work, produced early in his career, the technique and subject demonstrate a direct Dutch influence. Preliminary drawings show that Boucher copied the hen and strutting cockerel from a work by the Dutch artist Melchior de Hondecoeter, while the human figures reflect his study of Abraham Bloemaert's images of peasants. The subject prefigures Boucher's later pastoral paintings, which often feature amorous shepherds and shepherdesses frolicking among picturesque ruins, but with more overtly sentimental and playful overtones. Scenes of rustic simplicity in the Dutch manner appealed to Boucher's Parisian audience as well as to English collectors. ML

Charles-Antoine Coypel
French, 1694–1752
The Education of the Virgin,
about 1735–37
Oil on canvas
36⁵/₈ × 29 in.
(93 × 73.7 cm)
Gift of Dr. and Mrs. Irvin Abell, Jr. 1982.11

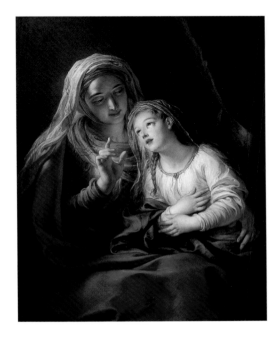

▼ **W**earing an elaborate suit of armor and a prominent silk sash, the Count of Beaujeu gazes confidently at the viewer. Although soldiers of his time did not fight in armor, he wears an example dating from the early seventeenth century in order to evoke notions of chivalry and his noble status. Following a formula popularized by artists from the preceding generation, Nattier places the count before a fictional battle scene, fluidly painted with highlights of yellow and red. Few details of the count's life are known, but his daughter's position as lady-in-waiting to Queen Marie Antoinette suggests the family's high social standing. Nattier, best known for his idealized female portraits, became a favorite among court society beginning in the 1730s, painting the daughters of Louis XV as well as the king's mistress, Madame de Pompadour. ML

Jean-Marc Nattier
French, 1685–1766
Portrait of Louis Léon de Bouthillier-Chavigny, Count of Beaujeu, 1745
Oil on canvas
39¹⁵/₁₆ × 31¹⁵/₁₆ in.
(101.4 × 81.1 cm)

Museum purchase,
Mrs. Blakemore Wheeler Fund 1966.14

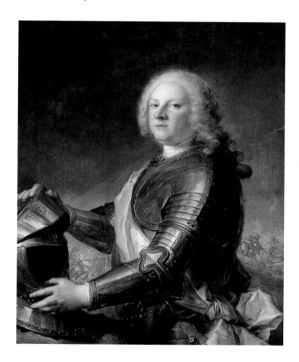

◄

In this depiction of a traditional religious subject, Coypel emphasizes the loving interaction between mother and daughter. The young Virgin Mary gazes intently at her mother, Anne, who tenderly draws the child close and patiently instructs her. Anne's education of Mary served as a model for eighteenth-century mothers, who were encouraged by popular treatises and journals to play a direct role in the rearing of their daughters and to treat them with affection and patience. Coypel originally paired *The Education of the Virgin* with a pendant showing a contemporary mother scowling at her child, a striking contrast further emphasized by the titles given to engravings after the paintings in 1737: *The Sweet and Artful Education Given by a Saint* and *The Dry and Repellant Education Given by a Prude.* KS

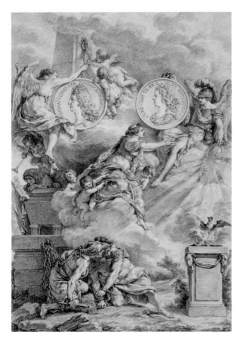

◀ This highly detailed drawing served as the model for an engraving that was part of a series entitled *The History of Louis XV in Medallions*. Cochin designed several of the individual compositions, including this symbolic illustration of Louis XV's accession to the throne at the age of five. On the left, a winged figure representing Fame places a medallion portrait of the late King Louis XIV on his tomb. The armored Spirit of France passes a portrait of Louis XV to a female figure symbolizing the new French state. At the base of the tomb, the defeated figures of Discord and War are bound in chains. A phoenix, the legendary bird that arose from its own ashes, appears at the lower right as a symbol of renewal. ML

Charles-Nicolas Cochin II
French, 1715–1790
Accession of Louis XV, 1754
Graphite on laid paper
13³/₁₆ × 9 in.
(33.5 × 22.9 cm)
Gift from the Preston Pope Satterwhite Collection 1941.98

Jean-Baptiste Perronneau
French, about 1715–1783
Portrait of Charles-Nicolas Cochin II, about 1759
Pastel on paper
21⁷/₈ × 18 in.
(55.6 × 45.7 cm)
Gift of Mrs. Berry V. Stoll 1974.46

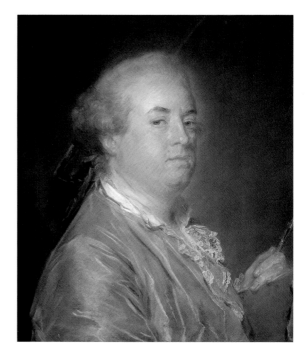

▼ **O**n February 15, 1755, this writing desk, or *secrétaire*, was entered into the *Journal du Garde-Meuble de la Couronne*, an inventory of furniture and other objects produced for France's royal residences. The desk was made in the workshop of Gilles Joubert for the château of Louis XV at Choisy, several miles outside Paris. When first made, it had black surfaces decorated with gold flowers in imitation of Asian lacquer. At some time during the later nineteenth century, interlocking veneers of turtle shell and intricately engraved brass were skillfully applied over the desk's original decor. The new surfaces were likely applied in England or France, probably in an attempt to update the desk's appearance. SE

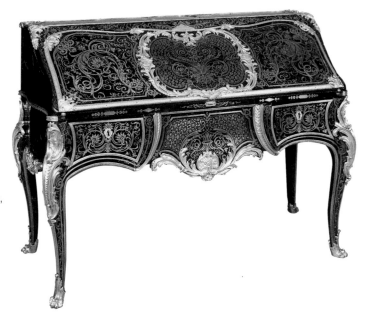

Workshop of **Gilles Joubert**
(French, 1689–1775), Paris
Writing desk, about 1755
Oak, pine, walnut, other woods,
sea turtle shell, brass, gilded
copper alloy (*ormolu*) mounts
41⅝ × 57¾ × 23⅝ in.
(105.7 × 146.7 × 60 cm)
Preston Pope Satterwhite Collection,
by exchange 1958.8.3

◄

Greatly admired for the freshness and subtle coloring of his pastel portraits, Perronneau depicts his friend and fellow member of the Académie Royale Charles-Nicolas Cochin holding the tools of his trade: a *porte-crayon* and an artist's portfolio. Cochin was an influential engraver, draftsman, and critic who illustrated more than two hundred books during his lifetime. He spent most of his career in service to Louis XV, who employed him to produce commemorative prints of every royal birth, marriage, and funeral beginning in 1737. The king also appointed him as keeper of his drawings collection in 1752. Because Cochin had time to pose for only the head, Perronneau convinced Pierre-Honoré Robbé de Beauveset to sit for the body. In a letter this poet complained about the rigors of modeling while dressed in Cochin's silk shirt. ML

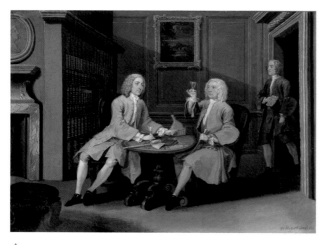

William Hogarth
English, 1697–1764
Dudley Woodbridge in His Chambers, 1730
Oil on canvas
16½ × 21¾ in.
(41.9 × 55.2 cm)

Museum purchase, Preston Pope Satterwhite Fund 1976.30

▲

Seated in a well-appointed room, a distinguished gentleman raises his wineglass to toast his host, seated to the left. A servant enters to deliver a letter addressed to his employer, "Dudley Woodbridge Esq. of yᵉ Middle Temple, London." The occasion they celebrate may be Woodbridge's call to the bar, which occurred around the time this canvas was painted. *Dudley Woodbridge in His Chambers* is an early example of a conversation piece, a type of group portrait popularized by Hogarth during the late 1720s and 1730s. These paintings combined portraiture and genre, depicting groups of figures in domestic interiors or gardens engaged in casual daily activities. KS

▶

Unlike most prominent English artists of his time, who were based in London, Wright lived and worked mainly in his native Derby. He is best known for his "candlelight" paintings, in which a single light source creates dramatic contrasts of light and shade. Wright's preoccupation with the play of light across a subject, evident in this figure study, continued throughout his career. He was particularly drawn to the velvety gradations of tone associated with mezzotint engraving, and he emulated the effect here in black and white chalks. Indulging in a romantic fantasy, Wright dresses the young man in a turban of fur with a crown made from a striped, tasseled scarf, a whimsy that reflects a contemporary fascination with Turkish costume and also provides a variety of textures to test Wright's masterful use of his materials. ML

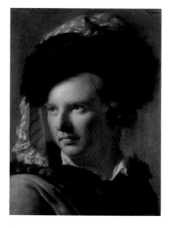

Joseph Wright of Derby
English, 1734–1797
Young Man in Fur Cap,
about 1772–73
Black chalk heightened with white on wove paper
16⅞ × 11⅝ in. (42.9 × 29.5 cm)

Purchase, Museum Art Fund 1963.30

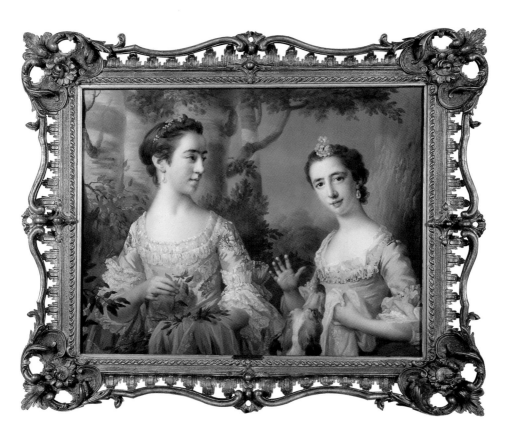

▲

During the eighteenth century, portraitist Francis Cotes was almost as celebrated in England as Sir Joshua Reynolds and Thomas Gainsborough. This magnificent pastel of two girls—sisters, in all probability—is a rare double portrait by the artist. The girlish dresses, paired with quite grown-up earrings, suggest that the girls are in their mid-teens and almost ready for marriage. More than just giving attractive likenesses, this pastel also suggests that the girls would make good wives. English viewers would have understood their walk in the woods as a sign of their unaffected naturalness, and the attentive dog as an emblem of their loyalty and good nature. The mid-eighteenth-century frame may be the pastel's original. RC

Francis Cotes
English, 1726–1770
Double Portrait, 1757
Pastel on blue laid paper mounted on canvas
Canvas: 27 × 33$^1/_{16}$ in.
(68.6 × 83.9 cm)
Framed: 37 × 43$^1/_8$ × 3$^1/_4$ in.
(94 × 109.5 × 8.3 cm)
Bequest of Alice Speed Stoll 1998.6.2

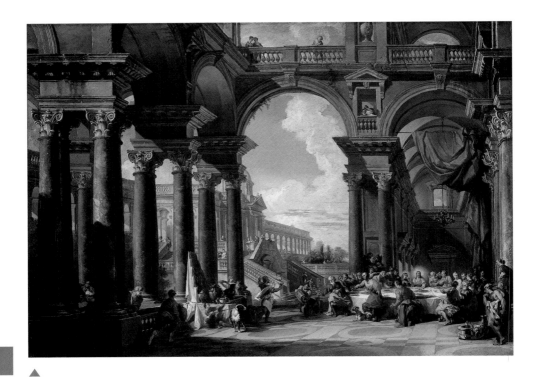

▲

According to the biblical Gospel of John, Christ performed his first public miracle while attending a wedding in the small village of Cana in Galilee. When the host ran out of wine, Christ ordered the servants to fill stone vessels with water, which he miraculously transformed into wine of the finest quality. Panini depicts the celebration as a sumptuous banquet set within a soaring imaginary Baroque structure. A celebrated painter, architect, and stage designer, Panini specialized in elaborate architectural views. His detailed topographical depictions of ancient and modern Rome, as well as his architectural fantasies, were enthusiastically collected by wealthy British gentlemen, who traveled to Italy as part of their Grand Tour. KS

Giovanni Paolo Panini
Italian, about 1692–1765
The Wedding at Cana, about 1725
Oil on canvas
39^1/$_{16}$ × 54 in.
(99.2 × 137.2 cm)

*Museum purchase, Preston Pope
Satterwhite Reserve Fund 1959.13*

Pompeo Batoni
Italian, 1708–1787
*Portrait of Ralph Howard, later
1st Viscount Wicklow*, 1752
Oil on canvas
39^1/$_8$ × 29^3/$_{16}$ in.
(99.4 × 74.1 cm)

Purchase, Museum Art Fund 1960.8

Giovanni Battista Tiepolo
Italian, 1696–1770
The Sacrifice of Iphigenia,
about 1750
Oil on canvas
15¼ × 24½ in.
(38.7 × 62.2 cm)
Anonymous gift 1975.2

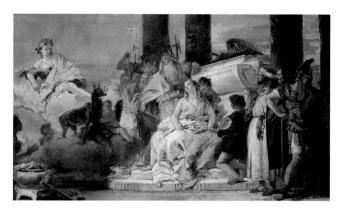

▲
Buttery brushwork and fluid lines characterize the oil sketches of Tiepolo, the most brilliant decorative painter in eighteenth-century Italy. This sketch likely served as a preparatory study for a fresco in the Villa Cornaro in Merlengo. Largely destroyed in the nineteenth century, the wall paintings there illustrated scenes from the life of Iphigenia, the daughter of the Greek commander Agamemnon. According to the ancient playwright Euripides, Agamemnon was ordered to sacrifice his daughter to the goddess Artemis, whom he had offended. Here Iphigenia, awaiting the fatal blow from the priest's dagger, swoons before a tomblike altar, while her sorrowful father turns away and buries his face in his hand. Awestruck spectators witness the arrival of Artemis, who descends on a cloud. She brings a deer to serve as the offering, sparing the maiden's life. KS

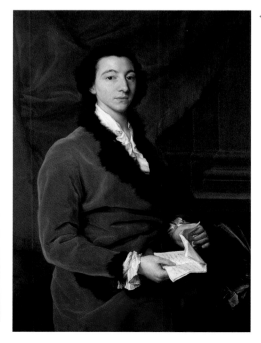

◀ **D**uring the eighteenth century, fashionable young British gentlemen often completed their education by going on the Grand Tour to Italy. In 1751, Ralph Howard, an Irishman who in 1785 was to become the 1st Viscount Wicklow, set off with his tutor, a Mr. Benson, to spend several months enjoying the sights and pleasures of Italy. While in Rome, in addition to this portrait from Batoni, Howard commissioned numerous works of art, notably paintings from the British landscapist Richard Wilson and a caricature from Joshua Reynolds.

Howard was among the English and Irish visitors who first discovered Batoni, before the painter achieved an international reputation and became the John Singer Sargent of his day. Batoni paints Howard with a lively directness, focusing on his face, his hands—holding a letter—and the fur trim of his red velvet coat. RC

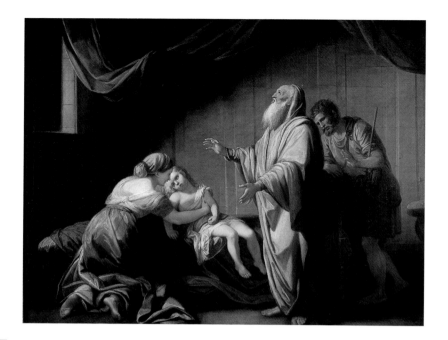

Benjamin West
American, active in Great Britain,
1738–1820
Elisha Raising the
Shunammite's Son, 1766
Oil on canvas
40³/₁₆ × 50¹/₄ in.
(102.1 × 127.6 cm)

Museum purchase from the Dr. George
Angus Robertson Bequest 1964.7

▲ **B**orn in rural Pennsylvania, West studied in Philadelphia and worked in New York as a portraitist before traveling to Italy in 1760. In 1763 he settled in London, where he soon became the first American artist to achieve international acclaim. He joined a new generation of British artists who aspired to raise the intellectual standards of their profession by painting historical subjects rather than simply meeting the lucrative demand for portraiture. In this work West depicts a biblical story from the Book of Kings, in which the prophet Elisha revives a dead boy. The statuesque figures placed in a shallow space are reminiscent of the processions found on Classical friezes, and in this way the work prefigures West's leading role in Europe's Neoclassical movement. Largely owing to the success of such paintings, he was appointed historical painter to King George III in 1772 and president of the Royal Academy in 1792. ML

Thomas Gainsborough
English, 1727–1788
Wooded River Landscape with
Peasants Resting and Church
Tower, about 1750
Oil on canvas
9³/₈ × 12¹/₂ in.
(23.8 × 31.8 cm)
Gift of the Charter Collectors 2005.19.1

See page 81 for a landscape by
Jacob van Ruisdael.

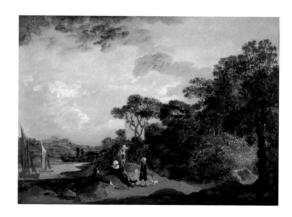

▶

Although Gainsborough made his living and reputation as a portraitist, landscape painting remained his "infinite delight." He learned to paint naturalistic landscapes through studying the work of such seventeenth-century Dutch painters as Jacob van Ruisdael, Jan Wijnants, and Meindert Hobbema. This small oil, created when Gainsborough was in his early twenties, shows the Dutch influence in the peasants at the side of the road, the cloud-filled sky with its low horizon, and the alternating areas of light and dark foliage. Like most of the artist's landscapes, this is not an actual view but one invented in the studio. At the very end of his life, Gainsborough paid homage to these early works when he wrote of his fondness for his "first imatations [*sic*] of little Dutch Landskips." RC

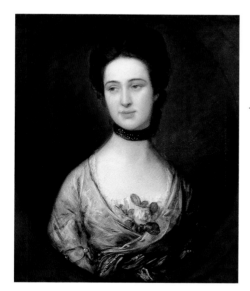

Thomas Gainsborough
English, 1727–1788
Portrait of Mrs. John Hallam,
about 1774
Oil on canvas
30 × 25 in.
(76.2 × 63.5 cm)
Bequest of Mrs. Leonard T. Davidson 1970.31.1

◀ **A**lthough little is known about her life, Eleanor Hallam is described as "a woman of much intelligence and delicacy of feeling." The sister of a poet and Church of England clergyman, she married John Hallam, canon of Windsor and later dean of Bristol Cathedral. Gainsborough succeeds in portraying her as both beautiful and intelligent, with a calm, introspective mien. The artist employs animated brushwork to sketch in the diaphanous fabric that overlays her blue gown, and he completes her simple, feminine attire with a garnet necklace, roses tucked into her bodice, and a fringed scarf tied around her waist. Gainsborough probably painted this portrait when he was still living in Bath, just before his move to London in 1774 and his subsequent rapid ascent to the top rank of English portraitists. RC

Workshop of **Boulton & Fothergill**,
Soho, Birmingham, England
Candlesticks, 1768–69
Silver
Each: 12⁷⁄₈ × 6 in.
(32.7 × 15.2 cm)
Gift from the James C. Codell, Jr., Collection
1993.9.192 a,b

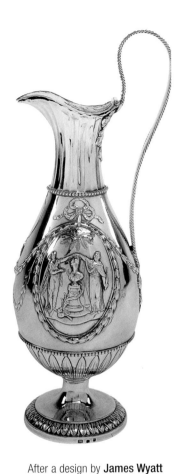

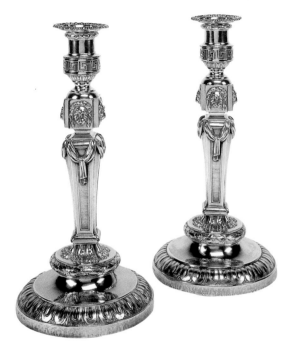

These two candlesticks, copied from French models of the
1760s, were among the early designs in silver produced at
Matthew Boulton's Birmingham metalworks. Boulton, the
son of a button, buckle, and "toy" (small metal goods)
producer, eventually manufactured a vast range of metal
objects in a purpose-built factory; John Fothergill was
his business partner from 1762 until Fothergill's death in
1782. By maximizing the division of labor, embracing new
production techniques, and aggressively marketing his
wares, Boulton became one of the leading figures in
Britain's Industrial Revolution. He also entered into a
partnership with James Watt, developer of the first
practical steam engine. Boulton and Watt supplied engines
to a variety of industries, thereby powering much of the
Industrial Revolution. SE

After a design by **James Wyatt**
English, 1746–1813
Covered jug, 1775–76
Made by Boulton & Fothergill,
Soho, Birmingham, England
Silver
14¹⁄₈ × 4¹⁄₂ × 5⁵⁄₈ in.
(35.9 × 11.4 × 14.3 cm)
Gift from the James C. Codell, Jr., Collection
1993.9.156

◀ In a letter to a patron, businessman Matthew Boulton revealed his pragmatic design philosophy: "I only wish to excell [*sic*] in the execution of that taste which my employers most approve." In Boulton's day, fashionable taste meant references to Classical Greek and Roman sources. The aesthetic, though, was more inventive than scholarly, freely mixing Classical elements and idioms from various sources. Boulton's jug, for example, incorporates beading, leafy swags, and Classically costumed figures placing a wreath upon a bust. This piecemeal Classicism not only suited the tastes of the time, but also allowed Boulton and his contemporaries to reuse and recombine various ornaments across a range of designs. SE

▼ This elegant epergne, a table piece used to hold fruit and sweets, was originally commissioned from Matthew Boulton by Sir Robert Rich, a prominent army officer. To create such high-style designs, Boulton relied on many sources, including the architect James Wyatt. Correspondence surrounding the commission confirms Wyatt's role in this epergne's design. Much of its ornament—the winged female figures (harpies), clawed feet, and other elements—can also be found in surviving Wyatt drawings for other silver forms. For Boulton, Rich unfortunately proved to be a very difficult customer: he demanded that the epergne be enlarged after previously approving the completed design, he complained about its price, and he did not pay Boulton until some seven months after taking delivery. SE

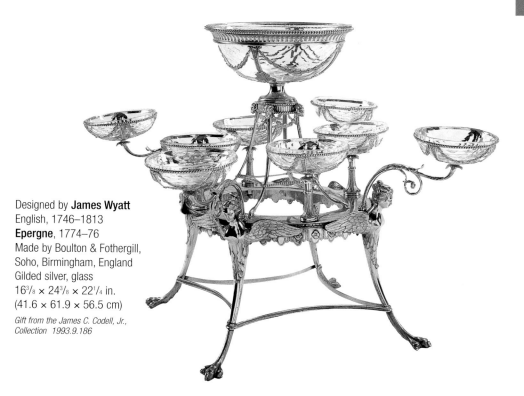

Designed by **James Wyatt**
English, 1746–1813
Epergne, 1774–76
Made by Boulton & Fothergill,
Soho, Birmingham, England
Gilded silver, glass
16³/₈ × 24³/₈ × 22¹/₄ in.
(41.6 × 61.9 × 56.5 cm)
Gift from the James C. Codell, Jr.,
Collection 1993.9.186

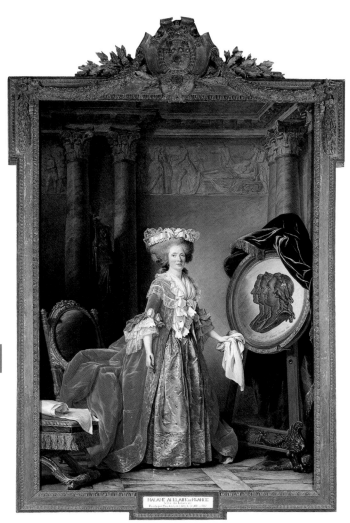

Adélaïde Labille-Guiard
French, 1749–1803
Portrait of Madame Adélaïde,
about 1787
Oil on canvas
Canvas: 107³/₄ × 73³/₄ in.
(273.7 × 187.3 cm)
Framed: 136¹/₂ × 88³/₈ × 5 in.
(346.7 × 224.5 × 12.7 cm)
Gift of Mrs. Berry V. Stoll 1982.21

▲

Madame Adélaïde of France, the aunt of Louis XVI and daughter of Louis XV, ranked second only to the queen, Marie Antoinette, among the women of the French royal family. This portrait by the princess's official court painter, Labille-Guiard, presents her surrounded with details that attest to her filial devotion and piety, and to the noble legacy of the Bourbon family. She poses, *porte-crayon* in hand, before a framed oval on which she has depicted her late parents and brother in profile above an inscription in French: "Their image is still the delight of my life." High on the wall, a relief sculpture commemorates her selfless visit to her father as he lay dying of smallpox, which she contracted. The architectural plan resting on the footstool is for a convent that Madame Adélaïde sponsored. Labille-Guiard's first version of this portrait, painted for the princess, now hangs at Versailles. This version remained in the artist's possession throughout her life. Madame Adélaïde, forced by the Revolution to flee France, died impoverished in Trieste in 1800. ML

▶ **A** highly inventive and versatile artist, Robert was one of the most sought-after landscape painters and garden designers of his day. His *Hermit in a Garden*, originally part of a large decorative ensemble, reflects the eighteenth-century taste for picturesque gardens featuring imaginative "follies" or fabrications. Quaint hermitages (sometimes occupied by hired monks), grottoes, Classical ruins, or Chinese pagodas were often constructed within formal garden settings, offering surprise encounters intended to inspire the viewer. Here, nestled within a lush, imaginary garden setting, an aged hermit studies a manuscript. In the background stands his simple shelter, and from a balustrade above, four maidens teasingly attempt to distract him from his meditations. KS

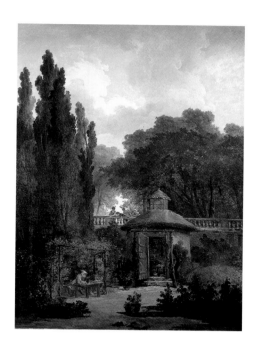

Hubert Robert
French, 1733–1808
A Hermit in a Garden, about 1790
Oil on canvas
59⅝ × 31½ in.
(151.4 × 80 cm)
Given in memory of their mother,
Mrs. John Vance Collis,
by Mrs. Condict Moore,
Mrs. William W. Hancock, Jr.,
and Mrs. Joe M. Rodes 1994.13

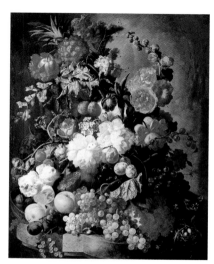

▼ **V**an Os continued the great tradition of Dutch flower painting through the eighteenth century. His still lifes—with terra-cotta vases, marble plinths, and dewy wooded backgrounds derived from his predecessor Jan van Huysum—are distinctive for their extravagant displays of fruit and flowers and their high-keyed color. In this painting, the artist composes exquisitely rendered fruit, blossoms, insects, and small animals around two exuberant, intersecting S-curves. A master of contrasting textures, Van Os opposes smooth, speckled bird's eggs with a nest's rough twigs, and hard, wrinkled walnut shells with their soft meat, nibbled by a mouse. Among this bounty, Van Os presents animals and insects—a cat stealthily approaching a bird's nest and a fly atop a peach—as surrogates for the viewer, feeling the varied surfaces and traversing the tangle of flowers and leaves. RC

Jan van Os
Dutch, 1744–1808
Still Life with Fruit and Flowers,
late 1700s
Oil on panel
34¹⁵⁄₁₆ × 28⁵⁄₁₆ in. (88.7 × 71.9 cm)
Gift of Mrs. John Harris Clay 1992.13

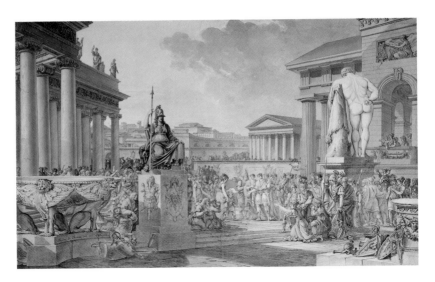

Thomas de Thomon
French, about 1754–1813
A Roman Emperor Petitioned for Clemency, 1798
Pen and brushed ink, gray-and-brown wash, heightened with white, over graphite on paper
26¹/₁₆ × 40⁷/₁₆ in.
(66.2 × 102.7 cm)
*Gift of Mrs. George Garvin Brown
1976.11.2*

▲ **A** crowd fills the Roman Forum to witness a young woman petition an emperor for leniency. Although the exact episode portrayed is unknown, Thomon, like many Neoclassical artists, probably derived his subject from Roman history, and presents his scene as a model of fairness and compassion. His ambitious composition freely combines fanciful detail with actual monuments. In the center appears the Forum of Augustus, with niches in its curved walls containing statues of famous Romans, while on the right stands the monumental Roman sculpture known as the Farnese *Hercules*, unearthed in 1546 at the Baths of Caracalla. Trained as an architect, Thomon visited Italy during the 1780s, sketching ancient ruins that he would later incorporate into classicizing landscapes. A royalist, he fled France during the Revolution and eventually settled in Russia, where he became court architect to Czar Alexander I in 1802. ᴋꜱ

▶

Admired as the "pearl of Naples," Celeste Coltellini was a preeminent mezzo-soprano renowned for her acting abilities. Her moving performance as the tragic lead in Giovanni Paisiello's *Nina* elicited shouts from tearful audience members hoping to console her character as she descended into madness. In this portrait, Celeste's penetrating gaze, impish smile, and mass of untamed curls convey the captivating and vibrant personality of a woman once described as "lively, spiritual, intelligent, and full of playfulness." An amateur artist herself, Celeste befriended Gros in Genoa in 1793, shortly after her marriage to Swiss banker Jean-George Meuricoffre. Gros spent seven years in Italy studying, teaching, and painting portraits. ᴋꜱ

▼ **A**n early exponent of the Neoclassical style, Lebarbier portrays a dramatic moment from the Trojan War, as recounted in Homer's *Iliad*. Paris precipitated the war by abducting the beautiful Helen from the Greek city-state of Sparta. In the midst of battle, the goddess Aphrodite saved Paris from death by transporting him back to his home in Troy, and to Helen. In this scene, Hector, Paris's older brother, urges him to return and fight. Helen, garbed in white, remains seated with her attendants, as Paris dutifully takes up his shield and sword. This subject reflects Lebarbier's Republican sympathies, communicating a message of civic virtue during a tumultuous period in French history. ML

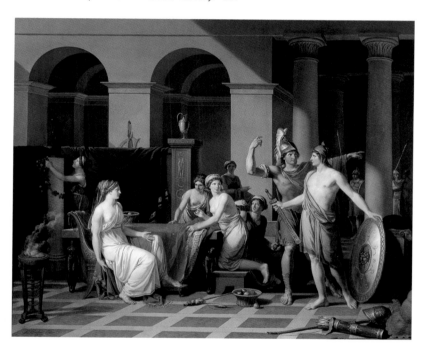

Antoine-Jean Gros
French, 1771–1835
Portrait of Celeste Coltellini,
Madame Meuricoffre,
about 1790s
Oil on canvas
26³/₄ × 19¹/₂ in.
(67.9 × 49.5 cm)
Gift of Mrs. Berry V. Stoll 1983.10

Jean Jacques François Lebarbier
French, 1738–1826
Helen and Paris, 1799
Oil on canvas
34 × 40 in.
(86.4 × 101.6 cm)
Gift of the Charter Collectors 1998.21

Merry Joseph Blondel
French, 1781–1853
Portrait of Madame Houbigant,
born Nicole Deschamps,
about 1807
Oil on canvas
41³/₄ × 33 in. (106 × 83.8 cm)
Gift of Mrs. Hattie Bishop Speed,
by exchange 1993.17

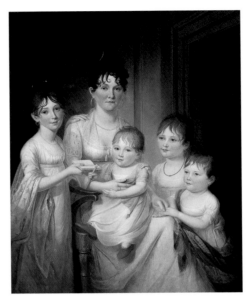

James Peale
American, 1749–1831
Portrait of Madame Dubocq and
Her Children, 1807
Oil on canvas
51¹/₈ × 41³/₁₆ in.
(129.9 × 104.6 cm)
Gift of Mrs. Aglaé Kent Bixby 1932.29.1

▲

The sitter in this portrait was a member of the Houbigant
family, which established the renowned perfume house
of the same name in Paris in 1775. Madame Houbigant's
high-waisted dress, the Grecian chair, and the scrollwork
on the wall reflect the popularity of Classical design,
inspired by contemporary archaeological discoveries.
Her ostrich-feather hat and red cashmere shawl, an Indian
import that Napoleon and his officers brought back from
their Egyptian campaign, were the height of fashion in
1807. Although Blondel depicts his sitter as a stylish
woman, he also presents her with a direct, intelligent
gaze, and includes books that attest to her education
and intellectual pursuits. In addition to his portrait work,
Blondel was also highly successful as a decorative painter,
and adorned the ceilings in several royal palaces as well
as the Louvre. ML

◀ **J**ames Peale, brother of Charles Willson Peale, painted this imposing portrait of Marie Françoise Trochon de Lorrière Dubocq and her children in Philadelphia in 1807. A daughter of a French count, Madame Dubocq settled in Haiti after the French Revolution and later moved to Philadelphia with her husband, William Dubocq. The family joined the city's thriving French émigré community, and by 1805 William was established as a china merchant. Peale lavishes attention on the sitters' fashionable Neoclassical gowns and jewelry, and suggests a rapport between mother and children through their affectionate intertwining gestures and the painting's harmonious tones of silvery gray and rose.

The portrait accompanied the Dubocq family when they settled in Shippingport, Kentucky, in the 1830s, and was given to the Speed by the granddaughter of Marie Aglaé Dubocq, shown second from right. RC

American, New York City
Couch, 1815–25
Maple, gilt paint, cane, other woods
29¹/₂ × 86 × 24⁵/₈ in.
(74.9 × 218.4 × 62.5 cm)
Bequest of Mrs. Leonard T. Davidson
1970.31.9.2

▼ **D**uring the early decades of the nineteenth century, fashionable American consumers favored what was then often called the antique or Grecian taste; they would certainly have found much to like in this elegant couch, one of a pair in the Speed's collection. In form and decoration it was inspired by late eighteenth-century French prototypes, which were also emulated in England. Those who made and decorated this couch (two distinct sets of artisans) learned the new style through such sources as published designs, imported European pieces, and the products of their competitors. An interest in ancient sources is most evident in this couch's painted decoration, which ultimately derives from ancient Greek and Roman architecture, wall murals, and other surviving artifacts. SE

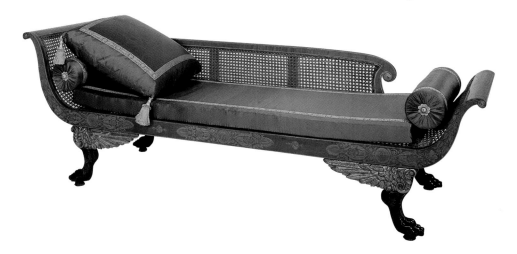

▼ About 1811, soon after his second marriage, Thomas Speed built a compact but architecturally sophisticated brick home for his family near Bardstown, a prosperous county seat located southeast of Louisville. This door surround, clothed in the same Renaissance-inspired Classicism found elsewhere in central Kentucky, acted as an imposing processional arch for those entering the house, which was known as Cottage Grove. Through such grand architectural details, Speed's new home—built next to the log cabin the family had previously occupied—symbolized his rising economic status as a landholder, farmer, slave owner, and merchant. The Speed family legacy would continue unabated: Thomas's great-nephew, for example, was James Breckinridge Speed, for whom the Speed Art Museum is named. SE

American, Bardstown, Kentucky
Door surround, about 1811
Poplar, red cedar
142^{5}/$_{16}$ × 111^{3}/$_{4}$ × 26 in.
(361.5 × 283.8 × 66 cm)
Gift of Mr. and Mrs. John S. Speed 1999.6

▶
When Asa Blanchard advertised the opening of his Lexington silver shop in 1807, he said he would make "Silver Teapots, Sugar and Cream Pots, Tankards, Cans and Tumblers and all kinds of Ladles and Spoons." While he made no mention of candlesticks, his shop did produce this pair for Isaac Shelby, a Revolutionary War hero and Kentucky's first governor, an office he held from 1792 to 1796 and again from 1812 to 1816. The only early, Kentucky-made silver candlesticks presently known to have survived, they were objects of great luxury when first produced. SE

▶ **F**rom the end of the eighteenth century through the first decades of the nineteenth, settler upon settler poured into Kentucky. Silversmith Asa Blanchard was one of the newcomers, setting up shop in Lexington around 1807. He soon built a prosperous business, producing spoons, ladles, teapots, and other forms in a simplified, Classical style. The large quantities of surviving silver that bear Blanchard's mark suggest that, along with several known apprentices, he also employed journeymen to work at the benches in his shop. His business successes allowed him to indulge in such relative luxuries as this portrait, commissioned from the prominent Kentucky artist Matthew Harris Jouett. SE

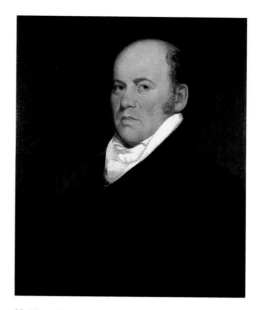

Matthew Harris Jouett
American, 1788–1827
Portrait of Asa Blanchard,
about 1817–20
Oil on canvas
27 × 21⁵/₈ in.
(68.6 × 54.9 cm)

Gift of Rowland D. and Eleanor Bingham
Miller, Mr. and Mrs. Owsley Brown II,
Laura Lee Brown and Steve Wilson, and
John S. Speed 2000.4.1

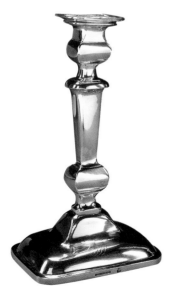

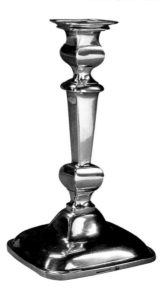

Workshop of **Asa Blanchard**
(American, died 1838), Lexington,
Kentucky
Candlesticks, about 1815
Silver
Each: 10³/₈ × 5¹¹/₁₆ × 4³/₁₆ in.
(26.4 × 14.4 × 10.6 cm)

Museum purchase 1956.12.1–.2

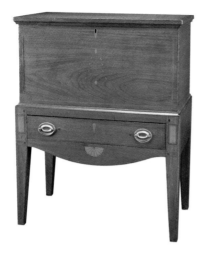

American, central Kentucky,
possibly the Lincoln County area
Sugar chest, 1805–25
Walnut, poplar, other woods
34 × 25³/₁₆ × 14¹/₈ in.
(86.4 × 64 × 35.9 cm)
Gift of Edith and John Brewer 2004.23

◀ **M**ost popular between about 1800 and about 1840, sugar chests, sugar desks, and other related forms were primarily produced in the central regions of Kentucky and Tennessee. Regardless of origin, all were devoted to protecting sugar, a costly commodity during the early nineteenth century. This chest, configured as a rectangular box atop a base with tapered legs, follows a typical early nineteenth-century format. Its extensive inlay, however, is less common; it made the chest an expensive status symbol in its day. Placed in the dining-room or parlor for all to see, the chest kept the valuable sugar close at hand for sweetening the tea, coffee, mixed drinks, and alcoholic punches that lubricated the period's social rituals. SE

▶

Along with sugar chests of various sorts, well-to-do Kentuckians also used sugar desks to store sugar and other household consumables, such as coffee, tea, and spices. In this example the fall front opens to reveal a sliding horizontal panel that covers the sugar storage compartment below. One can imagine the desk's first owner, probably a resident of Bourbon County in north-central Kentucky, keeping track of accounts at the desk while storing documents, ink, important papers, sugar tongs, tea, and other items in its drawers. The configuration of the drawers, particularly the concave center section, is an unusual feature. The extra time required to shape the concave drawer fronts, combined with the desk's various inlays, would have added significantly to its original cost. SE

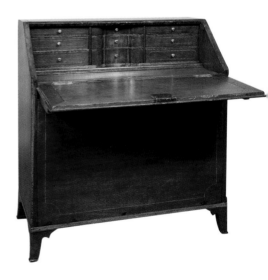

American, probably Bourbon
County, Kentucky
Sugar desk, about 1810
Cherry, poplar, other woods
34³/₈ × 31³/₈ × 15⁵/₈ in.
(87.3 × 79.7 × 39.7 cm)
*Gift of Mrs. Hattie Bishop Speed,
by exchange 1994.1*

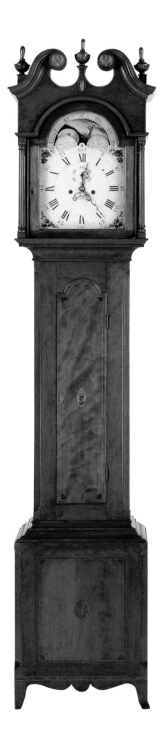

▼ **L**owry, a cabinetmaker active in Frankfort from at least 1804 until 1810, conveniently stamped the case of this clock with his name. Perhaps working with other artisans in his shop, he enlivened this piece with extensive inlay, complex moldings, and other flourishes. The finished product, more elaborate than many surviving Kentucky clocks, was first owned by James Ellis, an early resident of central Kentucky's prosperous Bluegrass region. By the early nineteenth century the region's merchants and artisans supplied such well-to-do consumers as Ellis with a wide range of luxury goods that included fine locally made furniture, French wallpaper, and English cut glass. Suppliers offered flexible payment plans. Lowry, for example, offered to trade cabinetwork for cash, pork, beef, or whiskey. SE

Case made by **William Lowry**
(American, dates unknown),
Frankfort, Kentucky
Tall clock, 1805–10
Cherry, walnut, poplar, other woods
98³/₄ × 21¹/₁₆ × 12¹/₄ in.
(250.8 × 53.5 × 31.1 cm)
*Bequest of Alice Speed Stoll,
by exchange 2004.3*

Matthew Harris Jouett
American, 1788–1827
Portrait of Mrs. John Norton,
born Sarah Low, about 1820–25
Oil on canvas
38³/₄ × 30⁹/₁₆ in.
(98.4 × 77.6 cm)

Gift of Robert L. Boone, Jr.,
Charles N. Boone, Elizabeth B. Shmock,
and Sarah B. Burke in memory of their
parents, Elizabeth Sharpe Boone and
Robert Lee Boone 1971.6.2

◀ **B**orn in Mercer County, Jouett was Kentucky's leading portrait painter during the first quarter of the nineteenth century. After studying under Gilbert Stuart in Boston in 1816, he returned to Lexington, where his reputation as "Stuart's pupil" brought him numerous commissions. His portrait of Sarah Norton is perhaps his most colorful and flamboyant likeness. Her ample figure, rosy cheeks, and fashionable attire suggest her life of privilege, but she was best known as a devout and charitable Methodist. In 1858 the Methodist Episcopal Church, South, chronicled her good works in the pages of the *Life of Mrs. Sarah Norton: An Illustration of Practical Piety*. There she remarks, "I am never so happy as when I attend to my *regular* duties faithfully . . . daily reading the Bible, and secret prayer at least *three* times a day." ML

Chester Harding
American, 1792–1866
Portrait of the John Speed
Smith Family, 1819
Oil on canvas
97⁹/₁₆ × 76¹/₂ in.
(247.8 × 194.3 cm)

Gift of William Stucky 1956.14

▼ **F**rom 1808 to 1819, years before the publication of his famous four-volume *Birds of America*, Audubon attempted to run general stores in rural Kentucky, and spent hours sketching wildlife in the region. After an early business failure, he took refuge with the Berthoud family in Shippingport, Kentucky, near Louisville. Perhaps following the death of his friend James Berthoud in the summer of 1819, Audubon drew this portrait of him, as well as the companion portrait of Mrs. Berthoud and a portrait of their son Nicholas, also in the Speed's collection. According to family tradition, Berthoud was actually the Marquis de Saint-Pierre, an aristocrat who adopted the name of a servant when he fled France in 1794 to escape the Revolution. KS

 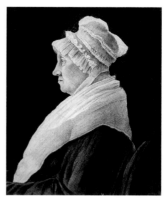

John James Audubon
American, 1785–1851
Portrait of James Berthoud,
about 1819
Black chalk and carbon pencil
on paper
10 × 7⅞ in.
(25.4 × 20 cm)
Museum purchase 1935.35.1

John James Audubon
American, 1785–1851
*Portrait of Mrs. James
Berthoud*, about 1819
Black chalk heightened with
white on paper
10 × 8 in.
(25.4 × 20.3 cm)
Museum purchase 1935.35.2

◀ **B**orn in rural Massachusetts, Harding rose from enterprising frontier artist to one of America's leading portraitists, traveling widely as he painted prominent European and American figures. To establish himself in the profession, he moved to Paris, Kentucky, around 1818, with the encouragement of his brother Horace, who had already settled there. According to his autobiography, Harding painted roughly one hundred portraits of Kentucky's prosperous citizens between 1818 and 1820, at a rate of $25 a head. As his first full-length and group portrait, this large-scale composition is remarkably ambitious. Harding depicts John Speed Smith, a rising politician, his wife, Eliza Lewis Clay, and their daughter Sallie Ann in their home in Richmond, Kentucky. The furnishings, red window treatments, and ingrain carpet provide rare documentation of a prosperous early Kentucky interior. ML

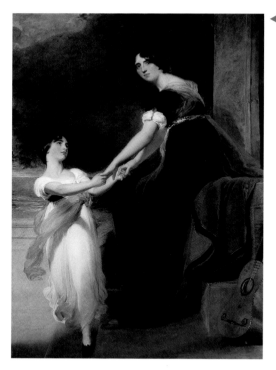

◄ **T**his portrait displays the lively spontaneity and refined elegance that made Lawrence one of the most popular portraitists of his time. On a seaside terrace, Susan, Countess of Guilford, and her young daughter Georgiana clasp each other's hands affectionately. The dark, dramatic sky sets off the flowing lines of their graceful pose and draws attention to their loving gesture. In 1807, approximately five years before this work was painted, Lawrence, who faced chronic financial difficulties, was near bankruptcy. Thomas Coutts, a wealthy Scottish banker, assisted him in managing his debt, and a year later Coutts showed his continued willingness to help his friend by commissioning portraits of his three daughters, including this of his eldest child, Lady Guilford. ML

Thomas Lawrence
English, 1769–1830
Portrait of Susan, Countess of Guilford, and Her Daughter Georgiana, about 1812
Oil on canvas
82⁵/₈ × 58 in.
(209.9 × 147.3 cm)
Purchase, Museum Art Fund 1959.2

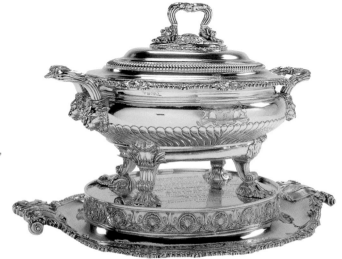

Workshop of **Paul Storr** (English, 1771–1844), London
Tureen and stand, 1813–14
Silver
13¹/₂ × 19⁹/₁₆ × 14³/₁₆ in.
(34.3 × 49.7 × 36 cm)
Anonymous gift 1991.24.1 a–c

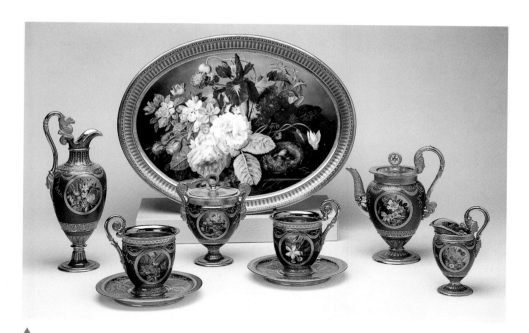

▲

Made to the highest aesthetic and technical standards, this richly decorated tea and coffee set, or *déjeuner* (breakfast set), represented the height of fashion for its age. Its shapes, enlivened by a stern sculptural griffin atop the coffeepot and by sumptuously gilded festoons, ribbons, and leaves, followed what was then often called the antique, Classical, or Grecian taste. Lush flower painting, a Sèvres specialty, relieves the tight symmetry of the gilded elements. As with many of Sèvres's finest pieces, this set became a royal gift: it was sent to a German baron in the name of Louis XVIII as a royal "thank you"; the baron had previously given Louis a portrait of the king's ill-fated older brother, Louis XVI. SE

◄

During Britain's many battles with Napoleon, Rowland Hill became one of the country's leading military commanders. When Hill returned home from war in 1814 he received a hero's welcome in Shrewsbury, near his estate in west-central England. Along with a grand public monument erected in his honor, Lord Hill also received a silver service from the town's drapers, a prosperous guild associated with the cloth trade. These two pieces, both in the muscular Classical style favored at the time, come from the Hill service. The stand's inscription recognizes Hill's "brilliant Achievements" and "mild and generous qualities." SE

Sèvres Porcelain Manufactory,
Sèvres, France
Tea and coffee service, 1814
Coffeepot, teapot, cream pot, and sugar bowl designed by
Jean-Marie-Ferdinand Régnier
(French, 1774–1857)
Flowers painted by
Denis Désiré Riocreux
(French, 1791–1872)
Gilding by
Antoine Gabriel Boullemier
(French, active 1802–1842) and
François Antoine Boullemier
(French, active 1813–1855)
Hard-paste porcelain
Coffeepot, height: 10³/₈ in.
(26.4 cm)
Tray: 13⁷/₁₆ × 17¹/₄ in.
(34.1 × 43.8 cm)

Purchased with funds from the Alice Speed Stoll Accessions Trust 1999.5.1–.7

▼ **M**ichel spent most of his career painting the countryside surrounding his native Paris, particularly the still-rural hills of Montmartre. In this panoramic view, extending to the River Seine and Paris in the distance, a turbulent sky dominates the scene, and nature appears to dwarf the quarry workers encamped beneath one of Montmartre's numerous windmills. Michel fully exploits the tactile qualities of paint, using thick impasto and slashing brushstrokes to render the texture of the chalky hillside. Unlike the idealized landscapes of his contemporaries, Michel's landscapes were inspired directly by nature, which he first captured in *plein-air* sketches. The naturalistic Dutch landscapes by Ruisdael, Hobbema, and others that Michel copied and restored in his youth were equally influential in his work. Although he painted largely in obscurity, Michel is recognized today as an important precursor to the Barbizon School of landscape painting. RC

Georges Michel
French, 1763–1843
Landscape with a Mill with a View of Montmartre,
after 1830
Oil on paper laid down on canvas
29⅞ × 41½ in.
(75.9 × 105.4 cm)
Gift of the Charter Collectors 2002.18

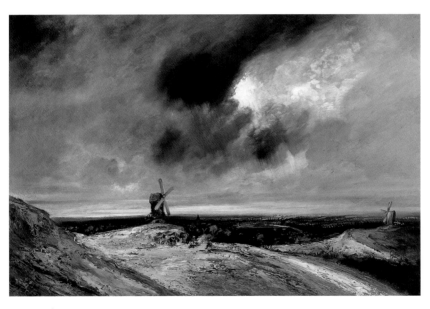

▶ **T**his study of a rural washhouse and landscape near the Italian town of Marino represents an important moment in Corot's artistic development. Sketching directly from nature, the artist conveys the remarkable intensity of Mediterranean sunlight blazing down on the rocky, uneven terrain. A single figure, carrying a load of wash on her head, provides a sense of scale. While traveling in Italy from 1825 to 1828, Corot produced approximately 150 *plein-air* studies of the Roman countryside. Following traditional academic practice, he used these sketches as aids in composing Classical landscapes in his studio. They came, however, to be valued in their own right as freshly observed, evocative compositions. ML

Eugène Delacroix
French, 1798–1863
Greenwich, 1825
Watercolor over traces of graphite
on board
4⁹/₁₆ × 7¹/₂ in.
(11.6 × 19.1 cm)
Purchase, Museum Art Fund 1963.21

▲

Eugène Delacroix, best known for dramatic history paintings that embodied the spirit of Romanticism, painted this sketch during a three-month stay in England. The journey had a profound impact on the artist, who was inspired by the lighter palette, loose brushwork, and naturalistic landscapes of contemporary British painters. This watercolor of Greenwich is one of several that Delacroix painted of historic sites in London and views further down the River Thames. The Queen's House (then part of the Royal Hospital School and now the National Maritime Museum) appears through the trees on the right, while the dome of St. Paul's Cathedral is on the horizon on the left. Delacroix's remarkable watercolor technique combines sweeping washes, dabs of dry brush, and finger smudges to bring out textural variety in the landscape. KS

Jean-Baptiste-Camille Corot
French, 1796–1875
A Washhouse at Marino
(*Marino—Un Lavoir*), 1826–27
Oil on paper mounted on board
11 × 17³/₈ in.
(28 × 44.1 cm)
*Museum purchase, Mrs. Blakemore
Wheeler Fund 1966.2*

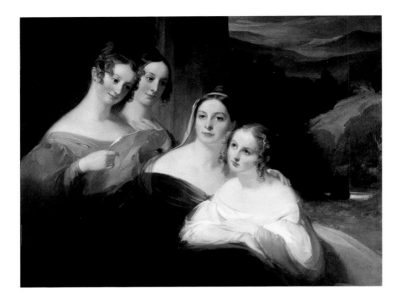

Thomas Sully
American, 1783–1872
The Walsh Sisters, 1834–35
Oil on canvas
42⁷/₈ × 54⁷/₁₆ in.
(108.9 × 138.3 cm)
*Bequest from the Preston Pope Satterwhite
Collection 1949.30.305*

▲ **S**ully enjoyed a lengthy and distinguished career, during which he produced more than two thousand portraits. His fluid, romantic style appealed to a variety of sitters, from powerful political leaders to members of Philadelphia's high society. In March 1835 Sully completed this group portrait of the daughters of Robert Walsh, a noted journalist and diplomat from Philadelphia, who himself had posed for the artist in 1814. With sensitivity and a confident hand Sully adds flattering and revealing details to the girls' portrait. The youngest girl's white dress, bow mouth, and upturned eyes suggest the innocence of youth, while the relaxed smile and poised carriage of the eldest daughter, in the center, convey her graceful refinement. KS

Oliver Frazer
American, 1808–1864
*Portrait of the Anderson
Children*, 1839
Oil on canvas
30¹/₈ × 25 in.
(76.5 × 63.5 cm)
*Bequest of Miss Kate Barbaroux
1949.18*

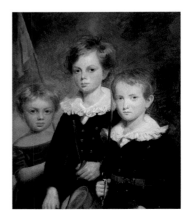

▼ **W**hen West exhibited *The Present* at the American Art Union in New York in 1849, critics applauded the "delicate differences of feeling" portrayed by the artist. "Surprise, delight, curiosity, envy, sympathy, and indifference are admirably expressed" on the faces of family and friends, who watch as a young bride examines an elaborate amethyst-and-gold necklace she has received as a wedding gift. A native of Lexington, Kentucky, West first worked as an itinerant portraitist in the Mississippi River Valley from 1810 to 1819, during which time he also maintained a base in Philadelphia and an artistic association with Thomas Sully. In 1819 he sailed to Europe, where his charm and good humor earned him favor among many prominent members of society. In addition to his portraits of such famous literary figures as Washington Irving and Lord Byron, West painted genre subjects noted for their delicate charm and high polish. He painted *The Present* while in London, where he lived from 1825 to 1837, and exhibited it at the British Institution in 1833. KS

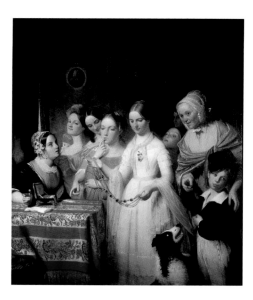

William Edward West
American, 1788–1857
The Present, 1833
Oil on canvas
38¹⁄₈ × 31³⁄₄ in.
(96.8 × 80.6 cm)
Bequest of Mrs. Blakemore Wheeler
1964.31.33

◀ **F**razer was the most extensively trained early Kentucky artist: he studied under portraitists Matthew Harris Jouett in Kentucky and Thomas Sully in Philadelphia before traveling in 1834 to Europe, where he studied with Thomas Couture. He returned to Lexington in 1838 to open a studio, and painted this charming, informal portrait the following year. Edward, John, and Benjamin Anderson (as seen from left to right) were sons of the artist's first cousin James Anderson and Mary Wigglesworth Anderson. Frazer breaks from the usual bust-length formal portraits of the time by depicting the Anderson boys at play, dressed up as soldiers on parade. The youngest, Edward, holds a flag, while John beats a drum and Benjamin stands at attention, raising a sword. Benjamin would later serve in the Confederate Army. ML

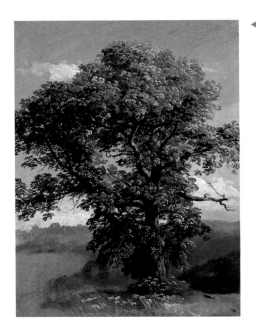

Thomas Cole
American, 1801–1848
Finished Study of a Tree,
about 1844–46
Oil on panel
16³/₈ × 12³/₈ in.
(41.6 × 31.4 cm)
Museum purchase 1971.10

◄ Landscape came into its own as a genre in American art during the nineteenth century: a manifestation of the nationalist feeling, also expressed in literature, that the country was best celebrated through its natural wonders. Cole was a key figure of the Hudson River School and widely celebrated for his large-scale paintings of the majestic wilderness of New York's Catskills and Lake George, and New Hampshire's White Mountains. This small, carefully observed portrait of a magnificent old oak, probably from the area around his studio in Catskill, New York, was produced late in Cole's career, when he had begun to work in a new way, sketching outdoors directly from nature and applying paint to panels without a preliminary drawing. Its high finish and carefully rendered detail suggest an independent work of art, rather than a preparatory study. LB

Thomas Addison Richards
American, 1820–1900
Meditation in the Catskills,
1851
Oil on canvas
59¹/₈ × 39¹⁵/₁₆ in.
(150.2 × 101.4 cm)
Gift of Dr. and Mrs. Irvin Abell, Jr. 1984.14

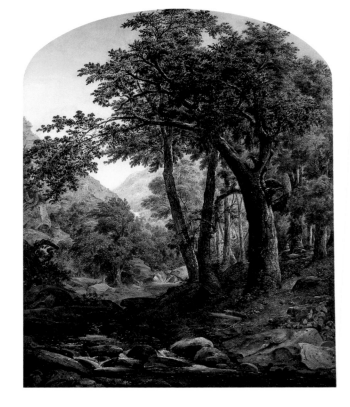

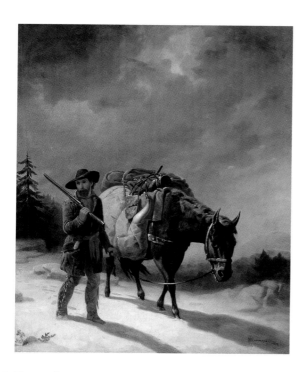

William Tylee Ranney
American, 1813–1857
A Trapper Crossing the Mountains, 1853
Oil on canvas
30 × 24³/₄ in.
(76.2 × 62.9 cm)

Museum purchase, Mrs. Eliza J. Bohon fund
1949.29

▲ Ranney's trapper represents quintessentially American themes prevalent in the nation's art and literature around the mid-nineteenth century. Dressed in a leather coat and buckskin leggings, and shouldering his rifle, the fur trapper leads his heavily laden mule through the mountains, leaving solitary tracks in the snow. Living by his wits in the Western wilderness, the trapper became an American hero, embodying the national ideals of a pioneering spirit, rugged individualism, and an enterprising character. Ranney emphasizes the mountain man's heroic stature by echoing the idealized pose and easy grace of a Classical Greek sculpture. The trapper's somewhat melancholy gaze suggests his awareness that civilization will soon reach this pristine region, dooming his rugged way of life forever. RC

◀ Richards spent most of his childhood in Hudson, New York. In 1844 he settled in New York City, where he was inducted into the National Academy in 1851, the year he painted this canvas. He made annual sketching trips to the Catskill Mountain region, which had become a popular tourist destination. Richards himself authored several popular travel narratives focused on American scenery, in which he encouraged visitors to seek out the lesser-known, more intimate natural settings, rather than the popular grand vistas. This scene is probably a view in the Kaaterskill Clove, a location renowned for its scenic beauty and a favored subject for Hudson River School artists. Richards inserts a lone figure seated in quiet contemplation among the trees to the right, perhaps recalling the words of Romantic poet William Cullen Bryant: "Father, thy hand hath reared these venerable columns . . . Be it ours to meditate, in these calm shades, thy milder majesty." ML

▶

Created by an anonymous carver, this oversize fireman protected the citizens of Louisville from his post atop the downtown station of the Mechanic Fire Company, located on First Street between Main and Market streets. When an alarm sounded, he was rotated to point toward the fire, directing the company's volunteers to the scene of the emergency. Since different volunteer companies—part firefighting outfits and part social clubs—often raced to the same fire, a speedy arrival was a matter of intense competition. A Louisville firefighter of the 1850s described the results: "fights occurred at practically every fire of consequence, when spanner, trumpets and fists were freely used, but never any gunplay." SE

American, probably Louisville, Kentucky
Chief Director, Mechanic Fire Company No. 1, about 1855
Painted wood
78 × 31³/₈ × 41 in.
(198.1 × 79.7 × 104.1 cm)
Gift of Mr. William C. Bittner 1949.17 a,b

▶

One of the most successful painters active in the South before the Civil War, Bush was raised in Franklin County, Kentucky. He traveled to Philadelphia around 1814, reportedly accompanied by Kentucky statesman Henry Clay, who helped fund his study under the distinguished portraitist Thomas Sully. Bush returned to Kentucky in 1818 and was advertising his services in Louisville by the following year. Later he traveled to New Orleans and Natchez, Mississippi, as an itinerant portrait painter. The influence of Sully, known for his alluring portraits of women, is particularly evident here in the sitter's deep, engaging eyes. Mary was the daughter of Kentucky judge George M. Bibb, who served as secretary of the treasury under President John Tyler. In 1841 she wed Sedley M. Lynch and moved with him to Mississippi, where she died of tuberculosis after just three years of marriage. ML

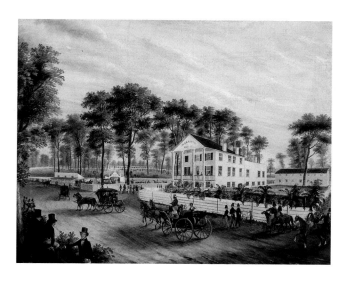

Robert Brammer
American, born Ireland, about
1811–1853
Augustus A. Von Smith
American, born Germany, active
about 1835–1842
*Oakland House and Race
Course, Louisville*, about 1840
Oil on canvas
28⅝ × 36 in.
(72.7 × 91.4 cm)
Purchase, Museum Art Fund 1956.19

▲ In 1839, thirty-six years before the first Kentucky Derby, Louisville hosted
a horse race that drew ten thousand visitors and attracted attention across
the country. The high-stakes match took place at Oakland race course
and pitted Grey Eagle, the pride of Kentucky, against Wagner, a Virginia-
bred stallion. Wagner won the series of grueling four-mile races, earning
bragging rights for his owner and freedom for his enslaved jockey, Cato.
A year later Robert Brammer and Augustus Von Smith collaborated on this
canvas documenting the famous racetrack and its grand antebellum hotel.
Brammer, who specialized in landscapes, probably painted Oakland House
and the surrounding grounds, while Von Smith, a portraitist, contributed
the genteel figures. Little is known about these itinerant artists, who shared
a studio in Louisville during the early 1840s and also worked in Indiana,
Mississippi, and New Orleans. KS

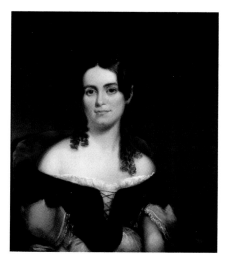

Joseph H. Bush
American, 1794–1865
*Portrait of Mary Lucy
Pocahontas Bibb*, about 1839
Oil on canvas
30 × 25 in.
(76.2 × 63.5 cm)
Gift of Mrs. Hattie Bishop Speed 1942.29

▶ **R**edgrave was one of the first Victorian artists to use his paintings to draw attention to contemporary social ills. *Going to Service*, among the earliest of these works, details the all-too-common plight of poor, unmarried country girls forced to find work in the city to support their families. The girl in this painting, identified by a label on her trunk as "Jane Homelove," bids farewell to her sick, widowed mother and younger sister. She prepares to leave for London, where she has found employment as a servant. Outside waits a carriage filled with girls also seeking work in the city. Those unable to find jobs may fall into prostitution, an ominous fate implied by the broadside pinned to the wall, featuring an image of St. Paul's Cathedral, a landmark that appeared in many Victorian paintings of prostitutes. ᴋs

▼ **D**uring France's Second Empire (1852–70), the bourgeoisie began to visit the salons and buy art in unprecedented numbers. This painting by Cabanel, an enormously successful artist trained at the École des Beaux-Arts, was exhibited at the Salon of 1857. It is a good example of the conservative side of Second Empire taste. Many patrons were not interested in the images of laborers and peasants produced by such radical artists as Gustave Courbet, preferring the work of academic painters, such as Cabanel, who took their subjects from literature, history, or religion. This painting is based on act I, scene iii of Shakespeare's *Othello*, in which Othello describes his courtship of Desdemona and her rapt attention to his tales of his adventures. To add psychological tension, Cabanel introduces into the idyllic moment the eavesdropping Iago, who foreshadows the tragedy to come. ʟʙ

Alexandre Cabanel
French, 1823–1889
Othello Relating His Adventures, 1857
Oil on canvas
45⁹/₁₆ × 51³/₁₆ in.
(115.7 × 130 cm)
Museum purchase 1972.36

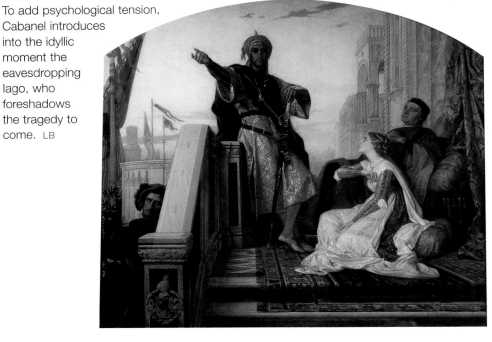

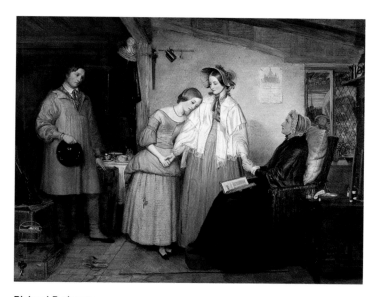

Richard Redgrave
British, 1804–1888
Going to Service, 1843
Oil on canvas
31 × 39³/₄ in.
(78.7 × 101 cm)
Gift of the Charter Collectors 1994.12

▶

Millet depicted the humble lives of French peasants with dignity and simple grandeur. Before about 1860 he could sell drawings more readily than paintings, and he rendered numerous closely observed scenes of domestic peasant life. Millet was fascinated by the peasants of the Barbizon region, such as this young mother, wearing the traditional Barbizon *marmotte*, or close-fitting scarf, and holding her swaddled infant. Millet derived this particular composition of figures in an interior illuminated by a side window from seventeenth-century Dutch genre paintings. The focal point is the mother's tender embrace of her sleeping child. Other than the sewing on the windowsill and the infant's cradle, the simple room contains nothing to distract from this timeless, monumental image of maternal love. RC

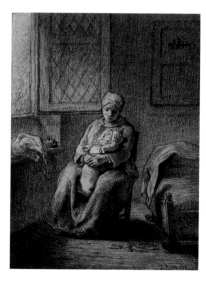

Jean-François Millet
French, 1814–1875
Baby in Arms (L'Enfant au maillot),
about 1857–60
Black Conté crayon on wove paper
12¹⁵/₁₆ × 9¹/₄ in. (32.9 × 23.5 cm)
Purchase, Museum Art Fund 1966.3

See page 84 for a seventeenth-century Dutch genre painting by Pieter Cornelisz. van Slingeland.

Thomas Ball
American, 1819–1911
Henry Clay, 1858
Bronze
30¹/₂ × 12¹/₈ × 10¹¹/₁₆ in.
(77.5 × 30.8 × 27.1 cm)
Purchase, Museum Art Fund 1965.22

Thomas Ball
American, 1819–1911
Daniel Webster, 1853
Bronze
29³/₄ × 13¹/₈ × 11¹/₄ in.
(75.6 × 33.3 × 28.6 cm)
Gift of Mrs. Hattie Bishop Speed 1942.205

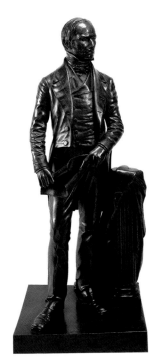
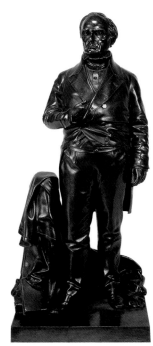

▲ Posed as if about to address Congress, two of the most prominent politicians of nineteenth-century America are here captured in statuettes, intended as pendants. Both Henry Clay and Daniel Webster were known as persuasive orators who worked to preserve the Union in the face of growing sectional tensions. Forcefully characterizing each man's features, Ball shows Clay and Webster in modern clothing rather than the Classical attire of traditional heroic sculpture. His startling realism was highly praised at the time. The half-columns symbolize strength and constancy while also referring to the tradition of skilled oration established in ancient Greece and Rome. After Ball modeled the figures in clay, the J.T. Ames Foundry in Chicopee, Massachusetts, primarily a manufactory of arms and cannons, cast them in bronze, making these sculptures two of the first in America to be patented and produced in large editions. ML

▶ Rogers's *Nydia* was the single most popular full-length American sculpture of the nineteenth century. The heroine of Sir Edward Bulwer-Lytton's epic novel of 1834, *The Last Days of Pompeii*, Nydia is a blind slave girl who falls in love with the noble-born Glaucus, although he loves the beautiful Ione. When Vesuvius erupts, Nydia, though blind, is able to "hear" her way to the docks, and valiantly leads the couple through the darkness to safety on a boat in the harbor. Rogers captures the terror of the moment in her anguished expression and forward rush, as well as in her gown, whipped by volcanic winds. The next morning Nydia, realizing the hopelessness of her love for Glaucus, throws herself overboard into the sea. Victorian viewers appreciated Rogers's depiction of Nydia's sentimental story of bravery and sacrifice, as well as the virtuosity of the sculpture's deeply carved and undercut surfaces. RC

▶ **V**ermont native Hiram Powers began his career in Cincinnati, modeling figures for a wax museum. In 1837 he settled in Florence, Italy, where he achieved great success creating sculptures that merged nineteenth-century sentiment with Classically inspired forms. In 1866 an American collector commissioned Powers to create a group of ideal busts depicting subjects he had never before rendered. In response Powers produced the Heavenly Graces: Faith, Hope, and Charity. He draped each in Classical garb and distinguished them by placing traditional attributes on their foreheads, such as the flame of Charity. Powers created a total of eight examples of *Charity* for collectors, including this figure purchased by Cincinnati businessman Henry Probasco, who also had requested an ideal bust portraying a novel subject. James Breckinridge Speed later purchased it for his private collection. KS

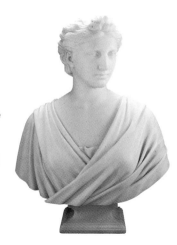

Hiram Powers
American, 1805–1873
Charity, modeled 1867,
carved 1871
Marble
28¼ × 20⁹/₁₆ × 12¾ in.
(71.8 × 52.2 × 32.4 cm)
Gift of Mrs. Hattie Bishop Speed 1928.50

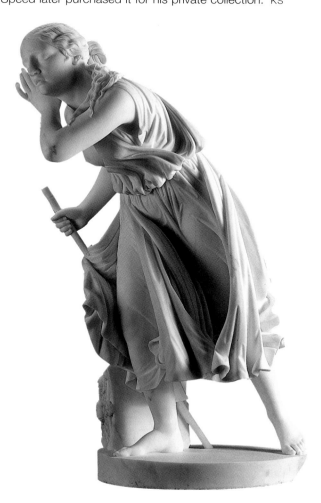

Randolph Rogers
American, 1825–1892
Nydia, the Blind Flower Girl
of Pompeii, after 1854
Marble
53⁷/₈ × 27 × 36¼ in.
(136.8 × 68.6 × 92.1 cm)
Given in memory of John W. Barr III,
by the Barr Family 2000.12

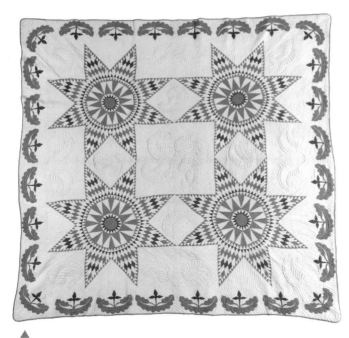

Sarah Means
American, 1826–1924
Quilt, about 1850
Cotton
102³/₄ × 99 in.
(261 × 251.5 cm)

*Bequest of Alice Speed Stoll,
by exchange 2005.15*

Although born in Tennessee, Means spent much of her long life in southwestern Kentucky's Christian County, located along the border between the two states. She made this quilt there around 1850. Like many other mid-nineteenth-century American quilters, she built a symmetrical, boldly geometric design from pieces of red and green fabric applied to a white ground. A recent study has suggested that such designs were ultimately inspired by the colliding geometric patterns seen in kaleidoscopes, devices that rose to great popularity during the 1820s. Both Means and her family judged the quilt a success: it shows few signs of use and remained in the family until acquired by the Speed. SE

Probably made by **Mary Mize**
American, born about 1834
Quilt, about 1850–55
Cotton
75¹/₄ × 71 in.
(191.1 × 180.3 cm)

*Purchased with funds from the
Alice Speed Stoll Accessions Trust
and gift of Shelly Zegart 2006.3*

▼ In describing her spinster aunt, one of Ivey's nieces wrote: "She never had any lessons in Art, just her own intent and creative instinct." These qualities served Ivey well; this quilt, made in Logan County, Kentucky, and another surviving example by Ivey at the Smithsonian Institution reflect the hand of a gifted designer and technician. Ivey was particularly adept at using raised motifs, often of a documentary nature, to decorate her quilts' white grounds. Here, for example, she included the figure of Kentucky statesman and three-time presidential candidate Henry Clay. She copied her heroic depiction from an engraving published in *Harper's Magazine* of April 28, 1860, which in turn reproduced Joel Tanner Hart's statue of Clay, erected in New Orleans in 1859. SE

Virginia Mason Ivey
American, born 1828
Quilt, about 1860
Cotton, wool
102¹/₄ × 85¹/₂ in.
(259.7 × 217.2 cm)

Purchased for the museum through the efforts of the Kentucky Quilt Project, Shelly Zegart, Eleanor Bingham Miller, and Jonathan Holstein, and through the generosity of the Bingham Enterprises Foundation of Kentucky, Incorporated, and several anonymous donors 1986.12

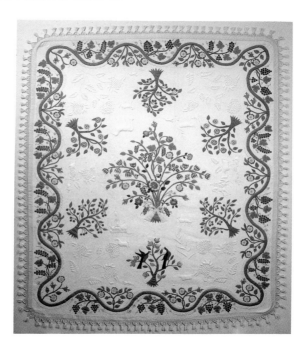

◄

In the midst of the Civil War, Mize, her husband, and her children crossed the border from Claiborne County, Tennessee, into southeastern Kentucky's Clay County. Eventually this free multiracial family, along with other African–American and multiracial families, formed a small community in or near Manchester, the county seat. This quilt, a stunning example of the "Princess Feather" pattern, may have been among the possessions brought to Kentucky by the Mize family: evidence from census records and the family's own oral history suggest that it was probably made by a young Mary Mize. If so, this traveling heirloom reflects the complex patterns of trade, travel, and taste that shaped the material lives of many Kentuckians. SE

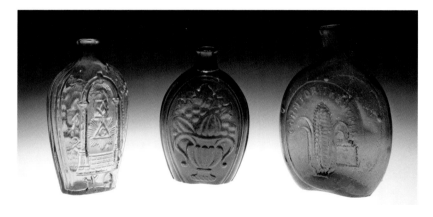

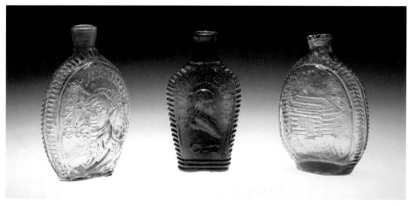

Top, from left to right:
Keene (Marlboro Street) Glassworks, Keene, New Hampshire;
Possibly the **Coventry Glassworks**, Coventry, Connecticut;
Baltimore Glassworks, Baltimore, Maryland
Flasks, about 1815–50
Glass
From left to right:
7¹/₂ × 4³/₈ × 2¹/₂ in.
(19.1 × 11.1 × 6.4 cm);
7 × 4³/₈ × 2⁵/₈ in.
(17.8 × 11.1 × 6.7 cm);
8³/₈ × 5⁷/₈ × 2³/₄ in.
(21.3 × 14.9 × 7 cm)

The Robinson S. Brown, Jr., Collection of Historical Flasks 2004.22.269, .251, and .325

Bottom, from left to right:
Anonymous American glassworks;
Coventry Glassworks, Coventry, Connecticut;
Anonymous American glassworks
Flasks, about 1825–40
Glass
From left to right:
6³/₄ × 4¹/₄ × 2³/₈ in.
(17.1 × 10.8 × 6 cm);
6³/₈ × 3¹/₄ × 2 in.
(16.2 × 8.3 × 5.1 cm);
6¹/₄ × 4¹/₄ × 2³/₈ in.
(15.9 × 10.8 × 6 cm)

The Robinson S. Brown, Jr., Collection of Historical Flasks 2004.22.1, .86, and .428

◀ **B**etween about 1815 and the early 1900s, glasshouses in New England, Ohio, Pittsburgh, Louisville, and elsewhere produced glass liquor flasks in vast numbers. Filled and refilled by saloon keepers, druggists, and others, the flasks served the country's prodigious thirst for distilled spirits. These three flasks, associated with glasshouses ranging from New Hampshire to Baltimore, incorporate motifs drawn from early nineteenth-century popular culture. The flask on the left, for example, depicts symbols associated with the Masons, a fraternal organization. The other two flasks, one decorated with an overflowing vase of flowers and the other with an ear of corn beneath the words "Corn for the World," suggest optimistic hopes for America's prosperity. SE

◀ **A**long with such familiar heroes as George Washington, less well-known figures also found their way into the designs of American liquor flasks. The flask in the center, for example, portrays De Witt Clinton, governor of New York from 1817 to 1821 and 1825 to 1828. During his time in office, Clinton became a popular hero for pushing through the development and construction of the Erie Canal. Other flasks incorporated political themes. The flask on the right pairs an image of a log cabin with the motto "Hard Cider," both references to the "common folk" image presented by William H. Harrison, a candidate in the presidential election of 1840. SE

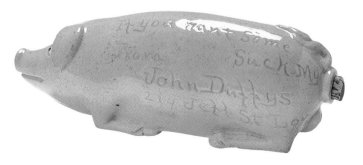

Pottery of **Henry Thomas**
(American, born about 1840),
Louisville, Kentucky
Flask, about 1874–79
Earthenware
$3^1/_4 \times 8^1/_8 \times 2^7/_8$ in.
(8.3 × 20.6 × 7.3 cm)
Gift of the Decorative Arts Collectors and
Clifton Anderson 2005.21.1

Thomas, an Ohio-born potter active in Louisville by the early 1860s, conveniently signed this amusing flask. Reflecting its intended use, it also bears the words "From John Duffys," a reference to a saloon keeper whose establishment was located at 214 Jefferson Street, near the city's courthouse. Thomas's smirking pig plays on the animal's traditional association with gluttony and laziness; liquor consumption, after all, was a frequently cited source of moral failing. This flask's inscription, running along one side and ending at the pig's posterior, reinforces the coarse and crude nature of its function: it reads, "If you want some suck my"—with the final word left to the reader's imagination. SE

▶ **K**nown from Boston to New Orleans, Louisville resident Sallie Ward was among the most famous southern belles of the nineteenth century. The daughter of a wealthy Kentucky businessman and politician, Sallie was vivacious, impetuous, and fun-loving, the envy of young women and the fancy of young men. Although staid members of society often perceived her actions as scandalous—she married four times, "painted" her face, and wore bloomers at formal events—her countless admirers quickly forgave her trespasses. Even portraitist G.P.A. Healy, whose prestigious sitters included presidents, royalty, and wealthy grand dames, purportedly described her as the most beautiful woman he had ever painted. In Healy's perceptive portrait of the thirty-three-year-old Sallie, her richly textured lace-and-moiré gown reveals her love of fashion, while her sparkling eyes, coquettish smile, and deceptively demure tilt of the head hint at her boundless spirit. KS

▼
Around 1850, Kentuckian John P. Dobyns received this set of silver, as the inscription on the pitcher notes, from "the farmers of Mason County." Dobyns, a merchant and all-round entrepreneur, was involved in the establishment of a turnpike and a railroad. This set may have been presented at the completion of one of his transportation ventures. While marked by the Kinsey brothers of Cincinnati, the richly decorated pitcher is virtually identical to one retailed during the period by New York City's Tiffany & Co. or one of its preceding partnerships; perhaps the Kinseys acquired a pitcher of the same design from a New York City silversmith who also sold to Tiffany's. The Kinseys may have made the set's unmarked goblets, but firms in New York City and elsewhere also produced very similar work. SE

Associated with the workshop of
Edward Kinsey (American,
1810–1865)
and
David Kinsey (American,
1819–1874), Cincinnati, Ohio
Pitcher and goblets,
about 1850
Silver
Pitcher: 11⁹/₁₆ × 8⁷/₁₆ × 5 in.
(29.4 × 21.4 × 12.7 cm)
Goblets, each: 5⁷/₈ × 3³/₈ in.
(14.9 × 8.6 cm)
Bequest of Alice Speed Stoll, by exchange
2004.10 and 2004.15 a,b

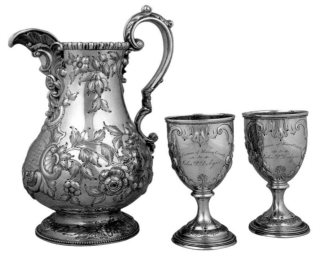

George Peter Alexander Healy
American, 1813–1894
Portrait of Sallie Ward, 1860
Oil on canvas
53¹⁵/₁₆ × 40¹/₄ in.
(137 × 102.2 cm)
*Gift of Mrs. John W. Hunt and
Mrs. Ruth Hunt Hillson 1939.96*

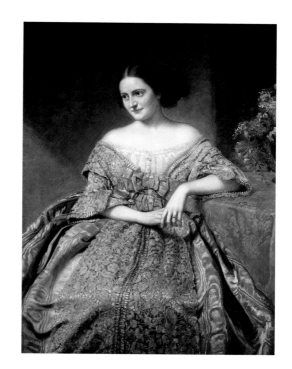

Charles Bullett
French, 1820 or 1826–1873
*Portrait of Charles and
Matilda Bullett*, 1866
Marble
Diameter: 20¹/₄ in. (51.4 cm)
Gift of Miss Hannah L. Muldoon 1950.18.3

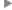

After studying at the École des Beaux-Arts,
French native Charles Bullett immigrated to
America in 1849. He worked for a period
in Cincinnati and eventually settled in
Louisville, where he became a partner in
a local marbleworks business. In 1863
Bullett returned to Europe to oversee
the company's new production studio
in Carrara, Italy, a town famous for its
quarries of fine white marble. In addition
to memorial statuary, Bullett also created
elegant, high-relief portrait medallions, such as
this self-portrait with his wife, Matilda. Inspired by
ancient Roman coins, profile portraits experienced a
revival in America at mid-century, and were produced in great
numbers in marble, wax, and cameo gemstones, although two-figure
portrait reliefs were rare. Bullett may have borrowed the motif of the oversize
acanthus leaves that conceal the truncated shoulders from Hiram Powers,
another Cincinnati artist working in Italy. KS

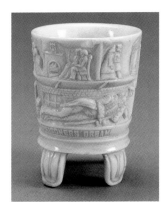

Albert P. Henry
American, 1836–1872
Prisoner's Dream, 1863
Bone
$2^7/_8$ × 2 in. (7.3 × 5.1 cm)
Gift of Captain Al. G. Waddell 1940.39

Albert P. Henry
American, 1836–1872
Abraham Lincoln, 1864
Marble
$25^1/_2$ × $23^1/_4$ × $16^1/_2$ in.
(64.8 × 59.1 × 41.9 cm)

*Deposited at the J.B. Speed Art Museum
by the Citizens of Louisville, Courtesy of
U.S. Judge Shackelford Miller and
Mr. Neville S. Bullitt PL1943.1*

◄ **T**hree sculptures shown here record the brief though promising career of a little-known Kentucky sculptor. Henry, an ironworker in Princeton, Kentucky, joined the Fifteenth Kentucky Cavalry and was captured by Confederate forces in 1863. During his nine-month internment in Libby Prison in Richmond, Virginia, he occupied himself by carving soup bones into small sculptures, chief among them *Prisoner's Dream*, which shows a sleeping prisoner dreaming of his return home. Upon his release, Henry determined to make sculpture his career and convinced President Lincoln to sit for a portrait bust. Lincoln subsequently appointed him consul at Ancona, Italy, allowing Henry the opportunity to train with fellow Kentucky sculptor Joel Tanner Hart and with Hiram Powers. Henry's marble bust of Lincoln, completed in Italy, was purchased for the city of Louisville. At its unveiling in 1867, James Speed, Lincoln's former attorney general, eulogized the slain president and praised the portrait's likeness. RC

▶

Henry's ideal bust *Genevieve*, completed shortly before his death at the age of thirty-six, demonstrates the rapid development of his sculptural sophistication during his brief career. The subject is most likely the heroine of Samuel Taylor Coleridge's popular Romantic poem "Love" (1799), in which the minstrel narrator sings of a knight wooing a lady, as he watches the reaction to his song of his own beloved Genevieve, who listens "with a flitting blush, with downcast eyes and modest grace." Henry's bust of Genevieve, a much-admired sculpture in Louisville, was among the works of art borrowed from a local private collection to decorate the rooms occupied by former president Ulysses S. Grant in the elegant Louisville Hotel during his visit in 1879. RC

▶ **C**onsidered Kentucky's most famous sculptor, Hart apprenticed as a stonecutter and apparently began carving his first busts in a Lexington stoneyard during the 1830s. After exhibiting in Philadelphia, he traveled to Florence in 1849 and there joined other American Neoclassical sculptors. During the 1850s Hart invented a pointing instrument that used about two hundred needlelike rods to obtain a large number of measurements simultaneously, enabling him to copy more precisely the form of a person's head or an existing sculpture. In 1860 Kentucky statesman John J. Crittenden obtained permission for Hart to produce a direct copy of the *Venus de' Medici* in Florence's Uffizi Palace. The Civil War intervened, however, and his permit was revoked. In 1872 Hart acquired a plaster reproduction of the sculpture, from which he created this marble. His *Venus de' Medici* was displayed at the Louisville Industrial Exposition from 1874 to 1880. ML

The measuring instrument invented by Joel Tanner Hart is now in the collection of the Louisville Science Center.

Joel Tanner Hart
American, 1810–1877
Venus de' Medici, 1873
Marble
61⁷/₈ × 18³/₈ × 20¹/₄ in.
(157.2 × 46.7 × 51.4 cm)
Gift of the Louisville Free Public Library
1996.9.1

Albert P. Henry
American, 1836–1872
Genevieve, about 1870
Marble
24⁷/₈ × 18¹/₈ × 9⁵/₁₆ in.
(63.2 × 46 × 23.7 cm)
Gift of the Meldrum family 1930.54

▼ Stevens's work dwells often upon the privileged woman in the privacy of her own surroundings. Stevens was born and educated in Belgium but in 1852 moved permanently to Paris, where he established friendships with such artists as Edouard Manet, Berthe Morisot, and Edgar Degas. As he demonstrates here, he possessed an enviable skill for painting fashionable women's clothing. He was also quick to embrace the craze for Japanese art and design, following the opening of that nation's ports to trade with the West in 1854, and he often included exotic elements, such as this folding screen, in his

paintings. Merging portraiture and genre painting, Stevens typically represented his anonymous women in moments of private contemplation, creating a sense of psychological depth behind his luxurious surfaces. ML

Alfred Emile Léopold Stevens
Belgian, 1823–1906
Young Woman with a Japanese Screen, about 1880
Oil on canvas
23³/₄ × 20³/₈ in.
(60.3 × 51.8 cm)
Gift of the Charter Collectors and Mr. and Mrs. Jouett Ross Todd, by exchange 1989.11.2

▶ Like Alfred Stevens, Tissot achieved success in Paris during the 1860s with genre paintings depicting fashionable contemporary life. His alleged involvement in the Paris Commune in 1871 forced him to leave France that year. He took refuge in London and turned to English subjects to satisfy the tastes of his new audience. This painting, set in Gravesend on the River Thames, shows a couple and young girl in front of the Old Falcon Hotel, waiting to return by ferry to Tilbury rail station. The woman's distinctive striped dress displays Tissot's flair for depicting elegant modern clothing. Although he likely intended these quaint buildings along the Thames to epitomize picturesque old England for his viewers, his emotionally disconnected figures typify the detached objectivity of his French artistic contemporaries. ML

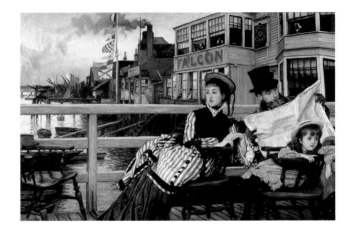

James Tissot
French, 1836–1902
Waiting for the Ferry at the Falcon Tavern, about 1874
Oil on canvas
26¹/₄ × 38³/₁₆ in.
(66.7 × 97 cm)
Gift of Mrs. Blakemore Wheeler 1963.41

► **W**hen lit, this luxurious confection of gold, silver, and cut and mirrored glass surely glittered like a huge, elaborately mounted diamond. Its fantastical imagery includes a trio of winged horses that fly upward from the base, away from snarling lions' heads and toward the lamplight above. Their escape from danger (and darkness) refers to the lamp's function: piercing the gloom with its light. Recently discovered marks on the lamp show that its design was registered with the British Board of Trade in 1883. The original drawing submitted at that time survives; it indicates that the present glass chimney and globe likely replaced a conical, cut and engraved glass shade. SE

Design registered by **Young's Paraffin Light and Mineral Oil Company** for its Clissold Lamp Works, Birmingham, England
Lamp, designed 1883
Gilded copper alloy (*ormolu*), silver-plated metal, brass, glass
36¼ × 13½ × 13½ in.
(92.1 × 34.3 × 34.3 cm)
Gift of the Decorative Arts Collectors
2001.13 a–l

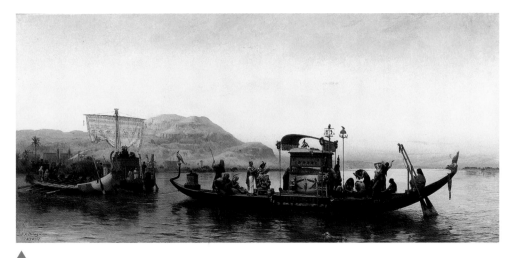

▲

Alabama-born Bridgman left for Paris in 1867 to train with the influential Jean-Léon Gérôme, from whom he adopted rigorous academic Realism applied to Orientalist subject matter. To see such subjects at first hand, Bridgman traveled through North Africa and Egypt in 1873. When he exhibited this painting in Paris in 1877 and 1878, it created a sensation, earning the artist two medals and the Legion of Honor at the precocious age of thirty-one. Critics raved that he had outstripped Gérôme in the painting's landscape and lighting, and they repeatedly praised his archaeologically accurate depiction of the funeral barge crossing the Nile toward a burial in the Valley of the Kings. In 1878 Bridgman capped this critical triumph by selling the painting for the then extraordinary sum of $5000, to James Gordon Bennett, American publisher of the Paris *Herald*. RC

Frederick Arthur Bridgman
American, 1847–1928
The Funeral of a Mummy,
1876–77
Oil on canvas
45 × 91³/₈ in.
(114.3 × 232.1 cm)
Gift of Mr. Wendell Cherry 1990.8

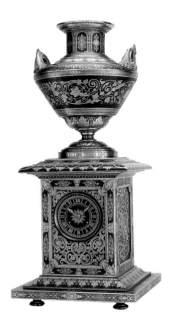

Workshop of **Plácido Zuloaga**
(Spanish, 1834–1910), Eibar,
Spain
Table clock, 1882
Iron, gold, silver
26¹/₂ × 11⁷/₁₆ × 11⁷/₁₆ in.
(67.3 × 29.1 × 29.1 cm)

Purchased with funds from the Alice Speed Stoll Accessions Trust and gift of Mrs. Blakemore Wheeler, by exchange 2005.11

In addition to his highly sought-after society portraits, Sargent created numerous drawings, watercolors, and oil sketches of exotic subjects during his travels abroad. In 1890 he embarked on a tour of Egypt, Greece, and Turkey to study at first hand the history, legends, and monuments of ancient cultures, which would inform his planned mural cycle for the new Boston Public Library. In Constantinople (now Istanbul, Turkey) he purportedly bribed an official to gain access to Santa Sophia, the great church built by the Byzantine emperor Justinian in AD 537 and subsequently converted to a mosque. With confident brushwork and a golden palette, Sargent captures in this sketch the grandeur and mystery of the building's expansive, light-filled interior. KS

John Singer Sargent
American, 1856–1925
Interior of Santa Sophia, Constantinople, 1891
Oil on canvas
32 × 24⅝ in.
(81.3 × 62.5 cm)
Purchase, Museum Art Fund 1960.5

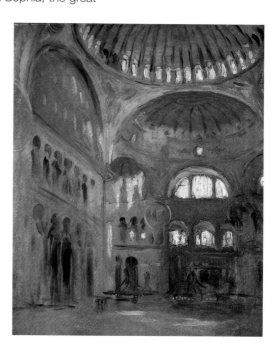

Beginning in the sixteenth century, damascening—the application of gold and silver to an iron ground—was often used to decorate weapons or small objects, such as boxes. By the late nineteenth century, Plácido Zuloaga, a member of a family of damasceners, was producing such pieces as this table clock: intricately damascened decorative objects of great size and extraordinary quality. To produce this and his other creations, Zuloaga orchestrated the work of various artisans, including iron forgers, damasceners, and engravers. The clock's densely applied ornament borrows freely from various sources, primarily sixteenth-century Renaissance prototypes. Together, its historical references, massive scale, and lavish handwork would have appealed to wealthy late nineteenth-century consumers; in an era of industrial expansion, a conspicuously crafted object in a historical style was the ultimate luxury good. SE

▼ **R**aspberries is one of the finest examples of the informal still-life compositions for which Brown is best known. He paints the fruit in a natural setting, not arranged conventionally on a tabletop, and fashions every gleaming red berry, green leaf, and blade of grass with meticulous finish and detail. This suggests that Brown was influenced by the theories of English aesthetician John Ruskin, prevalent from the mid-1840s on, urging painters to abandon the artificiality of the tabletop still-life arrangement and remain faithful to nature. Yet, though in a natural setting, the raspberries have not fallen haphazardly but have been gathered by some unseen hand. This recalls Ruskin's praise for painting subjects that, with their "artless origin in the village lane—have evidently been gathered only at the choice, and thrown down at the caprice, of the farmer's children." RC

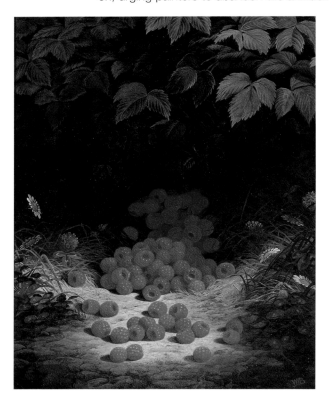

William Mason Brown
American, 1828–1898
Raspberries, about 1870
Oil on canvas
20¹/₈ × 16³/₁₆ in.
(51.1 × 41.1 cm)
Gift of Mrs. Hattie Bishop Speed 1927.29

▶
During the 1870s Homer painted several depictions of rural schools and schoolteachers. While the little red schoolhouse was gradually disappearing from the American landscape, the female schoolteacher was altogether new. During the Civil War many male teachers left their schools, never to return. Increasingly derided as brutal disciplinarians anyway, they were often replaced by young female teachers, who were respected for their superior training and professionalism. This change reflected a profound shift in America toward a view of childhood education as a process of natural development best stimulated by kindness, not the whip. In this watercolor the young teacher, recognizable by her book and prim dress, walks along a village lane, as children ascend the hill behind her. Such works by Homer found favor with the public and critics alike, who were eager for uniquely American subjects in art. RC

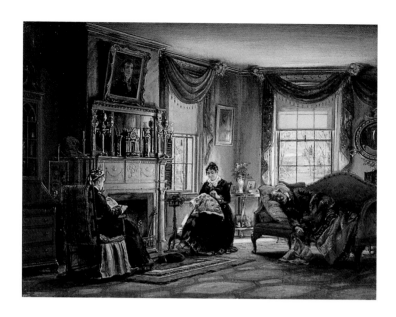

Edward Lamson Henry
American, 1841–1919
The Sitting Room, 1883
Oil on canvas
10¹/₈ × 13¹/₈ in.
(25.7 × 33.3 cm)
Gift of the Charter Collectors 1982.30

▲ **E.**L. Henry's jewel-like paintings often depicted an earlier America that, during the tumultuous decades following the Civil War, appealed to an audience fascinated by American history and soothed by the artist's nostalgic vision of the past. *The Sitting Room* may depict Henry's wife, Frances, the younger of the two women, in her family's colonial-period home in Johnstown, New York. On an autumn afternoon the women sit before a cozy fire, while an elderly man, an old soldier perhaps, dozes on the sofa. With its Adam mantelpiece, antiques, and ancestral portrait, the room evokes a bygone era while offering a comforting sense of continuity. RC

Winslow Homer
American, 1836–1910
The School Mistress,
about 1873
Watercolor on paper
9⁵/₈ × 7³/₄ in.
(24.4 × 19.7 cm)

*Gift of Mr. Henry Strater, in memory of
Adeline Helene Strater 1931.4*

Gustave Moreau
French, 1826–1898
Descent from the Cross,
about 1870
Oil on panel
5⁷/₈ × 5¹/₈ in.
(15 × 13 cm)
Bequest of Mrs. Baylor O. Hickman
1979.12

◀ **M**oreau became best known for enigmatic paintings featuring symbolic imagery drawn from ancient mythology and his own imagination. His religious paintings, however, stand apart from this other work in their embrace of traditional Christian iconography. During the years around 1870 Moreau produced at least five paintings depicting the lifeless body of Christ being tenderly removed from the cross following the Crucifixion. Despite this panel's small size, Moreau conveys the powerful grief of this moment through the use of expressive color and a dramatic, flowing composition. His careful execution of the painting's miniaturized details was perhaps an act of spiritual devotion, and the resulting jewel-like image suggests a deep spirituality. ML

Gustave Courbet
French, 1819–1877
La Dent de Jaman,
about 1874
Oil on canvas
19³/₄ × 24¹/₈ in.
(50.2 × 61.3 cm)
Bequest of Mrs. Blakemore Wheeler
1964.31.5

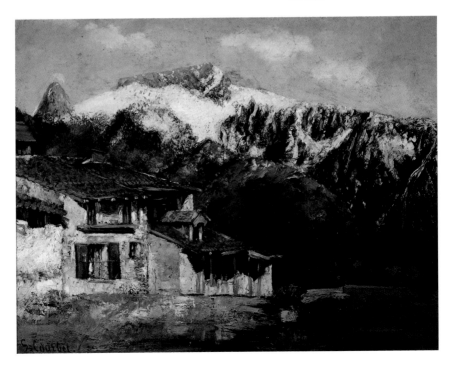

▶ In 1885 the city of Calais, France, commissioned Rodin to create a memorial honoring six local heroes who volunteered to sacrifice themselves in order to end a siege of their town during the Hundred Years' War (1337–1453). The monumental *Burghers of Calais* depicts the six men bound by ropes and stripped down to their shirts as they are led out of the city to the enemy camp, where they would later be spared by the sympathetic English queen. Through the use of coarse forms and exaggerated gestures, Rodin poignantly conveys the psychological turmoil and intense emotions of the six would-be martyrs as they confront death. Following the unveiling of the monument in 1895, Rodin issued small bronze sculptures of the individual burghers, including this figure of Pierre de Wissant. KS

◀ **C**ourbet, a controversial artist hostile to state patronage and the academic system, was a vocal proponent of Realism in painting, and cultivated strong relationships with the political Left. His humble subjects were commonly interpreted by conservative critics as political statements. Courbet often used broad and irregular brushstrokes and applied paint with a palette knife, resulting in heavily built-up surfaces. His handling of paint, much admired by Vincent van Gogh, Paul Cézanne, and Camille Pissarro, constituted a contentious alternative to the polished academic technique. This view of the Alps includes the pointed peak of La Dent de Jaman, and was painted during the artist's exile in Switzerland, following his imprisonment for the demolition of the Vendôme Column during the uprising known as the Paris Commune of 1871. Courbet was ordered to pay the costs of re-erecting the column, and in exile produced many paintings with an eye to the market, in the hope of raising this money and returning to France. LB

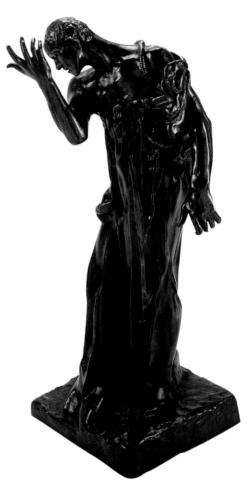

Auguste Rodin
French, 1840–1917
A Burgher of Calais (Pierre de Wissant), designed 1884–85, cast about 1899–1905/06
Bronze
17³/₄ × 8¹/₈ × 9 in.
(45.1 × 20.6 × 22.9 cm)
Museum purchase with additional contributions 1968.19

Edgar Degas
French, 1834–1917
Study for *Miss Lala at the Cirque Fernando*, 1879
Pastel on laid paper
19¹⁄₈ × 12¹⁄₂ in.
(48.6 × 31.8 cm)
Bequest of Mrs. Blakemore Wheeler 1964.31.10

◀ In the 1870s there was a surge of interest among avant-garde artists in depicting popular culture, and Degas in particular produced many images of Parisian entertainments. This drawing is a preparatory study for his painting of the celebrated circus performer Miss Lala, a European woman of African descent known as "the Black Venus," who astonished Paris with her spectacular act at the Cirque Fernando. Degas depicts her suspended from an "iron jaw," a thick strap with a leather mouthpiece at one end. Hanging from it by only her teeth, Lala hoisted herself up to the three-story-high ceiling of the Cirque Fernando by pulling a rope threaded though a pulley. The drawing evidences Degas's interests, also seen in his many paintings of dancers, in the positioning of the female body, the technical aspects of its performance, and its feats of strength. LB

William-Adolphe Bouguereau
French, 1825–1905
Going to the Well (Allant à la fontaine), 1893
Oil on canvas
35¹⁄₄ × 21¹⁄₄ in.
(89.5 × 54 cm)
Gift of Mrs. Hattie Bishop Speed 1927.33

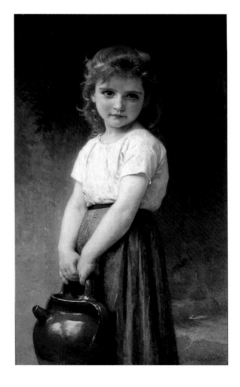

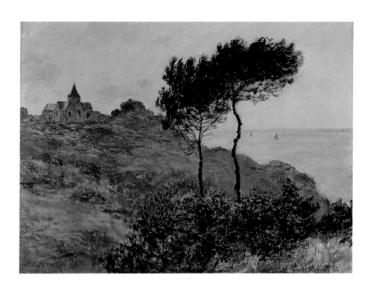

Claude Monet
French, 1840–1926
The Church at Varengeville,
Grey Weather, 1882
Oil on canvas
25⅝ × 32 in.
(65.1 × 81.3 cm)
Bequest of Mrs. Blakemore Wheeler
1964.31.20

▲ **T**hroughout his life Monet turned repeatedly to the sea for emotional renewal, artistic inspiration, and a host of subjects guaranteed to appeal to Parisian collectors. He made frequent trips to the Normandy coast during the 1880s, painting rocky shorelines and breathtaking vistas in the popular tourist towns of Dieppe, Étretat, and Pourville. In nearby Varengeville, Monet spotted this mariners' church perched atop a steep cliff overlooking the English Channel. Positioning his easel on a hillside opposite the church, he painted three versions of this scene at various times of day and under different atmospheric conditions, a practice that anticipates his haystacks and Rouen Cathedral series of the 1890s. Here the twin trees, curving coastline, and church spire form a striking silhouette that is offset by the frenzied brushwork defining the foreground foliage. KS

◀

One of the most popular artists of his time, Bouguereau received many official honors throughout his career, and remained devoted to the technical precision and high finish fostered by the French Academy. Although avant-garde artists and critics disapproved of his conservative approach, many collectors were drawn to his idealized, sentimental images. Unlike the sometimes harsh view of rural toil offered by such Realist artists as Jean-François Millet, Bouguereau's images of picturesque peasant children appealed to urban viewers eager to indulge in an ideal of rustic simplicity. This young girl, who appears throughout Bouguereau's late work as the epitome of childhood innocence, probably posed in his studio in La Rochelle, his native town, during the summer of 1893. Bouguereau depicts her pausing on her way to the well, her simple clothing giving her a timeless presence. ML

▶ During the 1870s, Whistler created a series of nighttime views of the River Thames, inspired in part by Japanese woodcuts depicting harbors and moonlit scenes. He emphasized the abstract nature of his images by calling them *Nocturnes*, a term for musical compositions that evoke a dreamy or contemplative mood. Rowing along the river at night, Whistler would memorize the color, tone, and arrangement of forms he observed. Later he translated his impressions on to canvas, paper, or lithographic stone in the studio. For this print, one of his earliest lithographs, Whistler used diluted washes of tusche to produce subtle tonal effects. The result is a delicate, nearly abstract harmony of forms dissolving in a hazy mist. KS

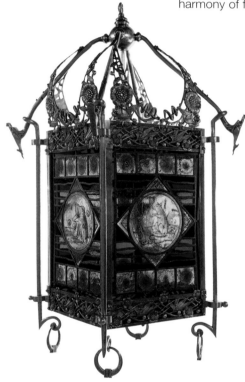

◀ In 1854 Commodore Matthew Perry opened Japan to trade with the United States, helping inspire a widespread fascination with Japanese art and design. Designers and manufacturers eagerly responded by incorporating Japanese motifs—often adulterated or even imagined—into all sorts of household goods. The new aesthetic permeates this sparkling lantern, from its simplified flowers and foliage to the delicate, playful creatures that occupy its glass panels. The painted figures emulate the work of the Japanese artist Katsushika Hokusai. His drawings of animals, plants, and people were widely copied and adapted in the West during the later nineteenth century. While the artist responsible for the lantern's painted figures remains anonymous, the metalwork resembles designs produced by I.P. Frink, a lighting-fixture manufacturer. SE

Attributed to the firm of **I.P. Frink**, New York City
Lantern, about 1883
Bronze, brass, stained and painted glass
30 × 15³⁄₈ × 15¹⁄₈ in.
(76.2 × 39.1 × 38.4 cm)

Purchased with funds from the Decorative Arts Collectors and the Alice Speed Stoll Accessions Trust 2004.17

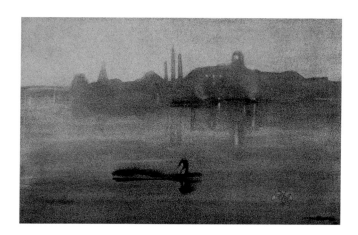

James Abbott McNeill Whistler
American, 1834–1903
Nocturne, 1878
Lithotint on blue-gray paper laid
down on white wove paper
10$^{11}/_{16}$ × 14$^{3}/_{16}$ in.
(27.2 × 36 cm)

*Gift and partial purchase from the
Steven L. Block Collection
made possible in part by
Mrs. W.L. Lyons Brown 2004.7.38*

James Abbott McNeill Whistler
American, 1834–1903
Draped Figure, Reclining, 1892
Color transfer lithograph in gray,
green, pink, yellow, blue, and
purple on thin laid Japan paper
8$^{5}/_{16}$ × 12$^{3}/_{16}$ in.
(21.2 × 31 cm)

*Gift and partial purchase from the
Steven L. Block Collection
made possible in part by
Mrs. W.L. Lyons Brown 2004.7.9*

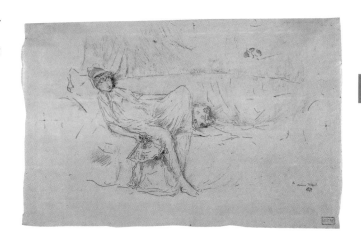

▲

An American artist who spent almost his entire career abroad, Whistler
was instrumental in repositioning lithography as an artistic, not just
commercial, medium in England. He considered lithography an extension
of drawing, and during the 1890s he produced a small number of color
lithographs that duplicated the subtlety of his pastels. With great economy
of line, *Draped Figure, Reclining* depicts a languid studio model enveloped
in the myriad folds of a diaphanous gown. Whistler may have found
inspiration in the draped terra-cotta figures from Tanagra being collected
in England at that time. Working beside his Parisian printer Henry Belfond
(to whom this sheet is dedicated), Whistler mixed the inks himself. He
continually refined the hues, and as a result each impression is unique.
Whistler originally planned to issue his color lithographs as a series entitled
Songs on Stone, recalling the musical analogies of his earlier *Nocturnes*
and *Arrangements*, but the series never came to fruition. KS

Designed by
William Arthur Smith Benson
English, 1854–1924
Fire screen, about 1895
Copper, brass, iron
34³/₄ × 32³/₁₆ × 2³/₈ in.
(88.3 × 81.8 × 6 cm)

Gift of the Tarrant Foundation,
Adele and Leonard Leight,
Christopher Nalley,
V. Benson Small, Jr.,
the Jeffry J. Christofferson Family,
Patrick Stallard, and
Carla Sue and Brad Broecker
1999.11

▲

William Morris, one of the key figures in England's late nineteenth- and
early twentieth-century Arts and Crafts movement, referred to his friend
W.A.S. Benson as "Mr. Brass Benson." The name suited Benson, a designer
who used polished brass and copper to create light fixtures, water kettles,
and a host of other domestic objects. This fire screen ranks among his more
ambitious efforts. Expanses of brilliantly polished copper became petal-like
leaves intended to scatter light about the room. Such designs catered to
well-to-do consumers who favored the relative simplicity of Arts and Crafts
designs over the dense ornamental flourishes of Victorian eclecticism. SE

▶

As its name implies, the late nineteenth-century design movement known
as Art Nouveau sought alternatives to the prevailing taste for historical
revivals. And yet, in spite of its name, the movement often straddled the old
and the new. Eckmann's sumptuous vase illustrates the dichotomy. True to
Art Nouveau principles, Eckmann found inspiration in nature rather than in
past styles; tendril-like arms, rising up from richly patinated bronze leaves,
embrace this simple, Chinese-inspired vase. His confection, however,
ultimately derives from the eighteenth-century taste for Asian porcelains
fitted with gilded metal mounts. The vase's realistically rendered leaves and
tendrils even recall French-made mounts of the mid-eighteenth century. SE

Enid Yandell
American, 1869–1934
Mermaid and Fisherboy,
about 1897
Painted plaster
10³/₄ × 7 × 5¹/₄ in.
(27.3 × 17.8 × 13.3 cm)
Gift of Mrs. J.J. Trask 1941.14.7

Designed by
Otto Eckmann
German, 1865–1902
Vase, 1897–1900
Porcelain probably made by the
Royal Porcelain Manufactory
(KPM), Berlin
Mounts made in the workshop
of Otto Schulz (German,
1848–1911), Berlin
Soft-paste porcelain, bronze
20¹/₄ × 10³/₄ × 6 in.
(51.4 × 27.3 × 15.2 cm)
*Purchased with funds from the
Alice Speed Stoll Accessions Trust 2000.3*

▲

Having forged a career in sculpture at a time when few
women entered the field, Louisville native Enid Yandell
became the first female member of the National Sculpture
Society in 1898. This design for a tankard stands out
as one of her most inventive pieces, retelling a German
Rhineland legend in which a young fisherboy falls in love
with a mermaid and follows her into the sea, never to be
seen again. Here the fisher, kneeling on a rock, forms the
tankard's lid, while the mermaid's sensuous, arching body
becomes its handle. The lips of the two figures meet
in a kiss when the lid is raised. Initially cast in bronze
as a wedding gift for Yandell's sister, the tankard was
subsequently marketed in silver by Tiffany & Co. during
the Christmas season of 1899. ML

Madeline Yale Wynne
American, 1847–1918
Chest, 1899
Oak, iron, paint
25 × 39¹/₈ × 22 in.
(63.5 × 99.4 × 55.9 cm)

Gift of the Decorative Arts Collectors and Ralph Raby 2003.17.1

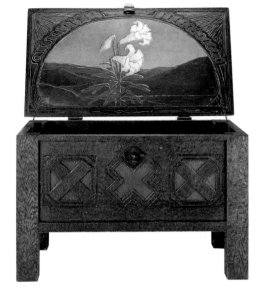

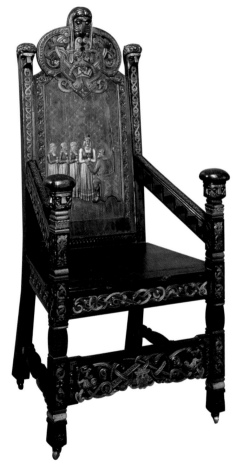

Designed by
Lars Kinsarvik
Norwegian, 1846–1925
Armchair, about 1900
Pine, paint
56¹/₂ × 25 × 23 in.
(143.5 × 63.5 × 58.4 cm)

Gift of Miss Letitia Alexander 1935.11.1

◄

Decorated with Viking maidens and a Norseman seated on his own colorful throne, Kinsarvik's romantic design conjures the powers of Norwegian history and mythology. Its intertwined, linear ornamentation played on Norway's fascination with Viking ships excavated during the late nineteenth century; similar motifs decorated the ships' hulls. By evoking the Viking past, Kinsarvik's furniture also rode a wave of Norwegian nationalism powered by the country's struggle for political independence from Sweden (finally achieved in 1905). The use of historical romance in the name of national identity was not unique to Norway. In other countries during the same period, historical references—frequently borrowed from vernacular and folk traditions—often found their way into progressive designs. SE

◀ **W**ynne, daughter of Linus Yale, Jr., inventor of the Yale lock, was one of the most prominent, multitalented, and ubiquitous women of the late nineteenth- and early twentieth-century American Arts and Crafts movement. True to the movement's tenets, she founded craft societies in Massachusetts and Chicago, excelled as a metalsmith and jewelry maker, and, for a brief time, made furniture, including this chest. Her unique amalgam mixes linear, Celtic-inspired carving, X-shaped front panels borrowed from New England colonial chests, and religious imagery, most notably a carved depiction of the Virgin Mary on the top. The religious theme continues on the interior: an atmospheric painting on the underside of the top incorporates three white lilies, traditional symbols of the Virgin. SE

▶

This chair's story begins in 1894, with the design of San Francisco's Church of the New Jerusalem. The Swedenborgian church building was an iconoclastic, rustic affair featuring chairs rather than pews. The chairs, romantically conceived as latter-day representations of Spanish mission furniture, were stark and unornamented; their simplicity, combined with their rustic historical references (whether real or imagined), made them early expressions of the American Arts and Crafts movement. This chair, made to furnish one of Schweinfurth's later architectural commissions, followed the same design as the Swedenborgian originals. Examples of the design were also eventually sent to New York, where they were copied and widely marketed as "Mission" furniture. The name, as well as the design itself, helped inspire the work of better-known Arts and Crafts furniture makers, such as Gustav Stickley. SE

Probably designed by **Albert Cicero Schweinfurth** (American, 1864–1900) or possibly by **Bernard Maybeck** (American, 1862–1957)
Side chair, designed 1894
Made by Forbes Manufacturing Company, San Francisco, California
Wood (species of *Cordia*), dried grass
36³/₁₆ × 21¹/₈ × 19⁷/₈ in. (91.9 × 53.7 × 50.5 cm)
Purchased with funds from the Alice Speed Stoll Accessions Trust 2001.5.2

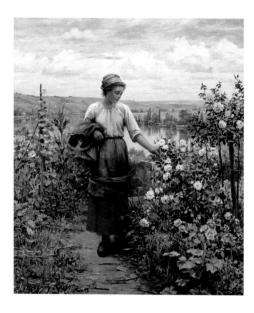

Daniel Ridgway Knight
American, 1839–1924
The Roses, about 1898
Oil on canvas
$32^{3}/_{16} \times 25^{11}/_{16}$ in.
(81.8 × 65.2 cm)

Gift of Mrs. Hattie Bishop Speed 1928.27

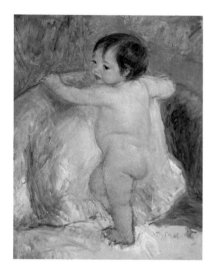

Mary Cassatt
American, 1844–1926
The Child, about 1905
Oil on canvas
$29^{7}/_{8} \times 21^{5}/_{8}$ in.
(75.9 × 54.9 cm)

Gift of Mrs. Blakemore Wheeler 1964.22

◀ **A** native of Allegheny City, Pennsylvania (now in Pittsburgh), Cassatt settled in 1874 in Paris, where she found it easier to conduct a professional career as a woman. There she became the only American artist to exhibit with the Impressionists. Like her friend and mentor Edgar Degas, Cassatt chose her subjects from modern life. During the 1880s, she began painting contemporary women and children engaged in everyday activities, a theme that would come to characterize her work. She painted this oil of a baby as a preliminary study for a competition to decorate the new statehouse in Harrisburg, Pennsylvania. Cassatt planned circular murals portraying mothers and children as overdoors for the women's lounge, but news of widespread corruption associated with the decorative campaign prompted her to abandon the project. KS

The Harrisburg capitol building, envisioned by architect Joseph M. Huston as a "palace of art," featured decorations by leading Pennsylvania-born artists. A native of Bellefonte, Pennsylvania, George Grey Barnard created his *Prodigal Son* in conjunction with the Harrisburg project (see page 162).

◀ **K**night, like his Pennsylvania Academy of the Fine Arts classmate Mary Cassatt, worked primarily in France. In 1874, following an excursion to the Barbizon region, he began painting the peasant subjects that would become the hallmark of his work. Knight rejected as pessimistic Jean-François Millet's vision of the often downtrodden, but noble, peasant, preferring instead to show "happy and contented" peasants at rest and at play in the French countryside. Nostalgic American audiences embraced Knight's idealized portrayal of rural life, which brought him enormous success. During the 1890s he purchased a house in Rolleboise, forty miles west of Paris. His paintings from this period, such as *The Roses*, often show pink-cheeked young peasant women in his garden overlooking the River Seine. KS

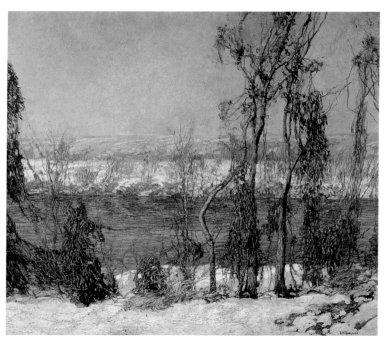

▶

Redfield was the leading member of the Pennsylvania Impressionists, a group of landscape painters working around New Hope, Pennsylvania, during the first decades of the twentieth century. His paintings earned top awards at every major art competition in the country and were embraced by critics and the public alike. Described by his close friend the artist Robert Henri as a "painter of creeks and snow," Redfield, a rugged outdoorsman, prided himself on painting *plein-air* scenes along the Delaware River in "one go," even during harsh weather. In *The Riverbank*, Redfield employs cool blue-grays to convey the crisp, icy air of winter. Rich, impastoed brushstrokes weave a network of barren vines, twigs, and tree branches through which the viewer observes the river beyond. KS

Edward Willis Redfield
American, 1869–1965
The Riverbank, Lambertville, New Jersey, about 1905–08
Oil on canvas
49⁷/₈ × 56³/₁₆ in.
(126.7 × 142.7 cm)
Anonymous gift 1984.13

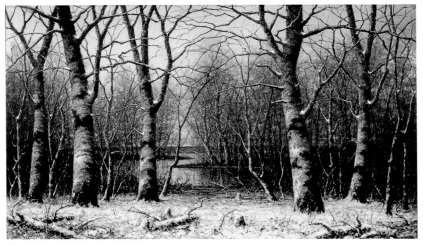

▲

The German-born Brenner emigrated from Bavaria in 1853 and eventually settled with his family in Louisville. Essentially self-taught, he began his career as a sign painter and glazier before taking up landscape painting in the 1870s. At the time of his death his obituary in *The Courier-Journal* hailed him as "Kentucky's greatest artist." Brenner specialized in the striking white-barked beech trees featured prominently in this snowy scene along the Ohio River at twilight. He painted directly from nature in all seasons, and devised a portable hut with windows to allow him to work outside even on cold winter days. ML

Carl C. Brenner
American, 1838–1888
Winter, 1885
Oil on canvas
30¹/₈ × 50⁵/₈ in.
(76.5 × 128.6 cm)
Bequest of Mrs. Elizabeth M. Gray 1958.24

▶

Revenaugh, born in Zanesville, Ohio, trained as a doctor and served in the Union Army during the Civil War. After the war he studied art with John Mix Stanley in Detroit from 1865 to 1866. He moved to Louisville in 1880 and became one of the city's few resident portrait artists during the late nineteenth century, as well as a noted violinmaker. Although portraiture was his primary focus, this painting of a newsboy peddling Louisville's *Courier-Journal* during a snowstorm has become Revenaugh's most famous work. Beginning in the 1830s with the development of the "penny press," newsboys became a regular fixture on the streets of most American cities, where they competed to sell papers to passersby. In art and literature the hardworking newsboy came to symbolize the American entrepreneurial spirit; however, for social reformers he was also an example of child exploitation. In this compassionate depiction Revenaugh honors the boy for his heroic work ethic yet empathizes with his difficult plight. ML

Patty Prather Thum
American, 1853–1926
The Lady of the Lilies,
about 1910
Oil on canvas
25¹/₂ × 36⁵/₈ in.
(64.8 × 93 cm)
Gift of Mrs. Hattie Bishop Speed 1928.34

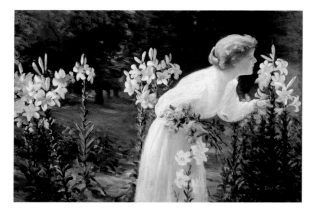

▶

Thum was one of Louisville's most admired artists during the late nineteenth and early twentieth centuries. She exhibited nationally and received an honorable mention at the Columbian Exposition in Chicago in 1893. Color lithographs of her floral still lifes were sold nationwide, furthering her reputation. She also wrote art criticism for *The Louisville Herald* newspaper and articles on flower-painting techniques for *The Art Amateur* magazine. Thum studied painting at Vassar College with Henry Van Ingen and at the Art Students League in New York with William Merritt Chase, who advocated the kind of fluid brushwork evident in *The Lady of the Lilies*. Thum based this painting on a photograph by Kate Matthews depicting the daughter of Annie Fellows Johnston, author of the *Little Colonel* novels, which explore the aristocracy of old Kentucky. KS

Aurelius O. Revenaugh
American, 1840–1908
Newsboy, about 1900
Oil on canvas
43³/₁₆ × 27³/₁₆ in.
(109.7 × 69.1 cm)
Gift of Mrs. Silas Starr 1939.22.7

George Grey Barnard
American, 1863–1938
Prodigal Son, 1904–06
Marble
$80^1/_4 \times 53^7/_8 \times 59$ in.
(203.8 × 136.8 × 149.9 cm)
Gift of Mr. and Mrs. Richard S. Reynolds
1939.19

▶

After studying and exhibiting in Paris, Barnard, a Pennsylvania native, returned in 1894 to New York, where he succeeded Augustus Saint-Gaudens in 1900 as sculpture instructor at the Art Students League. *Prodigal Son* relates to his large commission in 1902 to decorate the new Pennsylvania State Capitol building in Harrisburg. The artist conceived two large sculptural groupings flanking the main entrance; one of them, titled *The Unbroken Law*, incorporated this father-and-son subject. Sensing that the powerful subject could stand on its own, Barnard later made *Prodigal Son* as an independent sculpture to the same scale as the original Pennsylvania grouping. The son kneels in repentance as his father encircles him in a strong, forgiving embrace. These expressive figures, appearing in places to emerge from the rough-hewn stone itself, embody the dual influences of Michelangelo and Rodin on Barnard's art. This sculpture was featured prominently in the center of the first gallery of the famous New York Armory Show in 1913. ML

▶

Remington's lively depictions of cowboys, Indians, and Rough Riders present a nostalgic vision of the American West. Born in Canton, New York, Remington traveled throughout the western territories during the 1880s, only to realize that the frontier lifestyle was rapidly giving way to industrialization and settlement. "I knew the wild riders and vacant land were about to vanish forever," he once explained, "and the more I considered the subject, the bigger forever loomed." In his studio in New York, Remington immortalized in his paintings and sculpture the mythic characters that came to symbolize the rugged, untamed spirit of the West. In *The Mountain Man*, a buckskin-clad Iroquois trapper and his horse precariously descend a steep slope in an apt portrayal of the danger and isolation experienced by the Rocky Mountain fur traders during the 1830s and 1840s. The Speed's sculpture is cast number 13 and was likely produced during the artist's lifetime. KS

John George Brown
American, 1831–1913
The Blacksmith, about 1900
Oil on canvas
35¹/₂ × 40 in.
(90.2 × 101.6 cm)
Gift of Mrs. E. Gary Sutcliffe 1992.1

Brown became one of America's most popular painters through his depictions of plucky street urchins, newsboys, and bootblacks, reminiscent of Horatio Alger. Born in England, Brown immigrated to New York City in 1853 and rose from being a simple glasscutter to a highly successful painter, whose many patrons included the likes of William H. Vanderbilt and John Jacob Astor. After the 1880s Brown focused on scenes of the rural elderly, such as this white-bearded blacksmith, who works at his forge, surrounded by well-used hand tools. With his gift for characterization, Brown captures the artisan's dignity and pride in his work.

The Blacksmith once belonged to the founder of United States Steel, Judge Elbert H. Gary (1846–1927), whose rural Illinois roots may have given him a personal appreciation for this noble figure from America's pre-industrial past. RC

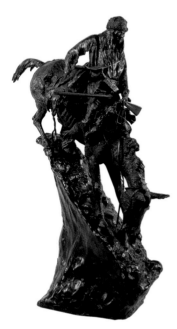

Frederic Remington
American, 1861–1909
The Mountain Man, designed
1903, cast about 1907–09
Bronze
28 × 12¹/₂ × 21 in.
(71.1 × 31.8 × 53.3 cm)
Gift of Mrs. Henry Fitzhugh, Jr. 1983.13

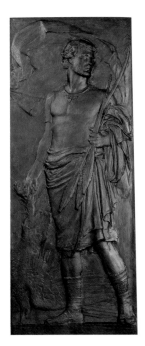

In 1861, at the age of thirteen, Saint-Gaudens began to master the subtleties of relief sculpture as an apprentice cameo cutter in New York. In 1881–82 he produced the Speed's plaster relief of *Actaeon* as the model for a finished relief (now lost) that craftsmen executed in exotic woods, stone, and bronze for the dining-room ceiling of the palatial house of Cornelius Vanderbilt II on Fifth Avenue. *Actaeon* was one of four mythological figures representing an aspect of food or drink in the dining-room. The Greek hunter is armed with a bow and arrows and carries a game bird.

Saint-Gaudens's most popular portrait relief was of Scottish-born author Robert Louis Stevenson. During visits to America in 1887 and 1888 for treatment of his tuberculosis, Stevenson, propped up in bed, writing and smoking his ever-present cigarette, posed for the sculptor. The verses on the relief are from a poem, reflecting on fleeting youth, from Stevenson's *Underwoods* collection. Although the first version of *Stevenson* was rectangular, Saint-Gaudens preferred this later circular format, which brings the viewer closer to the writer. RC

Augustus Saint-Gaudens
American, 1848–1907
Actaeon, 1881–82
Painted plaster relief
63¼ × 25³/₁₆ × 3⅝ in.
(160.5 × 64 × 9 cm)
Gift of C.S. Paolo 1930.53

Augustus Saint-Gaudens
American, 1848–1907
Robert Louis Stevenson, 1889
Bronze
Diameter: 11⅞ in. (30.2 cm)
Museum purchase 1967.30

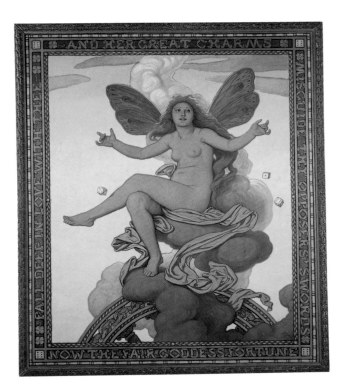

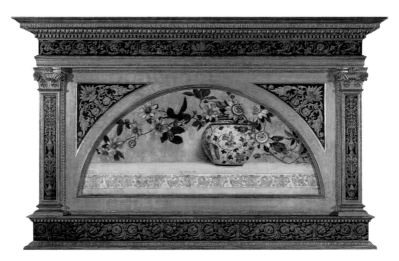

▶
Born in Buffalo, Coleman trained there with William H. Beard, and later with Thomas Couture in Paris. In 1886 he settled permanently on the island of Capri in his Villa Narcissus, which he filled with an eclectic collection of Roman, Renaissance, and Middle Eastern decorative objects that often, as here, appear in his paintings. Coleman became a leading figure in the local expatriate art colony, which included his friend Elihu Vedder. In *Passion Flowers*, Coleman's depiction of an antique maiolica vessel and flowering branches displayed in a niche demonstrates his keen interest in the decorative. The artist designed the elaborate, Renaissance-inspired frame to complement the painting, which, he instructed, was "to go over a mantel, shelf or piece of furniture." Hattie Bishop Speed purchased the painting directly from the artist about 1922. RC

Charles Caryl Coleman
American, 1840–1928
Passion Flowers, 1917
Oil on canvas
Canvas:
25¼ × 52¾ in.
(64.1 × 134 cm)
Frame:
50¼ × 77⅝ × 7½ in.
(127.6 × 197.2 × 19.1 cm)
Gift of Mrs. Hattie Bishop Speed 1942.351

Elihu Vedder
American, 1836–1923
Fortune, 1899
Oil on canvas
Canvas:
81⅞ × 68⅞ in.
(208 × 174.9 cm)
Frame:
85½ × 72⅝ × 2⅞ in.
(217.2 × 184.5 × 7.3 cm)
Gift of Mrs. Hattie Bishop Speed 1929.29.1

◀ **V**isionary painter, sculptor, illustrator, and poet Elihu Vedder developed a vocabulary of symbols drawn from traditional emblems and filtered through his imagination. Perhaps haunted by events in his own life, including the premature deaths of two of his children, Vedder was fascinated by the concept of fate. His paintings and drawings repeatedly depict the allegorical figure of Fortune, that fickle goddess of destiny and chance who randomly bestows her favors. Here Vedder shows a traditional winged Fortune scattering dice from her perch atop a wheel, an ancient emblem of instability and change. Interspersed with lucky four-leaf clovers around the perimeter are these words, inscribed by Vedder: "Now the fair goddess Fortune fall deep in love with thee, and her great charms misguide thy opposers' swords." KS

▼ "**A**rt," Cézanne declared, "is a harmony parallel to nature." While seeking that harmony, the artist found apples to be an ideal subject for his explorations of form and composition. In the Speed's still life, Cézanne creates two apples of remarkable roundness and solidity through brushstrokes of closely related tones and concentric bands of color. The plate, painted in thin, transparent washes, appears slightly warped because it is observed simultaneously from two viewpoints. Rendered in a colorful patchwork of square brushstrokes, the tabletop tilts sharply upward, while an adjacent strip of unpainted canvas demonstrates Cézanne's lack of interest in traditional finish. A horizontal band across the top, effectively eliminating spatial recession, represents a detail from Cézanne's first painting, a screen made for his father's study about 1860. Cézanne arranges the screen so that its painted leaves rhyme with the leaves of the apple and those decorating the plate, thereby reinforcing the metaphor of art and nature. RC

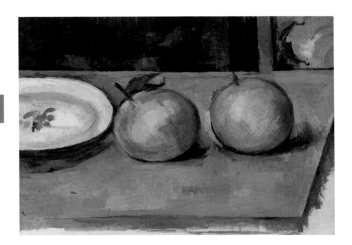

Paul Cézanne
French, 1839–1906
Two Apples on a Table,
about 1895–1900
Oil on canvas
9$\frac{1}{2}$ × 13$\frac{1}{16}$ in.
(24.1 × 33.2 cm)

*Purchased with funds from the
Alice Speed Stoll Accessions Trust
and with funds donated by Wayne Perkey
and Family, Mrs. W.L. Lyons Brown,
Mrs. Harry S. Frazier, Jr., Sandra A. Frazier,
Mr. and Mrs. Randall B. Hockensmith,
The University of Louisville Foundation, Inc.,
Dr. and Mrs. Condict Moore,
Helen Condon Powell, and
Mr. and Mrs. Edmund A. Steinbock, Jr.
2000.21*

▶

Brancusi was one of the most influential sculptors of the twentieth century. Raised in rural Romania, he left in 1903 for Paris, where he worked for most of his life. This bronze, one of his best-known works, refines and distorts nature as it seeks to reveal the essence of its subject. The model was Margit Pogany, a Hungarian art student who sat for Brancusi from December 1910 to January 1911. He then carved the first version of this sculpture in marble from memory and followed it with four bronze casts, including this one. The three casts still known to exist have nearly identical polished bronze finishes and patinated black hair. Photographs of Pogany show that the sculpture exaggerates her round face and large eyes, although the black hair arranged in a chignon more closely recalls her actual appearance. Over the years Brancusi returned to this subject several times, further simplifying it and extending its possibilities. ML

Giacomo Balla
Italian, 1871 or 1874–1958
Line of Speed (Linea di velocità), 1913
Charcoal on wove paper
23⁹/₁₆ × 28⁹/₁₆ in.
(59.9 × 72.5 cm)
Purchase, Museum Art Fund 1965.9

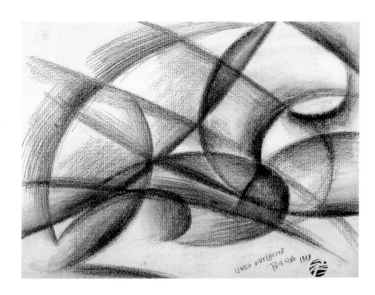

▲ In many ways this drawing epitomizes the ideals of the Italian Futurist movement, in which Balla played a leading role. The Futurists sought to make a violent break from the past by introducing a new artistic vocabulary to express the dynamism of the modern world. Their theoretical manifesto, published in 1909, declared, "The world's magnificence has been enriched by a new beauty: the beauty of speed." In his series of *Linea di velocità* drawings of 1913, Balla conveyed the sensation of modern velocity through abstracted rhythms of lines and shading. The work of physiologist Étienne-Jules Marey, who produced linear diagrams of movement patterns based on time-delay photography, strongly influenced this imagery. ML

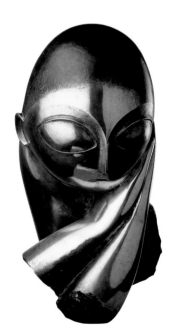

Constantin Brancusi
French, born Romania,
1876–1957
Mademoiselle Pogany I, 1913
Polished bronze with black patina
17¹/₈ × 9¹/₈ × 12¹/₄ in.
(43.5 × 23.2 × 31.1 cm)
Bequest of Mrs. Mabel Hussey Degen 1954.16

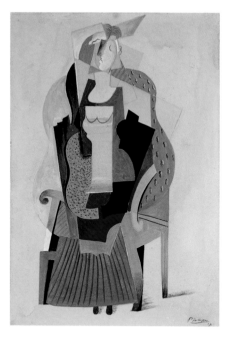

◀ **R**ecognized as one of the most influential artists of the twentieth century, Picasso collaborated with Georges Braque in the development of Cubism, a style characterized by the fragmentation of forms and space. In this work, recognizable elements of a young girl seem to merge with an armchair and the contours of a guitar. With overlapping planes that produce a collage effect, and the figure's jumbled facial features, *Young Girl in an Armchair* represents the late, synthetic phase of Cubism. In 1917 Picasso visited Rome to work on set and costume designs for the Ballets Russes, and the strong, contrasting colors here may reflect his fascination with Italy's *commedia dell'arte*, a traditional form of theater known for its vibrant costumes. ML

Pablo Picasso
Spanish, 1881–1973
Young Girl in an Armchair, 1917
Graphite and gouache on
wove paper
12⅝ × 8⁵⁄₁₆ in.
(32.1 × 21.1 cm)
Purchase, Museum Art Fund 1962.9

Olaf Rude
Danish, 1886–1957
Interior with Woman in Red Dress, 1919
Oil on canvas
49½ × 39⅝ in.
(125.7 × 100.6 cm)
Gift of the Charter Collectors 1988.10

Emil Nolde
German, 1867–1956
***Landscape No. 1 with Red
Cottage***, probably after 1927
Watercolor and black ink on
Asian paper
13¹/₂ × 18¹/₂ in.
(34.3 × 47 cm)
Purchase, Museum Art Fund 1960.4

▲ Like many German Expressionists early in the twentieth
century, Nolde used vibrant color to express emotions,
independently developing a new watercolor technique to
achieve this artistic end. On moistened, highly absorbent
paper, he applied thin pigments and allowed them to flow
together, often directing their spontaneous movements
with cotton. In the resulting images, the bright paper shines
through the wash of color, creating the glowing effect
beautifully demonstrated by this landscape. The building
depicted here, known as Seebüllhof, was a farm cottage
located next to the home that Nolde built for himself and
his wife in 1927 amid the flat marshlands of northern
Germany. The red walls and low-hanging roof are typical
of the rural architecture of this region. ML

◄

The woman depicted here was vacationing on the island of Bornholm,
to the east of Denmark in the Baltic Sea, when Olaf Rude asked
her to sit for him in his studio. He had moved to the island in 1919
at the invitation of a group of other Danish artists who were already
established there. The painting shows a clear influence from the
modern French styles of the time: the composition's geometric structure
reflects aspects of Cubism, while the flat planes of bold color recall the
paintings of Matisse. Rude first became aware of contemporary artistic
trends in France when he traveled to Paris in 1911. The strong impact
of this visit on his work can be seen throughout the paintings he
produced in the years following his return to Denmark. ML

William Sommer
American, 1867–1949
Brandywine Landscape,
about 1914
Oil on panel
20¹/₄ × 26¹/₈ in.
(51.4 × 66.4 cm)
Partial and promised gift, anonymous Louisville collection 2006.7.3

▼ **B**orn in Detroit to German immigrant parents, Sommer had one year of formal art training in 1890–91 at the art academy in Munich, where he received solid academic instruction but little exposure to the avant-garde works regularly exhibited in Paris. In 1907 he took a job as a lithographer in Cleveland. Largely through his friendships with progressively minded Cleveland artists, such as William Zorach, and his own voracious reading, Sommer educated himself about modern art.

In 1914 Sommer and his family settled on four acres in Brandywine, Ohio, between Cleveland and Akron. His delight in his new home can be seen in *Brandywine Landscape.* With a nod to German Expressionism, Cézanne, and the Fauves, Sommer forges a unique, vigorous style with shifting planes of color, dominated by oranges, pinks, and purples, enclosed by heavy black lines. RC

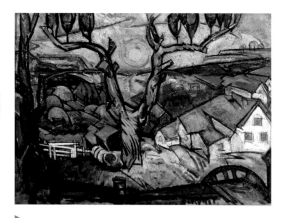

▶

Maurer was one of the first Americans to paint in the Fauve style. Born in New York City, he studied briefly at the National Academy of Design before leaving for Paris in 1897. His sixteen-year sojourn there, during which he joined the artistic circle around Gertrude and Leo Stein, introduced him to avant-garde art. He may also have briefly attended Matisse's painting school. Vigorously brushed landscapes in Fauve-inspired colors began to replace Maurer's earlier Whistler-like figure studies in muted tones. After returning to Manhattan in 1914, he continued to paint Fauvist landscapes for a decade, usually depicting the deeply wooded countryside around Marlboro, New York, in the Hudson River Valley. *Landscape*, depicting a sun-dappled Marlboro hillside, shows Maurer's free, unimpeded handling of paint and radiant, jewel-like colors. RC

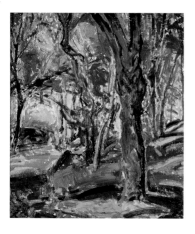

Alfred Henry Maurer
American, 1868–1932
Landscape, about 1916–25
Oil on gessoed board
21¹/₂ × 18¹/₂ in.
(54.6 × 47 cm)
Partial and promised gift, anonymous Louisville collection 2006.7.2

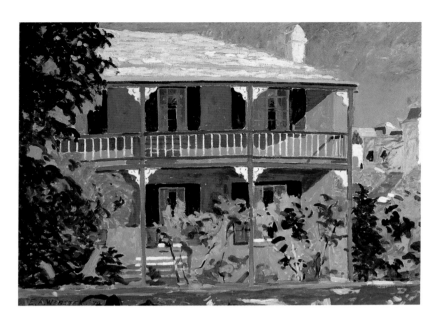

Edwin Ambrose Webster
American, 1869–1935
Red House, Bermuda, 1920
Oil on canvas
29¹/₄ × 39¹/₂ in.
(74.3 × 100.3 cm)

*Partial and promised gift, anonymous
Louisville collection 2006.7.5*

▲ **U**nlike the many Modernists who turned to Europe or the urban environment for subjects, E. Ambrose Webster sought out sun-drenched locales, such as the tropics, for their intense color. After training at the Boston Museum School, Webster attended the Académie Julian in Paris from 1896 to 1898. However, work by Monet, Van Gogh, and others that he was able to see in exhibitions and galleries appears to have had the most profound effect on his art. Webster returned to America in 1900 and settled in Cape Cod's Provincetown because it was "full of color." The following year he established the Summer School of Art in Provincetown, which became an early outpost of American Modernism.

Webster first visited Bermuda in 1910. Painted a decade later, his vibrant *Red House, Bermuda* captures Webster's commitment to the island's dazzling light and color. RC

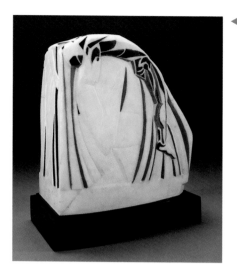

John Henry Bradley Storrs
American, 1885–1956
Pietà, about 1919
Marble, polychrome
11¹/₁₆ × 10 × 5¹/₄ in.
(28.1 × 25.4 × 13.3 cm)
*Given in memory of Dorothy Norton Clay by
her family 2003.1*

◀ **S**torrs was one of the first American sculptors to employ abstraction. After studying with Rodin from 1912 to 1914, he immediately struck out on his own, mining modern European art and various tribal arts as he rapidly developed his distinctive sculptural approach. In *Pietà*, Storrs employs planar forms derived from Cubism while suggesting movement via Futurist-inspired lines of force. His interest in another modern concept, time as the fourth dimension, is implied by his design of the piece, which demands to be viewed from all sides to be understood. The red, black, and emerald-green polychrome that activates the pristine marble comes from Northwest Coast Native American art, which Storrs collected. The artist adopts the age-old theme of the Pietà for this powerful expression of grief and loss in response to World War I, though here the Virgin kneels with Christ on her back, literally bearing the terrible burden of his death. RC

▶

Between the world wars, international exhibitions and favorable reviews propelled progressive Swedish design to a place of prominence in Europe and the United States. The glass designer Edward Hald was among those responsible for Sweden's rise. Trained as a painter—Henri Matisse was one of his teachers—Hald developed a playful, linear style that is deployed to full effect in his *Fireworks* vase. The design captures the joy of young and old (and even their pets) as they gather beneath a canopy of dazzling explosions. Such common subjects, rendered with warmth and whimsy, set Hald's work apart from the Classically inspired figures, geometric patterns, and other, equally detached, imagery used by many of his European contemporaries. SE

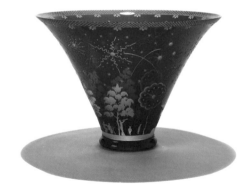

Designed by **Edward Hald**
Swedish, 1883–1980
***Fireworks* vase**, designed 1921,
this example 1938
Engraved by Karl Rössler (Swedish,
active 1923–1966)
Made by Orrefors Glassworks,
Orrefors, Sweden
Glass
8¹/₈ × 11 in. (20.6 × 27.9 cm)
*Partial and promised gift,
Adele and Leonard Leight Collection
2004.19.1*

▼ Inspired by archaic Greek art, Manship developed an elegant sculptural style characterized by rhythmic lines, smooth contours, and carefully articulated forms. Here he devises an armillary sphere—an ancient astronomical device marking the paths celestial bodies were thought to take around the Earth—to illustrate an allegory of the never-ending cycle of life. Bands bearing the names and signs of the zodiac encircle a central diagonal shaft representing Earth's axis, which points toward the North Star. Decorative patterns, such as the fiery outer band, symbolize the four elements, while the whole rests upon turtles, emblems of eternity. A family appears within the intersecting rings at the base. As Manship once explained, "Man, Woman and Child make up the Cycle of Life as the sphere itself symbolizes the Cycle of Eternity." KS

Paul Manship
American, 1885–1966
Cycle of Life—Armillary
Sphere, 1924
Gilt bronze
52¼ × 49¾ × 43⅛ in.
(132.7 × 126.4 × 109.5 cm)

Gift of Mr. and Mrs. Jouett Ross Todd
1964.17.6

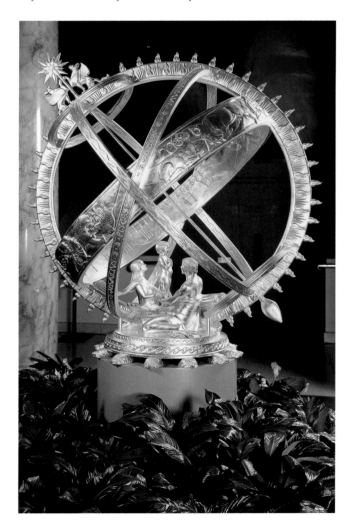

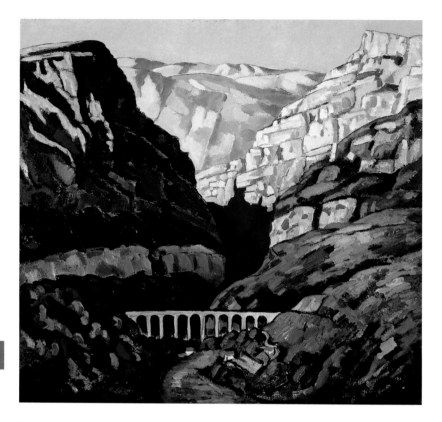

Marsden Hartley
American, 1877–1943
Maritime Alps, Vence, No. 9,
1925–26
Oil on canvas
31³/₈ × 31⁷/₁₆ in. (79.7 × 79.9 cm)
Purchase, Museum Art Fund 1960.3

▲ **T**hrough much of his career the American Modernist Marsden Hartley traveled in Europe and the United States seeking new subjects and experimenting with various artistic styles. In 1925, drawn to mountain imagery and seeking spiritual solace in nature, he leased a cottage in Vence, a small village nestled in the Maritime Alps in southern France. There, inspired by Paul Cézanne's paintings of Mont Sainte-Victoire, Hartley created a series of landscapes depicting the ravine where the River Loup flows under a railway viaduct to the sea. In these canvases Hartley adopts Cézanne's method of rendering volumes through the build-up of blocks of color. The striking juxtaposition of pinks, greens, and purples in *Maritime Alps, Vence, No. 9* suggests light and shadow dancing across the jagged mountains. KS

William Preston Dickinson
American, 1889–1930
Still Life with Eggplant,
about 1924
Pastel on paper
Sight: 13⁵/₈ × 19⁷/₁₆ in.
(34.6 × 49.4 cm)
Partial and promised gift, anonymous Louisville collection 2006.7.1

See page 166 for the Speed's still life by Paul Cézanne.

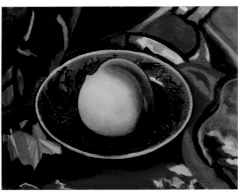

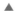

After art studies in New York and Paris, Dickinson returned in 1914 to New York, where he was drawn to the inherent geometry of Manhattan's urban landscape. His Cubist-inspired works from this period establish him as one of the earliest American Precisionists. In the 1920s Dickinson increasingly turned to still life, frequently adopting Cézanne's tilting tabletops and patterned backdrops to upend any orderly sense of space. In this still life, Dickinson's sumptuous palette bears out artist Louis Bouché's comparison of Dickinson's colors to the "tones of silk dyes." Dickinson's application of pastel ranges from dense, velvety smudges of black to the faintest touches of color. The curator and critic Holger Cahill wrote, "Next to Mary Cassatt he was the greatest American virtuoso in the pastel medium." RC

Joseph Stella
American, 1877–1946
The Peach, about 1929
Oil on canvas
11 × 14 in.
(27.9 × 35.6 cm)
Partial and promised gift, anonymous Louisville collection 2006.7.4

◀ **B**orn in an Italian mountain town, Stella immigrated to America in 1896. After studying art in New York, he spent from 1909 to 1912 in Italy and France, where he encountered the avant-garde movements of Fauvism, Cubism, and Futurism, and met Matisse, Picasso, and Modigliani. He returned to New York in late 1912, and his subsequent dynamic visions of that city made him the first American Futurist. Throughout his career Stella also expressed his abiding love of nature in paintings and drawings of fruit and flowers. He painted *The Peach* about 1929, at a time when his work assumed an especially rich intensity of color. The green, yellow, and red of the fruit, glowing against the bright-blue glazed bowl, are repeated in the bright pattern of the cloth background. RC

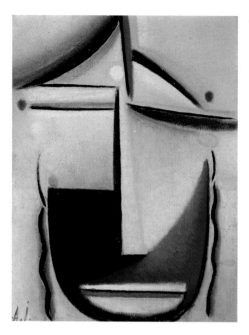

Alexei Jawlensky
Russian, 1864–1941
Abstract Head: Autumn and
Dying (Abstracter Kopf: Herbst
und Sterben), 1923
Oil on artist board
13³/₄ × 9¹³/₁₆ in.
(34.9 × 25 cm)

Gift of Dr. William Adams and
Dr. Chester Kratz 1979.13

◀ **J**awlensky once described a work of art as "God made visible." A deeply spiritual person, he believed that the only way he could infuse his paintings with religious feeling was through the depiction of the human face. He spent twenty years painting hundreds of human heads, progressively reducing the eyes, nose, and mouth to horizontal and vertical lines and flat geometric shapes. His goal was to create a simplified, iconic representation of the human form. Working within this schematic formula for his *Abstract Heads* series from 1921 to 1937, Jawlensky used harmonies of color and evocative titles to suggest emotions, states of being, nature, and the seasons, such as *Autumn and Dying* with its warm, autumnal palette. Loosely associated with the German Expressionists, Jawlensky developed a uniquely personal style that combined influences ranging from the traditional icons of his native Russia to the works of Vincent van Gogh, Wassily Kandinsky, and Henri Matisse. KS

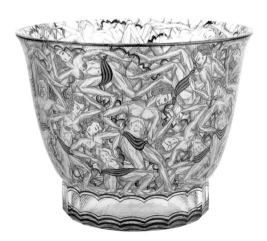

Design attributed to
Adolf Hegenbarth
Bohemian, dates unknown
Vase, 1925
Probably made at the State Technical School for Glass, Steinschönau, Czechoslovakia (now Kamenický Šenov, Czech Republic)
Glass, enamel
7³/₄ × 9³/₄ in.
(19.7 × 24.8 cm)

Purchased with funds from the
Alice Speed Stoll Accessions Trust and
the bequest of Mrs. Blakemore Wheeler,
by exchange 2002.13

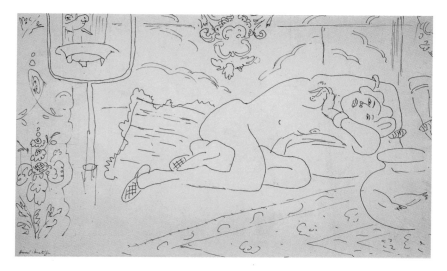

Henri Matisse
French, 1869–1954
Reclining Nude with Budgies
(*Nu allongé avec perruches*),
1929
Pen and black ink on wove paper
Image: 11¹⁄₈ × 18 in.
(28.3 × 45.7 cm)

Bequest from the Nancy Batson Rash and
Dillman A. Rash Collection 1998.19.4

▲ In this lyrical drawing, typical of studies that Matisse produced in the late 1920s, fluid lines give shape to a world of sensual beauty and pleasurable fantasy. Matisse crafted exotic settings using patterned textiles, plush cushions, and decorative screens in his apartment in the old part of Nice. In this artificial harem he transformed his nude models into idealized odalisques. Lisette, the model featured here, posed for the artist between 1929 and 1932. Several props, including the bowl of goldfish and the caged budgies, appear frequently in Matisse's other works from this period. Within this overall patterning of ornamental curves and sinuous lines, the figure's lounging body begins to merge with her sumptuous surroundings. ML

◀ In early twentieth-century Czechoslovakia (now the Czech Republic and Slovakia), Cubism—the rendering of three-dimensional forms as flattened, geometric patterns—escaped the confines of the picture frame and found its way into architecture, furniture, and a range of other media, including glass. This vase ranks among Czechoslovakia's great Cubist successes, its surfaces writhing with sensually intertwined men and women, each rendered as a series of diamond-like facets. The vase bears the initials "AH," most likely for designer Adolf Hegenbarth. Hegenbarth's glass designs won an award at Paris's famed Exposition des Arts Décoratifs of 1925, the international exhibition behind the term "Art Deco." This vase is also inscribed "1925," a tantalizing hint that it may have been part of Hegenbarth's Paris display. SE

▶

Masson was a member of the Surrealist movement from 1924 to 1929, a time when automatic writing—a technique in which text is produced without conscious control—was one of the movement's primary means of accessing the inspired, unconstrained, creative subject. Masson first began to experiment with automatic drawing in 1924 and attempted for many years to achieve its spontaneity of expression in painting, an inherently slower and more deliberate medium. *The Amphora* represents an early attempt to paint automatically. The center consists of dreamlike images—a nude female torso, foliage, a shore, and water—derived from Masson's automatic drawings. These are surrounded by a vestigial Cubist frame, in which shallow illusionary space is created through an accumulation of disrupted planes and contours. LB

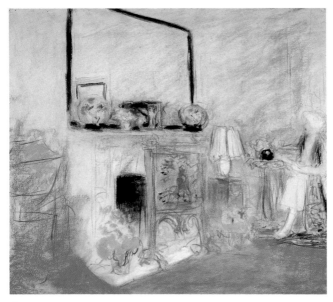

Edouard Vuillard
French, 1868–1940
Madame Hessel in Her Room at the Château des Clayes, 1930
Pastel on paper
22¼ × 24 in.
(56.5 × 61 cm)
Gift of Dr. Leonard T. Davidson 1971.5.1

▲

The Post-Impressionist and *intimiste* Edouard Vuillard had a lifelong fascination in his art with domestic interiors and their inhabitants. A favorite subject was his close friend and companion Madame Lucy Hessel and the Château des Clayes, her family's country home near Versailles. This view of Lucy's pink-hued room at Clayes centers on the mantelpiece, which is surmounted by painted crystal balls and a black-framed mirror. Potted pink geraniums and a fire screen stand before the hearth. Only a closer look reveals the white-haired Lucy herself, seated at the far right. With his subtle handling of pastel, Vuillard achieves an exceptionally atmospheric treatment of light and color, and this depiction of Lucy in her cheerful, comfortable retreat offers an evocative portrait of his friend. RC

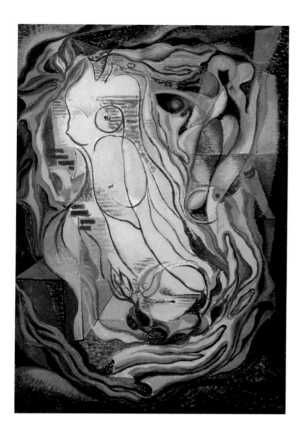

André Masson
French, 1896–1987
The Amphora, about 1925
Oil on canvas
32¹/₁₆ × 21⁵/₁₆ in.
(81.4 × 54.1 cm)
Gift of Sylvia and Joseph Slifka 2004.5.4

Henri Cartier-Bresson
French, 1908–2004
Hyères, France, negative 1932
Gelatin silver print
Image: 9⁹/₁₆ × 14³/₈ in.
(24.3 × 36.5 cm)
Museum Members purchase 1981.3.2

▶
When Cartier-Bresson took up the 35-mm Leica camera in 1932, he unknowingly set about defining the twentieth-century tradition of street photography. The immediacy of picture-taking using a handheld camera with a shutter fast enough to stop motion enabled him to isolate and capture the decisive moment in the fluid scene before him. He wrote: "Our only moment of creation is that 1/125th of a second when the

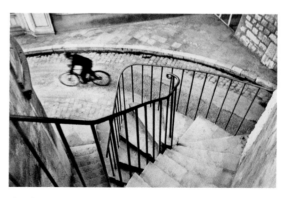

shutter clicks, the signal is given and motion is stopped."

For *Hyères, France*, Cartier-Bresson chose a vertigo-inducing point of view and prepared for the decisive moment that he knew would come. Working within a tightly defined physical space, he waited until the cyclist was in the perfect spot to bring his composition to life, and took the picture with a shutter speed slow enough to suggest motion by blurring the figure. BC

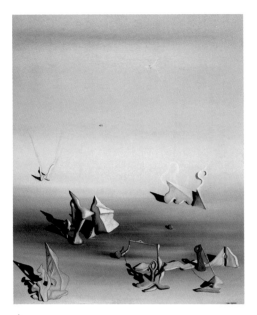

Yves Tanguy
French, 1900–1955
Other Ways
(*Les Autres Chemins*), 1939
Oil on panel
Sight: 13³/₄ × 10¹/₈ in.
(34.9 × 25.7 cm)

*Museum purchase with funds given by
Mr. and Mrs. Charles Horner 1964.5*

▲

Centered in Paris and heavily influenced by the
writings of Sigmund Freud, the Surrealist movement
asserted that the exploration of the unconscious mind
could reveal otherwise unattainable truths. Completely
self-taught, Tanguy devised imagery that embodied
Surrealist ideals. This painting's desert-like setting and
biomorphic forms are prominent features of his work
from the 1930s. With meticulous precision Tanguy
conveys a seemingly infinite space where otherworldly
objects are given a convincing sense of reality
through careful lighting, shadow, and perspective.
By excluding any signs of human presence, he
creates a landscape of solitude, perhaps evoking
the beginning or end of time. Like the imagery, the
painting's title remains deliberately ambiguous. ML

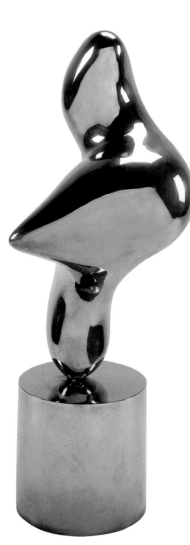

Hans Arp
French, born Germany,
1886–1966
Awakening, cast 1953 after
1938 plaster original
Bronze
26³/₈ × 9³/₈ × 8⁷/₈ in.
(67 × 23.8 × 22.5 cm)

Gift of Sylvia and Joseph Slifka 2004.5.2

▼ **A**rp began making reliefs during World War I in an effort to obliterate the customary distinctions between painting and sculpture. Though they hang on a wall, his reliefs break free of the rectangle that traditionally defines painting, and may be viewed in three-quarters or even profile. Their flat surfaces and uniform color repudiate the illusion of perspective usually achieved through modeling and shading; depth is conveyed instead through the shadows cast by the cut-out shapes. Arp also rejected conventional notions of the artist as maker by having others construct his reliefs. He continually experimented with the form, and in the 1930s began to create "constellations," in which a limited number of elements were recombined in constantly fresh variations. This compositional technique, also used in his poetry, was meant to imitate and evoke the natural processes of growth and development. LB

Hans Arp
French, born Germany,
1886–1966
***Constellation of White Forms
on a Violet Form***, 1953
Oil on wood
17⁷⁄₈ × 24¹⁄₂ × 2³⁄₈ in.
(45.4 × 62.2 × 6 cm)
Gift of Sylvia and Joseph Slifka 2004.5.1

◀ **A**rp was closely associated with the early twentieth-century Dada and Surrealist movements, which sought to revolutionize the visual arts. He played a pioneering role in opening up sculpture, previously dominated by the human figure, to the natural landscape. He did this by rejecting literal renderings of nature and fashioning a new vocabulary of biomorphic forms that sought instead to evoke it. In 1930 he began to produce sculpture in the round, after he discovered that he could use plaster to give three-dimensional form to these shapes. With this sculpture, which discourages a traditional hierarchy of views (front, back, side), he tried to convey the idea that creation is an eternal process of metamorphosis and growth. *Awakening* was intended for the outdoors, where it would promote harmony with the natural world. LB

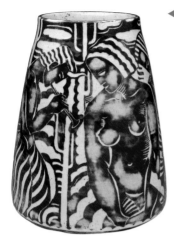

◀ This vase relies on a decorative vocabulary developed in France during the 1920s and 1930s. Sometimes referred to at the time as the "moderne" style, it is more commonly known today as Art Deco. True to many French examples, this vase's female figures are full and voluptuous, while the males are muscular and heroic. Randour's subjects also share the vaguely Classical feel often found in the work of his contemporaries; one figure, for example, appears to be Pan, god of the woods and fields. Whatever the vase's ultimate sources, an undercurrent of eroticism unifies the design. Eroticism was an important part of "moderne" taste, drawing on a popular culture dominated by flappers, Josephine Baker, and boisterous cabarets. SE

Louis Randour
Belgian, dates unknown
Vase, about 1935
Stoneware
12³/₈ × 9³/₈ in.
(31.4 × 23.8 cm)
Gift of the Decorative Arts Collectors
2002.17

▼

A pioneer of direct carving, Zorach was instrumental in twentieth-century American sculpture's break with academic style. Unlike nineteenth-century sculptors, whose plaster or clay models were cast in bronze or carved in marble by skilled craftsmen, direct carvers worked the stone or wood themselves, frequently allowing the material to guide the sculpture's form. Zorach particularly relished selecting unusual stones or pieces of wood with characteristics that often governed the subjects and designs of his sculptures. It is not difficult to imagine the golden tones and coarse grain of these two thick, rough-hewn planks suggesting a pair of reclining tigers. Zorach brings each animal's form and personality to vigorous life through deep relief carving and bold chisel marks, which delineate the tigers' stripes. RC

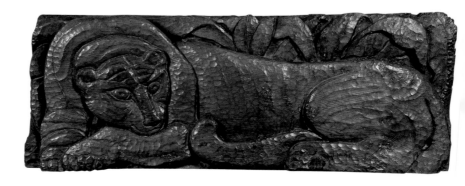

▶ **B**orn in Lithuania, Lovet-Lorski moved to the United States in 1920 after the Bolshevik Revolution and became a citizen five years later. Thanks to his congenial personality and wealthy connections, he quickly developed a lucrative artistic practice and found special favor among Hollywood celebrities. This sculpture's exotic subject and smooth, streamlined contours epitomized the Art Deco style of the 1920s and 1930s. The cultures of Polynesia, a group of islands in the South Pacific, gripped the popular imagination during this period. Favoring rare materials, Lovet-Lorski carved this striking head from lava. By powerfully stylizing the woman's features, he simultaneously invested her with the glamour of a film star and the timeless presence of an archaic idol. ML

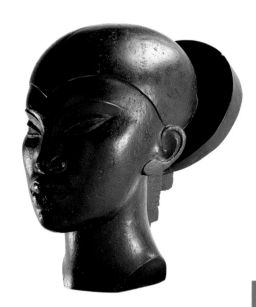

Boris Lovet-Lorski
American, born Lithuania, 1894–1973
Polynesia, 1934
Black paint on Stromboli lava
22¹/₄ × 10³/₄ × 16¹/₈ in.
(56.5 × 27.3 × 41 cm)
Gift of Mrs. Melpo Niarchos 1994.7.1

William Zorach
American, 1887–1966
Tiger, Tiger, 1943
Oak
Left: 15¹/₄ × 40 × 5¹/₈ in.
(38.7 × 101.6 × 13 cm)
Right: 15⁷/₈ × 40³/₄ × 4³/₄ in.
(40.3 × 103.5 × 12.1 cm)
Gift of Yum! Brands, Inc. 2001.1 a,b

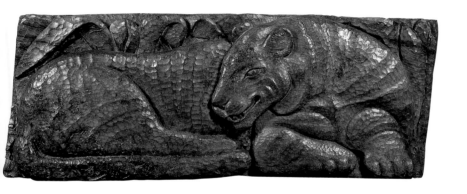

▼ **U**fer, who grew up in Louisville, became a member of the artists' colony in Taos, New Mexico, during the 1910s. Perhaps hoping to become, as one patron put it, "the Millet of the Indian," Ufer created a modern vision of the West. Forgoing picturesque views and romantic portraits, he instead depicted contemporary Native Americans, and occasionally Anglos, engaged in the activities of daily life. In *Bob Abbott and His Assistant*, Ufer depicts his friend, frequent model, and local Taos Pueblo member Jim Mirabal sitting on the bumper of a dilapidated car, while mechanic Bob Abbott pauses in his work under the hood. Ufer painted outdoors to capture the dappled effects of sunlight on the snow-patched New Mexican landscape. KS

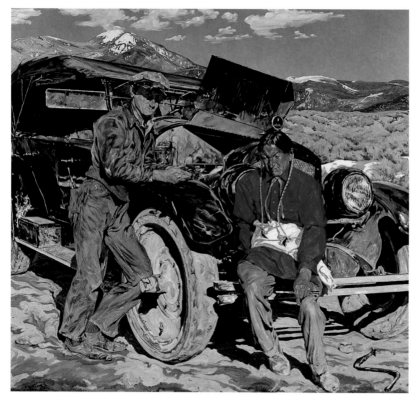

Walter Ufer
American, 1876–1936
Bob Abbott and His Assistant,
1935
Oil on canvas
50¹/₄ × 50¹/₂ in.
(127.6 × 128.3 cm)
Bequest of Mrs. Walter Ufer 1947.13

William S. Arrasmith
American, 1898–1965
*Bowman Field
Administration Building*,
1935
Colored pencil on board
20¹/₈ × 30¹/₈ in.
(51.1 × 76.5 cm)
Gift of Arrasmith, Judd & Rapp, Inc.
1987.13.1

▲
In 1935 Wischmeyer & Arrasmith, a Louisville architectural firm, designed an expansion for the 1929 administration building (also designed by the firm) at Bowman Field, the city's first airport. With this drawing Arrasmith presented the firm's vision for the new and improved building. His seductive rendering depicts the terminal—and 1930s air travel— as a glamorous, distinctively modern affair: the design rejected historical styles in favor of the day's fashionable look, now known as Art Deco. Elements of the style are evident in the building's strong vertical lines, large windows, and linear ornament. The building remains in use today, although commercial air operations were moved from Bowman Field to Standiford Field (now Louisville International Airport) in 1947. SE

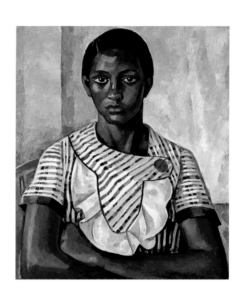

▶
Fisk was an active member of the New York avant garde during the first decades of the twentieth century. A student of Robert Henri, he frequented Alfred Stieglitz's 291 gallery, studied the works of Picasso and Cézanne, and attended gatherings of young Modernist painters hosted by Gertrude Stein in Paris. He found city life oppressive, however, and in 1926 he moved to Lexington, Kentucky, where he accepted a teaching position at the local university. In this portrait of Mary Daniel, his housekeeper and occasional model, Fisk denies spatial recession by setting her against an ambiguous background, and renders the planes of the face as patches of color in a manner inspired by Cézanne. KS

Edward Fisk
American, 1886–1944
Portrait of Mary Daniel,
about 1938
Oil on canvas
24 × 20³/₁₆ in.
(61 × 51.3 cm)
*Gift of Milton Fisk and
Allethaire Hendricks 2001.24.1*

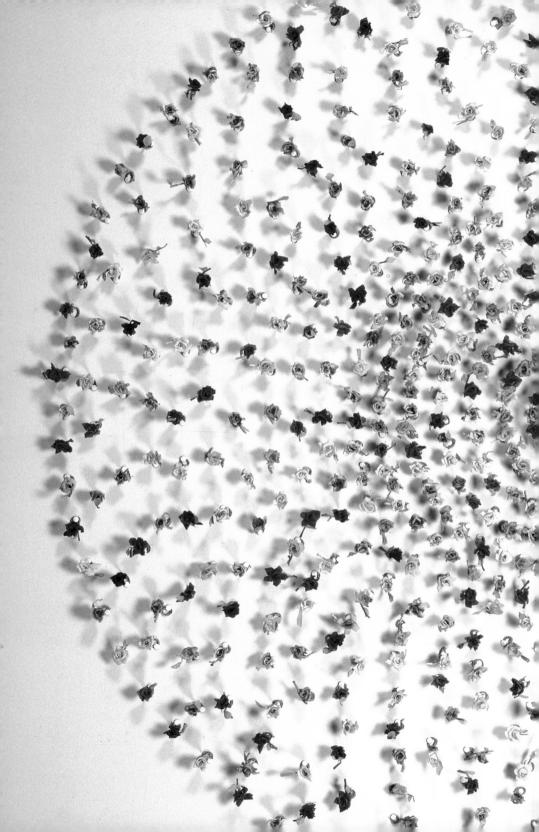

Contemporary Art

▶ **T**hroughout his career Ernst, a co-founder of the Cologne Dada group of artists and a major contributor to the theory and practice of Surrealism, used unconventional techniques to challenge and disrupt the aesthetic codes of Western academic art. His work involves a consistent principle of collage, which he defined as "the exploitation of the chance meeting of two distant realities on an unfamiliar plane." The purpose of these unsettling juxtapositions was to liberate the imagination. This late sculpture is cast from an assemblage of objects found on Ernst's property: two ox yokes and a printer's block spelling the word "Niniche." By alienating them from their original functions—agriculture and the technology of mass communication—Ernst challenges the conventional relationship between form and content. The title of the work draws attention to Ernst's method of questioning the meaning of objects, and invites the viewer to do the same. LB

▼

A leading pioneer of abstract art in Britain, Nicholson earned international attention in the 1950s with such large still-life paintings as *August 1954 (Greek)*. Using a Cubist-based vocabulary of flattened forms and planes, these works integrate color and drawing, tangible form and abstraction, and transparent and opaque paint into a refined yet monumental pictorial approach. In his Cornwall studio Nicholson kept a collection of jars, vases, and goblets that appear repeatedly in his table-top still lifes. Their contours and rhythms, delineated by razor-sharp lines or by flat, solid color, balance the rectilinear table structures below. Nicholson titled his completed works for their poetic, rather than literal, associations. In this work perhaps the white vessel shape, reminiscent of Greek marble, the blue band at the top, like an Aegean sky, and the warm, gray ground, evocative of ancient stone, suggested the subtitle. RC

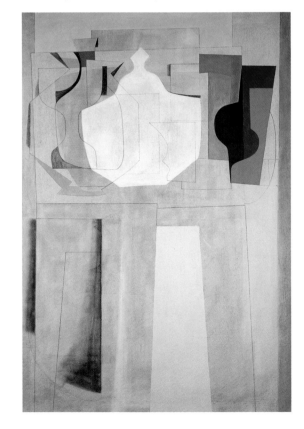

Ben Nicholson
British, 1894–1982
August 1954 (Greek), 1954
Oil on canvas
60¹/₈ × 39 in.
(152.7 × 99.1 cm)
Purchase, Museum Art Fund 1966.1

Max Ernst
German, 1891–1976
Are You Niniche?, 1955–56
Bronze
22¼ × 37½ × 8 in.
(56.5 × 95.3 × 20.3 cm)
Gift of Sylvia and Joseph Slifka 2004.5.3

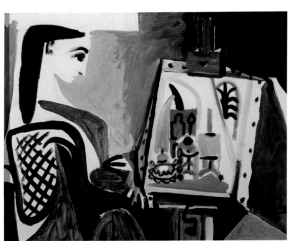

▶
Picasso painted this picture of his companion (and later wife) Jacqueline Roque in the studio of "La Californie," his villa overlooking Cannes. Seated in a wicker armchair and depicted in sharp profile, Jacqueline quietly contemplates one of the artist's paintings of the studio's interior, including its familiar arched window framing a palm tree outside, a canvas on an easel, and an elaborately scalloped samovar in the left corner. Picasso employs a harmonious palette of black, grays, browns, and green in broad, largely unmodulated areas, leaving such elements as Jacqueline's head and neck the white of the unpainted canvas. Picasso brings together in this work the two sustaining forces of his later years: his art and his relationship with Jacqueline, the most stable and enduring of his life. RC

Pablo Picasso
Spanish, 1881–1973
Woman in the Studio (Jacqueline Roque) [Femme dans l'atelier (Jacqueline Roque)], 1956
Oil on canvas
18 × 22½ in.
(45.7 × 57.2 cm)
Bequest from the Nancy Batson Rash and Dillman A. Rash Collection 1998.19.5

See page 168 for an earlier work by Pablo Picasso.

▶

Leedy began his career as a painter, spending time in New York City during the 1950s. There he absorbed the iconoclastic, visceral abstraction practiced by such Abstract Expressionists as Jackson Pollock and Willem de Kooning. Leedy brought this sensibility both to his paintings and to such clay objects as *Colorful Vessel*. Its chaotic composition and seemingly random patches of color capture the emotional energy that went into its creation. Leedy was perhaps the first American artist to use clay in this manner, ignoring the tradition of the rational, symmetrical vessel in favor of a more urgent and unexpected working method. Leedy's iconoclasm even extended to his choice of materials: here the colors come from bits of plastic resin affixed to the surface with a blowtorch. SE

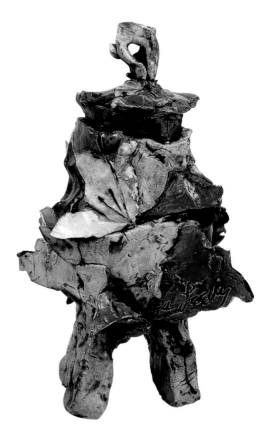

Jim Leedy
American, born 1930
Colorful Vessel, 1954
Stoneware, resin
$14^{1}/_{4} \times 8^{3}/_{8} \times 5^{1}/_{2}$ in.
(36.2 × 21.3 × 14 cm)

Partial and promised gift, Adele and Leonard Leight Collection 1994.16.1 a,b

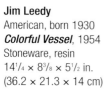

▶

In March 1962 Littleton—who trained as a ceramist—organized a workshop at the Toledo Museum of Art. The challenge was to see if free-blown glass could be a viable medium for individual artists. This early, tentative effort helped launch the contemporary studio glass movement in America. Explicitly acknowledging the act of creation, Littleton's own work carries the residue of his first experiments. Here two sagging, bulbous bubbles of hot glass, seemingly straight from the glassblower's pipe, are frozen in place. Littleton, however, transcends mere technique by slicing away the body of each form and pitting one against the other to create an abstract sculptural composition. SE

▼ Osolnik, a wood turner, launched his artistic career in the late 1930s with a secondhand lathe he purchased for $150. Among the vanguard of contemporary American craft artists, he spent six decades coaxing unique sculptural forms from stump wood, sawmill cast-offs, and fallen trees. Turned so as to emphasize the richly colored, contrasting figure of rosewood, these bowls embrace the undulating, amoeba-like aesthetic that defined up-to-date design in post–World War II America. SE

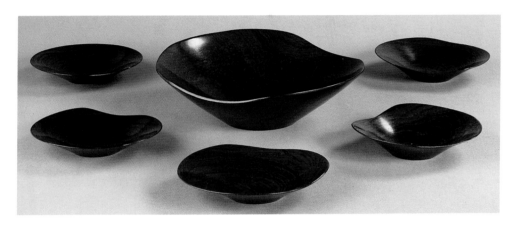

Rude Osolnik
American, 1915–2001
Salad set, about 1950
Rosewood
Large bowl:
3⁷/₈ × 12³/₈ × 11³/₈ in.
(9.8 × 31.4 × 28.9 cm)
Museum purchase 1999.4.1–.6

Harvey K. Littleton
American, born 1922
Red Schizoid Form, 1977
Glass
6³/₄ × 7¹/₈ × 4⁵/₈ in.
(17.1 × 18.1 × 11.7 cm)

Partial and promised gift, Adele and Leonard Leight Collection 1992.18.31

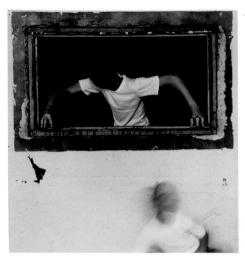

◀ Lexington, Kentucky, optometrist Gene Meatyard used the camera to explore artistic and philosophical concerns by taking the stuff of everyday life and creating extraordinary moments. He often placed friends and family, especially his children (as here), in his photographs, less as subjects *per se* than as elements in the composition, to be transformed into universal symbols. Meatyard was happy to describe his techniques and write about his aesthetic philosophy, but he would not explain his photographs, which he likened to Zen koans: riddles to be pondered. BC

Ralph Eugene Meatyard
American, 1925–1972
Untitled, 1962
Gelatin silver print
Image: 7 × 6¹/₂ in.
(17.8 × 16.5 cm)
Gift of Henry V. Heuser, Jr. 1991.23.76

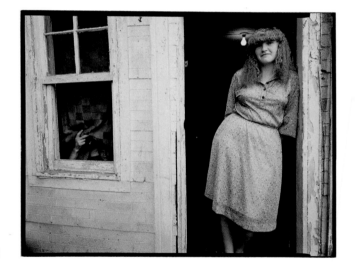

Nicholas Nixon
American, born 1947
Glasgow, KY, 1982
Gelatin silver print
Image: 7¹¹/₁₆ × 9¹¹/₁₆ in.
(19.5 × 24.6 cm)
Gift of Kate and Harry Talamini 1991.13.25

▲ Nixon photographs with an old-fashioned eight-by-ten view camera mounted on a tripod. He feels that his subjects find the size and steadiness of the camera "friendly and comforting Because it's slow they know I can't take anything they don't want to give easily." The boy and girl in this photo appear at ease with the photographer and with themselves, apparently confirming his theory. Nixon has constructed an elegant composition on the ground-glass focusing screen of his camera, with the door and window frames echoing the rectangular format of the film itself. Each frame within a frame can be viewed as a separate image, contributing to a whole that is greater than the sum of its parts. BC

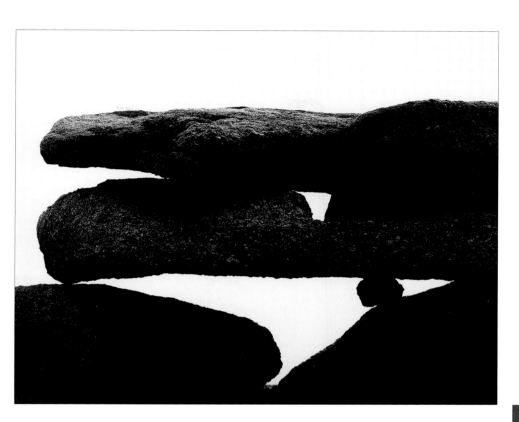

Aaron Siskind
American, 1903–1991
***Martha's Vineyard Rocks**, 1954*
Gelatin silver print
Image: 17¹/₂ × 22¹/₂ in.
(44.5 × 57.2 cm)
Gift of Harry A. Talamini 1986.6.4

▲ Siskind was not interested in his subject matter itself but rather in how he felt about it. These rocks were sculptural forms to him. The creative act began with his reaction to them, continued through their framing on the camera's ground glass, and concluded when the picture was printed on a sheet of photographic paper. Siskind was adamant in his belief that photographs were two-dimensional objects—flat planes only—and the idea of illusionary space in photographs was anathema to him. He was inspired by the relationships among the objects he photographed to the degree that his involvement in those relationships deeply moved him. He felt a successful photograph was one that resolved the tension between the subject and the feelings it aroused without eliminating that tension. BC

▼ **W**esley has frequently been associated with the Pop-art movement. Though it often draws on magazine and cartoon imagery, his work has less to do with Pop's sociological irony than with the imagination's ability to summon up the absurd. Using a limited color palette and bold graphic clarity, Wesley's images betray a sly humor that is often tinged with eroticism. In *Golden Horde*, four camels stand in front of each other, their stockinged hind legs crossed like dancing girls in a chorus line. While Wesley leaves the ultimate interpretation of this painting to the viewer, *Golden Horde* surreally fuses the erotic and the exotic in a preposterous mix of Genghis Khan and vaudeville. JR

John Wesley
American, born 1928
Golden Horde, 1966
Acrylic on canvas
35¹/₄ × 42¹/₄ in. (89.5 × 107.3 cm)
Gifted by James A. Patterson 2004.26

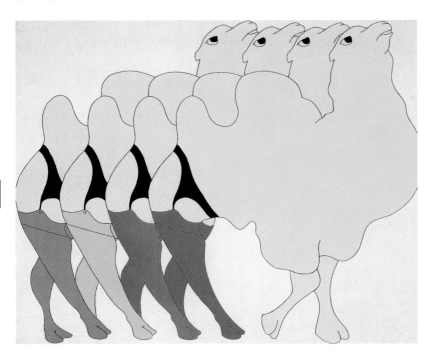

▶

Warhol, arguably the most famous American artist of the twentieth century, had an uncanny ability to select imagery, largely derived from existing news and publicity photographs, that was capable of conveying extraordinary social content. *Race Riot* is one of his earliest editioned prints, and uses a photograph by Charles Moore that was originally published on May 17, 1963, in *Life* magazine. Conflating high art and mass culture, Warhol here uses the screenprint process to convey in dramatic form brutality and political oppression at the height of the Civil Rights movement. JR

Robert Rauschenberg
American, born 1925
Untitled, 1963
Oil and screenprint ink on canvas
36 × 25 in. (91.4 × 63.5 cm)

*Museum purchase from funds given by
Mr. and Mrs. Charles Horner 1964.9*

Art © Robert Rauschenberg/Licensed by
VAGA, New York, NY

▲

One of the most innovative American artists of the twentieth century, Rauschenberg gained public attention in the 1950s with his "combines," assemblage works that freely incorporated painting and found objects. In 1962 he became interested in the possibilities of photo-screenprint processes and began a series of paintings using this industrial technique. After printing images of modern life from books, magazines, and his own photographs on to canvas, Rauschenberg overworked areas with oil paint in a manner reminiscent of Abstract Expressionism. In *Untitled*, pictures of a satellite antenna and an umbrella (a prop from a Merce Cunningham dance) vie with the dark washes of paint that partially obscure them. The work's seemingly random combinations give an impression of visual flux that invites multiple interpretations. JR

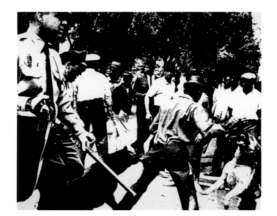

Andy Warhol
American, 1928–1987
Birmingham Race Riot, 1964
Photographic screenprint on paper
20 × 24 in. (50.8 × 61 cm)

*Gift of Douglas S. Cramer in honor of
Pauline Compton Cramer 2002.21*

Jean Dubuffet
French, 1901–1985
Appeal for Calm (Appel au calme), 1962
Gouache on paper
32 × 26⁵/₁₆ in.
(81.3 × 66.8 cm)
Bequest from the Nancy Batson Rash and Dillman A. Rash Collection 1998.19.2

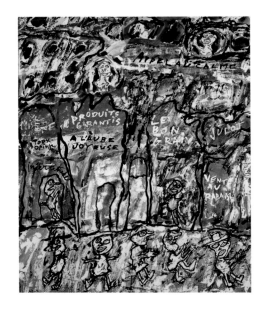

Marc Chagall
French, born Belorussia, 1887–1985
Waiting (L'Attente), 1967
Oil on canvas
36³/₈ × 25⁵/₈ in.
(92.4 × 65.1 cm)
Bequest from the Nancy Batson Rash and Dillman A. Rash Collection 1998.19.1

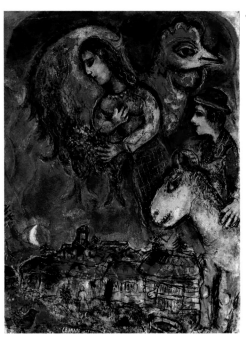

◀ When Chagall first arrived in Paris in 1910, he merged the rich artistic and folkloric traditions of his native Russia with European avant-garde elements in paintings distinctive for their dreamlike imagery and expressive color. Throughout his career Chagall returned repeatedly to the subject of lovers. Here a young woman, holding a bouquet, floats above the peaceful moonlit rooftops of the small Russian town of Vitebsk, Chagall's childhood home. The woman's graceful form merges with that of a large green cockerel, nearly filling the blue night sky. Her lover, accompanied by a yellow cow, gazes at her happily. Although the two figures may represent Chagall and his beloved first wife, Bella, or his second wife, Valentina, whom he married in 1952, above all they celebrate the timeless theme of lovers. RC

◀ **A** believer in and practitioner of an anti-aesthetic style that he called *Art Brut*, Dubuffet emerged as one of the most significant French painters of the postwar era. Rejecting traditional notions of beauty, he found inspiration in the art of children and of the insane, creating works that have the expressive immediacy of street graffiti. *Appeal for Calm* belongs to *Paris Circus,* a series that Dubuffet created on his return to Paris after living in the countryside for seven years. Following a period in which the artist had all but removed the human presence from his work, this series reflects the excitement and bustle of the metropolis, teeming with life and defined in strong lines and lively colors. JR

▼ *Reclining Figure: Angles* is considered a masterpiece of Moore's late career. The draped female figure represents the artist's continuing response to his encounter with Classical sculpture during his first trip to Greece, in 1951. Similarly, the semi-reclining pose and alertly turned head demonstrate Moore's fascination with the Toltec–Mayan sculpture of the warrior-priest Chacmool that, from the 1920s, inspired his obsession with the reclining figure. Moore equates the recumbent female form with landscape. In this example the upraised, draped knees, broad abdomen, and rounded breasts invite comparison with mountains, valleys, and hills, an impression reinforced by this cast's green-and-brown patination. Moore's careful working of the sculpture's surface—smoothing certain areas and scoring and scraping others, prior to casting, to make them appear weathered by centuries of erosion— contributes to the work's primordial power. RC

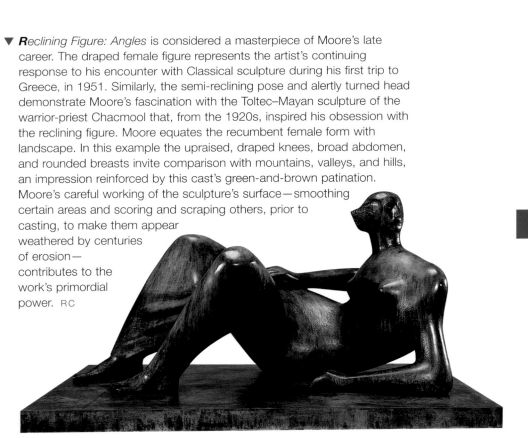

Henry Moore
British, 1898–1986
Reclining Figure: Angles, 1979
Bronze
48⁹/₁₆ × 90⁷/₁₆ × 61¹³/₁₆ in.
(123.3 × 229.7 × 157 cm)

Gift of Sara Shallenberger Brown in memory
of her husband, W.L. Lyons Brown 1981.21

Frank Stella
American, born 1936
Chocorua II, 1966
Fluorescent alkyd and epoxy
paints on canvas
120³/₈ × 128⁷/₁₆ in.
(305.8 × 326.2 cm)
Museum Members purchase 1967.44

▼ **R**eacting to the subjective approach of the Abstract Expressionists, Stella achieved almost instant recognition in the late 1950s with a series of black-striped paintings with compositions organized around strict but arbitrary procedures. Explaining that his art was "based on the fact that only what can be seen there *is* there," Stella championed paintings as objects rather than personal expressions. By the mid-1960s he was making canvases in shapes determined by interlocking and repeating geometric figures. *Chocorua II* belongs to a series of four large works showing an isosceles triangle penetrating a rectangle. Combining this simple design with flat, fluorescent colors, Stella focuses attention on the painting as a thing in itself rather than as a representation of something else. JR

▶
Gilliam's constructed collages of the 1970s mark a point of transition in his work. Having gained international recognition for his large stained and draped paintings of the 1960s, he began to cut up already painted canvases and to recombine them into preconceived geometric designs. This "cutting and pasting" of diverse elements resulted in such works as *For Day One*, the crisp lines and divisions of which contrast sharply with the swirling paint and stained canvas. While adumbrating the continued use of collage techniques in his large, moody "Black" paintings, *For Day One* is by contrast a kaleidoscope of color with a rigorous compositional structure that allows Gilliam's masterful use of his medium to shine through. JR

Helen Frankenthaler
American, born 1928
Situation, 1972
Acrylic on canvas
51³/₈ × 120¹/₄ in.
(130.5 × 305.4 cm)
Purchased with funds from the
New Art Collectors and the
National Endowment for the Arts
1972.42.1

▲ Introduced as a young artist to the Abstract Expressionists and inspired by the paintings of Jackson Pollock, Frankenthaler developed in the early 1950s a "soak-stain" technique that would become the hallmark of her work. Applying thinned-down, watery colors to the weave of unprimed canvas, she stains her paint into the fabric rather than creating a skin on its surface. Working on the floor, she directs the flow of paint into large-scale washes of pigment reminiscent of watercolor. In *Situation*, Frankenthaler commingles this technique with painted or drawn-in lines and areas of raw, unstained canvas to create a composition whose modulations of color and form, while remaining distinctly abstract, coalesce into the suggestion of a landscape. JR

Sam Gilliam
American, born 1933
For Day One, 1974–75
Acrylic, oil dye pigments on collaged, flat-mounted canvas
48¹/₂ × 48¹/₂ in.
(123.2 × 123.2 cm)
Gift of Henry V. Heuser, Jr.,
and museum purchase 1976.6

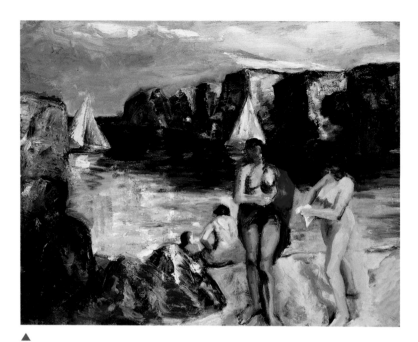

▲

Bischoff was a leading figure among the Bay Area artists, a group of San Francisco painters that included Richard Diebenkorn and David Park. After contributing to the local emergence of Abstract Expressionism, in 1952 Bischoff turned to figuration and began producing atmospheric compositions that merged representational imagery with expressive brushwork and luminous colors. *Four Figures and Two Boats*, with its bathers set against a backdrop of calm waters and dramatic cliffs, has an almost mythic quality. Rendering the landscape in bold geometric marks and reducing the figures' faces to simple, fleeting impressions, Bischoff engenders a hallucinatory sense of his subject that, in his own words, "dissolves all tangible facts into intangibles of feeling." JR

Elmer Bischoff
American, 1916–1991
Four Figures and Two Boats,
1966
Oil on canvas
79⁷/₈ × 95³/₄ in.
(202.9 × 243.2 cm)
Gift of the New Art Collectors 1985.9

▶

In the 1960s, when painting was dominated by abstraction, Pearlstein became a leader in the return to Realist imagery. Focusing on the model in the studio, he strove to transcribe what he saw as accurately as possible, and, in the process, developed a style the strong geometric underpinnings of which reveal his subjects in a uniquely literal and detached light. Pearlstein is interested in the "landscape" of the human form rather than the identities or emotions of his individual subjects. Avoiding eye contact, their limbs or heads often cropped by the edges of the canvas, his nudes are rendered in a uniform manner that imbues them with a matter-of-factness that is at once remote and intimate. JR

Alice Neel
American, 1900–1984
Priscilla Johnson, 1966
Oil on canvas
70¹/₁₆ × 30 in.
(178 × 76.2 cm)

*Purchased with funds from the
New Art Collectors and the
National Endowment for the Arts
1980.14*

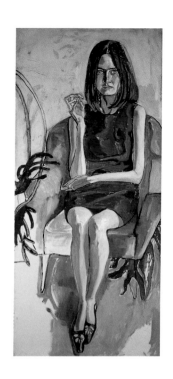

▶

Though Neel is often characterized as a Realist painter, her style reveals the strong influence of such turn-of-the-century European Expressionist artists as Oskar Kokoschka, Ernst Ludwig Kirchner, and Otto Dix. Like them, Neel seeks to express her own feelings while also revealing something essential about her sitter's personality, and she does so typically by elongating limbs or exaggerating features. Neel referred to herself as "a collector of souls," and her portraits—whether of Nobel laureates, art-world celebrities, relatives, or neighbors—are unfailingly, and often disconcertingly, honest. *Priscilla Johnson* depicts a friend of Neel's son; the dress, pose, and hair vividly comment on American youth of privilege in the 1960s. KK

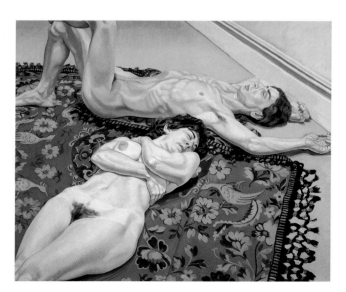

Philip Pearlstein
American, born 1924
Couple Lying on a Spanish Rug, 1971
Oil on canvas
60¹/₈ × 70¹/₄ in.
(152.7 × 178.4 cm)

*Purchased with funds from the
New Art Collectors and the
National Endowment for the Arts
1972.42.6*

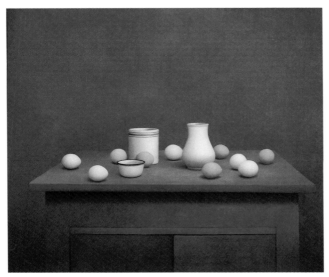

William Bailey
American, born 1930
Still Life of 10 Eggs, White Vase,
Blue and White Vase and
Enamel Cup, 1971
Oil on canvas
42¹/₈ × 48¹/₈ in.
(107 × 122.2 cm)
Gift of the New Art Collectors 1972.4.1

▲ **B**ailey's paintings, which recall the work of Italian Surrealist Giorgio de Chirico, render the ordinary and known in a way that is strange and timeless. Recorded from memory, rather than a studio set-up, Bailey's still lifes are painted in subtly gradated tones that shun textural detail and articulate spatial relationships in an almost abstract manner. While the crockery and eggs in this composition represent objects from the real world, there is no indication that they have ever contained anything or been used. As Bailey comments: "I don't think of them as still lifes. They become sometimes places, sometimes dramas, sometimes more or less abstract. The table is more or less a stage." JR

Don Eddy
American, born 1944
Silverware I, 1976
Acrylic on canvas
24¹/₈ × 26 in.
(61.3 × 66 cm)
Gift of Mr. and Mrs. Henry V. Heuser, Sr.
1976.16

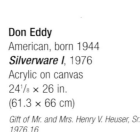

▼ **S**teadfastly investigating light, Currier has been occupied by the still-life motif for more than twenty years. Arranging and illuminating objects on a stage next to her easel, she reinvents the everyday in a manner concerned less with symbolism than with a tranquil simplicity. In *White Onions on Bag*, she transforms her humble subject on a scale that is unexpected, while imbuing these commonplace objects with a profound luminescence. Like Giorgio Morandi, Currier creates from the mundane and quotidian a particular sort of realism that continually readdresses the simple life. In this contemplative realm of light she eschews the dramatic and seeks instead to reveal the miraculous in the everyday. JR

Mary Ann Currier
American, born 1927
White Onions on Bag, 1983
Oil on canvas
42¹/₄ × 65⁷/₈ in.
(107.3 × 167.3 cm)
Gift of Mrs. George Norton, Jr. 1984.3

◄

The Photorealism movement, which emerged in the late 1960s, was considered an offshoot of Pop art. However, while Pop took American materialism as its subject, Photorealism concentrated on the visual ambiguities of representation. Using airbrush techniques and working with a meticulous attention to detail, Eddy finishes his paintings with a smooth, flat surface resembling photography. *Silverware I* is a precise, sharp rendering of the objective world where polished silver objects and a glass display case create a dazzling play of light and form. In this multiplicity of shapes and mirroring, reality itself becomes uncertain, and this seemingly straightforward representation takes on the quality of a complex abstraction. JR

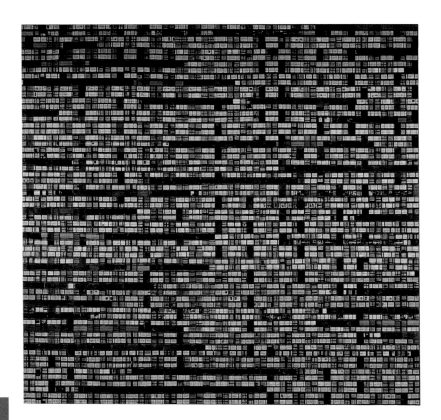

Arturo Alonzo Sandoval
American, born 1942
Cityscape No. 6, 1978
Machine-stitched and interlaced
35-mm microfilm, paper,
opalescent Mylar, Velcro, eyelets
84³/₈ × 84¹/₄ in. (214.3 × 214 cm)

Gift of C.J. Pressma and partial purchase
2000.15

▲ **C**ombining industrial materials and weaving techniques, and doubling as a metaphor for our world, *Cityscape No. 6* is an abstract work in which microfilm and Mylar, woven together, suggest the ordered disorder and information overload that accompany contemporary urban life. While the weave of film is strikingly rectilinear and austere, the individual frames remain indecipherable, banal, and ordinary. Suggesting gridiron street structures or the façades of glass office towers, *Cityscape No. 6* resonates with modernity. An artist who combines craft traditions with an innovative approach to industrial materials, Sandoval cunningly seduces the viewer by, in his own words, "making beauty from trash." JR

Tom Patti
American, born 1943
Tubated Bronze Airframe, 1978
Glass
3¹/₄ × 4¹/₄ × 3¹/₈ in.
(8.3 × 10.8 × 7.9 cm)
Partial and promised gift, Adele and
Leonard Leight Collection 1992.18.41

▶

Seeking what the artist has described as a "visual language of logic," Patti's sculpture appears passive and impersonal. Its sparse palette and simple cadence of geometric forms offer an alternative to the bright colors and fascination with technique often associated with contemporary glass; it is a handmade object that looks machine-made. Conceived as a detached composition understood solely in relation to itself, Patti's sculpture is associated with the Minimalist movement, which emerged in the United States in the 1960s. SE

▼ **L**eWitt's sculptures were assembled in accordance with strict sets of rules that produced forms that are both complex and visually intriguing. Viewing the cube as the building block of the world, in *Untitled (1-2-3-4-5-4-3-2-1 Cross)* LeWitt used this modular element in a simple progression of addition and subtraction. The resulting work, while straightforwardly logical in form, seems almost spiritual in its purity. LeWitt, often called the father of Conceptualism, insisted that "conceptual artists are mystics rather than rationalists. They leap to conclusions that logic cannot reach." KK

Sol LeWitt
American, 1928–2007
Untitled
(1-2-3-4-5-4-3-2-1 Cross),
1980
Painted aluminum
25¹/₄ × 165³/₄ × 165³/₄ in.
(64.1 × 421 × 421 cm)
Gift of the New Art Collectors 1987.18

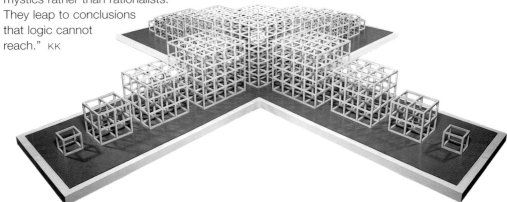

John DeAndrea
American, born 1941
Manet: Déjeuner sur l'herbe,
1982
Polyvinyl, polychromed in oil
Life-size

*Gift of the New Art Collectors of 1982
with additional funds from Atlantic Richfield
Foundation, the Alliance of the J.B. Speed
Art Museum, and Friends 1983.8 a–d*

▲

A leading artist of the Photorealist movement, DeAndrea is known for casts of human bodies reproduced in such fine detail that they are often mistaken for real people. This sculpture is based on Edouard Manet's famous painting *Déjeuner sur l'herbe* (1863), which shows a nude woman picnicking with two clothed men. DeAndrea used gray tones for his sculpture, rather than the lifelike colors of the painting, in part because he first became familiar with Manet's masterpiece through a black-and-white photograph. In DeAndrea's interpretation the men wear paint-spattered work clothes, suggesting that this is an artist's studio with a nude model, and in fact the figure in the dark T-shirt is a self-portrait of DeAndrea. JR

▶

Much of Rainey's work involves the recontextualization of ancient, Classical sculpture. Here a sheet of plate glass and an array of disfiguring marks violently mar an otherwise placid, Classically inspired torso. Rainey's title hints at a possible explanation: rather than Greek or Roman mythology, he invokes the mythological early Irish hero Cú Chulaind, whose violent and chaotic coming-of-age saga shares its name with this sculpture. Violence and chaos, in this case real rather than literary, have also plagued the artist's native Northern Ireland. SE

Clifford Rainey
Irish, born 1948
The Boyhood Deeds of Cú
Chulaind II, 1986
Glass
22³/₈ × 6³/₄ × 5¹/₂ in.
(56.8 × 17.1 × 14 cm)
Partial and promised gift, Adele and
Leonard Leight Collection 1992.18.43

David Levinthal
American, born 1949
Untitled (#MR098), from the
series *Modern Romance*,
1983–85
SX70 Polaroid land film
Image: 3¹/₈ × 3¹/₁₆ in.
(7.9 × 7.8 cm)
Gift of the New Art Collectors 2000.14.2.2

▲
Levinthal creates tableaux using toys and
models and then photographs them in
ways that (literally) blur their distinction from
reality. Representing small but pregnant
moments in a fictional urban narrative—
people in hotel rooms, in diners, on the
street—his photographs are reminiscent
of the film-noir genre of the late 1940s, as
well as of the paintings of Edward Hopper.
The individuals they depict are bathed
in a light that leaves them unfocused,
suggesting the alienation that accompanies
much city night-life. Levinthal's bleak
outlook evokes the singularity of the
individual urban experience, where the
soul seems lost in darkness, yet relief is
imminent in the recognition that these are
manufactured fictions. JR

▲

Celebration of shopping or critique of consumerism? Steinbach's work maintains this ambiguity through its stylish yet deadpan presentation of consumer objects. On pristine shelves that suggest both the cleanly manufactured forms of Minimalist sculpture and high-fashion commercial display, Steinbach elevates the everyday to the status of art in a variation on Marcel Duchamp's "ready-made." Juxtaposing American and Israeli cornflake boxes with ancient Near Eastern terra-cotta vessels, *stay with friends #1* suggests cultural contrasts between different types of containers (handmade versus mass-produced) and different languages (Hebrew versus English). Abstracted from an Israeli tourism slogan of the 1980s ("Come to Israel, stay with friends"), Steinbach's title implies that these are familiar objects to the artist, a bridge between his place of birth and his adopted homeland. JR

Haim Steinbach
American, born Israel 1944
***stay with friends #1**, 1986
Mixed-media assemblage
Overall: 32 × 145¹/₂ × 19¹/₂ in.
(81.3 × 369.6 × 49.5 cm)

Purchased with funds from the bequest of Esther Kraus and the bequest of Felicia Meyer Marsh, gift of the New Art Collectors, the Kentucky Arts Commission and the National Endowment for the Arts, and Mrs. Hattie Bishop Speed, by exchange 1993.8.1–.18

◄ **D**uring the 1980s Cragg made a number of radical works by sticking everyday, discarded materials to a wall so that they formed the outlines of recognizable objects. In *New Figuration*, fragments of plastic products and containers are arranged to make the image of a figure whose extended torso loops the loop. Cragg's title is at once ironic and earnest. While referring to the fashionable return of expressionistic figure painting in the art scene of the 1980s, it also suggests a reconsideration of the image's—and the viewer's—relationship to the material world. In this reconfiguring of consumerism's trash, Cragg combines ideas of wholeness with fragmentation and dissolution. JR

Tony Cragg
British, born 1949
New Figuration, 1985
Plastic wall construction
114 × 78¹/₂ × 2¹/₂ in.
(289.6 × 199.4 × 6.4 cm)

Gift of the New Art Collectors
1986.22.2.1–.164

Vito Acconci
American, born 1940
People's Wall, 1985
Painted wood, fabric, steel, mirrors
96 × 192¹/₄ × 39 in.
(243.8 × 488.3 × 99.1 cm)

Gift of Commonwealth Charities,
Jane, Elaine, Ed, and Marty Weinberg,
and their children 1991.18

◄ **C**elebrated since the 1960s for his concrete poetry, videos, installations, and performances, Acconci is an artist who has always been intensely concerned with the viewer's relationship to his work. Since the 1980s he has been designing sculptures and public artworks that resemble hybrid forms of architecture or furniture and encourage audience participation. *People's Wall* is like a large room divider with body-shaped cut-outs that allow the audience to maneuver themselves into these spaces and become part of the work. While accommodating the viewer's participation, this means of engagement also affirms the artist's power over his audience: viewers in the work are separated from other participants, their positions restricting how they can move, what they can see, and how they are perceived by others. JR

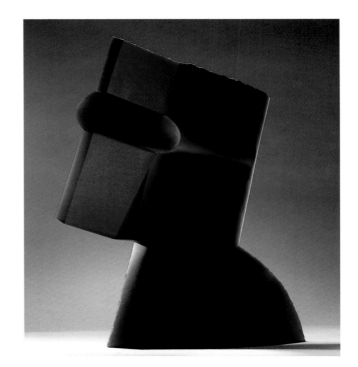

Stanislav Libenský
Czech, 1921–2002
Jaroslava Brychtová
Czech, born 1924
Queen II, 1992
Glass
32 × 26³/₄ × 3¹/₂ in.
(81.3 × 67.9 × 8.9 cm)
Partial and promised gift, Adele and
Leonard Leight Collection 1994.16.4

▲

The decades-long collaboration of spouses Libenský and Brychtová showed that glass could be used to produce compelling, monumental sculptures equal to those made from more traditional media, such as stone or metal. And, as *Queen II* demonstrates, the artists also managed to exploit glass's unique ability to transmit light. Their compositions began with Libenský's drawings, which were subsequently transformed into three-dimensional clay models by Brychtová. The sculptures were cast by melting glass within plaster molds made from Brychtová's clay prototypes. Stylistically, these restrained forms drew on a long-standing twentieth-century Czech tradition of abstraction that was heavily influenced by Cubism. Although spare, Libenský and Brychtová's work nevertheless possesses an emotive luminosity shaped by light and color. SE

▶

Like many of his Czech contemporaries, Vízner relies on the principles of twentieth-century Modernist design. Ornament is rejected as sentimental and excessive; in its place, shape and color define the viewer's experience. To achieve this vision, Vízner uses a limited range of cylinders, bowls, and plates, all made by machine cutting. True to his Modernist philosophy, he regards these uncompromising geometric forms as a rational, universal, visual language—one that explicitly rejects the fluid, expressive flourishes often found in the work of other contemporary artists who work in glass. SE

Václav Cigler
Czech, born 1929
Untitled, 1998
Glass
Each: 8 × 8¹/₄ × 9¹/₈ in.
(20.3 × 21 × 23.2 cm)

Partial and promised gift,
Adele and Leonard Leight Collection
1999.16.6 a,b

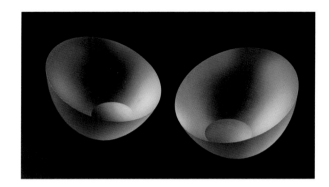

▲ **C**igler's sculpture explores the relationships between form, space, and viewer. At first glance the work seems purely formal: a compositional study of austere objects and the spaces they occupy and define. Its apparent sterility dissolves, however, as the viewer moves around the sculpture, and its opaque outer surfaces give way to transparent, mirrored interiors. As if depicting a dream, these surfaces capture, reflect, and distort images of the viewer and the surrounding space. For Cigler, the visual relationship between exterior and interior—one made possible by the transparent nature of glass—becomes a metaphor for the tension between our exterior personas and the conscious and subconscious worlds within. SE

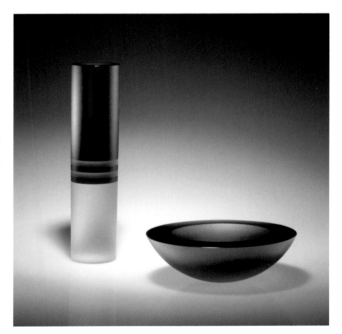

František Vízner
Czech, born 1936
Cylinder, 1990
Glass
16¹/₄ × 3⁷/₈ in.
(41.3 × 9.8 cm)

Partial and promised gift, Adele and
Leonard Leight Collection 1992.18.54

František Vízner
Czech, born 1936
Red Object, 1991
Glass
3⁵/₈ × 11¹/₄ in.
(9.2 × 28.6 cm)

Partial and promised gift, Adele and
Leonard Leight Collection 1994.16.24

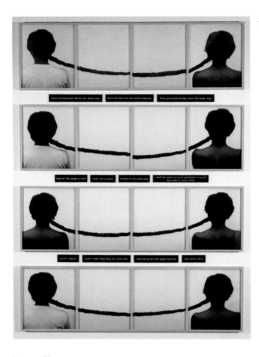

◀ **S**impson has commented that black women in the United States are treated by society as if they are faceless, without identity or individuality, and in much of her work she literalizes this issue by showing her models only from the back. The combination of images and text in *Same* raises questions about how we classify or characterize people through visual clues. Joined by their hair, the figures in *Same* are turned away from the viewer, while words and phrases inscribed on panels between the frames highlight the way that language guides the interpretation of images. Through this compelling illustration of the universal struggle for individuality, Simpson asks viewers to examine their own racial and sexual preconceptions. JR

Lorna Simpson
American, born 1960
Same, 1991
16 color Polaroids in four frames
with 11 plastic plaques
Overall: 118¹/₂ × 82¹/₄ in.
(301 × 208.9 cm)
Gift of the New Art Collectors 1991.22.2 a–e

▶

Rather than martyred saints or other religious subjects, Schaechter's stained glass favors secular, marginal subjects: often eccentrically dressed female figures whose worn and weary faces signify their plight. Here a morbidly depressed female figure languishes in her chair even as she sits amidst a cheerful carnival of colors and patterns. Irony also permeates the title. Though "Clown" suggests joy, "Stinkubus" is more malevolent. Schaechter's term plays on the words "incubus" and "succubus"—the names of male and female spirits who sexually prey on the sleeping. For Schaechter, the title refers not to her forlorn subject but to the context in which she resides; unnamed, the woman remains alienated and alone. SE

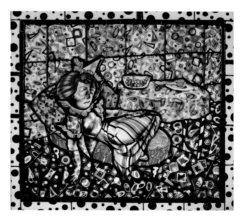

Judith Schaechter
American, born 1961
Clown Stinkubus, 1997
Stained glass
23³/₄ × 25³/₈ × 4⁵/₈ in.
(60.3 × 64.5 × 11.7 cm)
Partial and promised gift, Adele and Leonard Leight Collection 1998.22.12

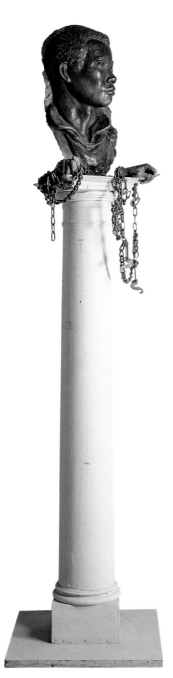

▼ **N**ationally recognized for public sculptures, such as the African–American Civil War Memorial in Washington, D.C., Hamilton often incorporates the residue of his monument-making in his improvisatory studio practices. The subject of *Untitled* is the kidnapped West African farmer Singbe-Pieh, who led the rebellion on the slave ship *Amistad* in 1839. The head is the original plaster cast Hamilton developed when making his bronze *Amistad* monument, here combined with elements found on the studio floor and discarded in the neighborhood. Through this mélange Hamilton honors Singbe-Pieh while speaking to both African–American history and the individual's struggle for identity. JR

Ed Hamilton
American, born 1947
Untitled, 1992–93
Plaster, wood, iron
Height: 107¹/₂ in. (273.1 cm)

Purchased in memory of Barbara Simmons Miller (1909–2000) with funds donated by the Speed Art Museum Community Support and Outreach Committee and the following donors: Brown & Williamson Tobacco Corp.; National City Bank; The Links, Incorporated, Louisville Chapter; Dr. and Mrs. S. Pearson Auerbach; New Zion Baptist Church, Rev. A. Russell Awkard, Pastor; Mr. and Mrs. Woodford Porter, Sr.; Alpha Kappa Alpha Sorority, Inc., Eta Omega Chapter; Delta Sigma Theta Sorority, Inc., Louisville Alumnae Chapter; The Girl Friends, Inc., Louisville Chapter; Jack & Jill of America, Inc., Louisville Chapter; Kentucky State University Foundation; The Moles, Louisville Chapter; National Coalition of 100 Black Women, Louisville Chapter; National Council of Negro Women, Kentuckiana Section; and 100 Black Men of Louisville 2000.8 a,b

Richard Marquis
American, born 1945
d'Marquis Bubbleboy #2, 1998
Glass
29¹/₈ × 12³/₈ × 7¹/₄ in.
(74 × 31.4 × 18.4 cm)

*Partial and promised gift, Adele and
Leonard Leight Collection 1999.16.8*

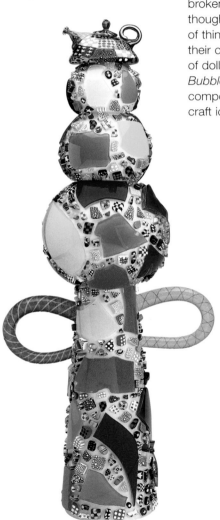

◄ **T**ypically playful, Marquis's sculpture deflates the
pretensions and clichés that populate the world of
contemporary art, craft, and design. The *Bubbleboy's*
body refers (as does the title) to the bubble formed
on the glassblower's pipe. Rather than being
indulgent displays of technique, though, Marquis's
bubbles act only as the canvas for a collage of
broken glass and applied *murrine*. The *murrine*,
though sliced from painstakingly constructed bundles
of thin glass rods, are intentionally cartoonish in both
their colors and their designs; they include images
of dollar signs and tick-tack-toe boards. The
Bubbleboy's hat concludes the artist's contrarian
composition: it reduces the teapot—a quintessential
craft icon—to a mere fashion accessory. SE

Bertil Vallien
Swedish, born 1938
Head 2, 1997
Glass, metal, wood support
Head:
8¹/₄ × 4³/₄ × 6⁷/₈ in.
(21 × 12.1 × 17.5 cm)
Wooden support, height:
64 in. (162.6 cm)

*Partial and promised gift, Adele and
Leonard Leight Collection 1999.16.3*

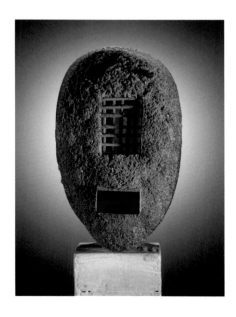

Mimmo Paladino
Italian, born 1948
Bread (Pane), from the series
Film, 1995
Etching and aquatint on
Arches paper
Image: 20¼ × 27¾ in.
(51.5 × 70.5 cm)
Gift of Sheila M. and Paul W. Chellgren
2002.22.39.2

▲ **P**aladino came to the forefront of the international art
scene in the late 1970s as one of a group of young Italian
artists who spearheaded an expressionist resurgence in
painting and sculpture. Dubbed the *Transavanguardia*
(Italian for "beyond the avant garde"), these artists wanted
to restore myth, mystery, and personal meaning to
contemporary art through the revival of figuration.
Paladino's works are characterized by delicate line
renderings of allegorical human figures, organic forms, and
geometrical shapes, all depicted in saturated colors. While
suggesting narratives, they remain nevertheless enigmatic,
their titles resonant rather than specifically meaningful.
Paladino's printmaking is characterized by the combination
of various techniques; an innovative craftsman, he often
works over his finished prints by hand. JR

◄
Vallien's prolific work in glass often deals with
remnants: remnants of history, remnants of culture,
and remnants of the psyche. *Head 2* falls into the
last category. It begins by turning the traditional
portrait inside out: rather than presenting a
recognizable face, the sculpture's mask-like quality,
awkwardly projecting glass squares, and metal grid
evoke a surreal internal world; rather than leaving the
viewer to wonder what lies below the surface, Vallien
seemingly presents the psyche itself. SE

Juan Muñoz
Spanish, 1953–2001
Piggy-Back ("A Caballito"),
1997
Bronze
Height: 68³/₄ in.
(174.6 cm)
Gift of the New Art Collectors 1997.2

▶

Muñoz avoids rendering his sculptures
realistically, explaining that "the more realistic
they are meant to be, the less interior life they
have." Influenced by the Minimalist artists of
the 1960s and 1970s, Muñoz's work was
concerned with the dynamic relationship
between object, viewer, and surrounding space.
Piggy-Back invites the viewer to take an active
role in its interpretation: it could symbolize
carrying someone else's burden, or it could
represent an internal struggle between two
aspects of the self. Describing himself as a
storyteller, Muñoz said, "I build metaphors in the
guise of sculptures because I don't know any
other way to explain to myself what it is that
troubles me." KK

▶

Described as "New Abstractionist," Murray's paintings are almost like
relief sculptures, their bold colors and forms heavily influenced by cartoon
drawing. Taking the everyday object as her subject matter, Murray
distorted it so that the familiar becomes ambiguous. Without being
sentimental, the preparatory sketches for *What Is Love* show that it
evolved from what curator Robert Storr has described as "an extended
meditation on snuggling, the simplest of comforts a couple can enjoy."
The result is a visual puzzle that resembles a bed the rumpled sheets and
encroaching bedposts of which could equally be the setting for something
comforting, passionate, or even nightmarish. Remarking only that the
painting is very close and personal to her, Murray leaves it to the viewer to
decide how best to interpret the image and perhaps answer the question
posed in its title. KK

Kiki Smith
American, born 1954
Untitled, 1992
Latex, glass
5³/₈ × 74³/₄ × 36³/₄ in.
(13.7 × 189.9 × 93.3 cm)
Gift of the New Art Collectors and
museum purchase 1995.4 a,b

▲ **S**mith uses images of the body as a means of exploring her subjective sense of her place within the world. As a feminist, she is also interested in creating an alternative to Classical art's self-contained, fixed, and harmonious representation of the female form. As a result, her figures often reveal the interior space of the body, confronting the viewer with a sometimes uncomfortable juxtaposition of the intimate and the universal. A glass rendering of a spine resting atop a latex mold of a woman's body, *Untitled* evokes both a literal and a symbolic flaying, suggesting the body as a site of existential pain. "In working with the body," Smith says, "I feel I'm actually making physical manifestations of psychical and spiritual dilemmas." KK

Elizabeth Murray
American, 1940–2007
What Is Love, 1995
Oil on canvas
98¹/₄ × 74 × 11 in.
(249.6 × 188 × 27.9 cm)
Gift of the New Art Collectors 1995.8

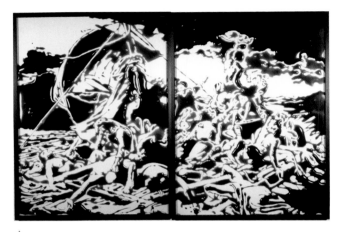

Vik Muniz
American, born Brazil 1961
The Raft of the Medusa,
from the series *Pictures
of Chocolate*, 1999
Silver dye bleach print
(Ilfochrome), two parts
Overall:
68³/₁₆ × 100⁷/₁₆ in.
(173.2 × 255.1 cm)

*Gift of the New Art Collectors
2000.14.3 a,b*

Art © Vik Muniz/Licensed by VAGA,
New York, NY

▲
Brazilian-born artist Vik Muniz loves crafty visual puzzles
that toy with perception. He can start with an anonymous
image and glamorize it or, contrariwise, take the well
known and subject it to the everyday. Part of his *Pictures
of Chocolate* series, *The Raft of the Medusa* is based on
Théodore Géricault's iconic French Romantic painting of
the same name. After copying the Géricault image on to
a light-box using Bosco chocolate sauce and a needle,
Muniz has translated the image into a photograph. The
result brings an ironic lightness to Géricault's dramatic
work, deflating its heroic gravity through the crude drawing
of the chocolate, the quickly articulated surface of which is
reminiscent of Jackson Pollock's action painting. JR

Los Carpinteros
Marco Antonio Castillo Valdés
(Cuban, born 1971),
Dagoberto Rodríguez Sánchez
(Cuban, born 1969),
Alexandre Arrechea
(Cuban, born 1970, member
until 2003)
Edificio Jerez, 2003
Cedar plywood
27¹/₂ × 136¹/₄ × 131 in.
(69.9 × 346.1 × 332.7 cm)

*Purchased with funds from the
New Art Collectors and the Alice Speed Stoll
Accessions Trust 2004.9.2*

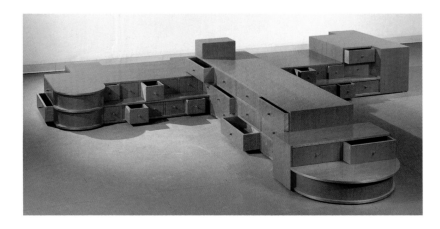

▼ **U**sing a colorful printed cloth called Dutch Wax, which is often perceived as representing "African-ness" but the origins of which are actually entangled with colonialism, Shonibare's work comments with wit and humor on themes of history, identity, and fantasy. *Three Graces* is based on a photograph of three women in Edwardian dress that the artist found in the archives of the Hendrik Christian Andersen Museum in Rome. Recreating them as mannequins dressed in Dutch Wax, *Three Graces* alludes not only to Classical Greek sculpture but also to ideas of history, fashion, commerce, and multiculturalism. Referring to this playful mix, the artist has said, "The mind should be allowed to travel and have fantasy and imagination. People's minds need to wander." JR

Yinka Shonibare, MBE
British, born 1962
Three Graces, 2001
Printed cotton textile,
three fiberglass mannequins,
three aluminum bases
Life-size

*Purchased with funds from the
Alice Speed Stoll Accessions Trust
2002.6 a–c*

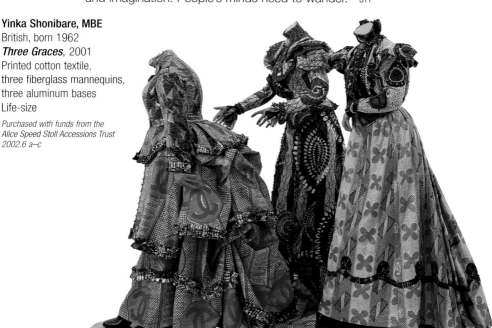

◄

The Cuban collective known as Los Carpinteros, formed in 1991, adopted their name in 1994, after fellow students in Havana compared their intense craft-oriented practice to the labor of carpenters. Working together as a team, they create sculptures and drawings that merge domestic and architectural forms in often humorous and surprising ways. *Edificio Jerez* is based loosely on a building of the same name in Havana; now demolished, it served as a language school during the Soviet era. The artists have adapted its form to create a hybrid sculpture that is simultaneously an architectural model and a useful piece of furniture. Combining ideas about public and private space, Los Carpinteros here suggest the interdependence of the individual and society while simultaneously questioning the distinction between high and low art. JR

▶

Apfelbaum creates works that communicate moods ranging from romantic and joyous to intimate and melancholic. *Wallflowers (Mixed Emotions)* consists of hundreds of crepe-paper flowers, pinned to the wall in concentric circles. While this geometry suggests the reduced and rigid aesthetic of Minimalism, Apfelbaum's choice of material and title imbues the work with a light and tender melancholy. "Wallflowers" is a term most readily associated with women who remain seated or are not partnered at a dance or party. In contrast, Apfelbaum's *Wallflowers* forms a delicate mandala of sorts that centers the eye and refuses to be ignored. JR

Catherine Yass
British, born 1963
Descent: HQ5: 1/4s, 4.7°,
0mm, 40mph, 2002
Ilfochrome transparency, light-box
64¹/₂ × 50³/₄ × 4⁷/₈ in.
(163.8 × 128.9 × 12.4 cm)
Gift of the New Art Collectors 2003.2

▲

Employing experimental photographic methods, Yass creates images of urban landscapes in which vivid colors suggest the intense bustle and energy that surround contemporary city living. Presented as a photographic light-box, the image used in *Descent* was taken while Yass stood on a tower-crane at the top of one of London's tallest building sites. As the shutter opened, the artist rotated the camera lens mechanically downwards. Traveling through 4.7 degrees of rotation at 40 miles per hour for a quarter of a second, the camera blurred the image into streaks of color and light, recording what the human eye cannot normally see, and suggesting the sensation of either falling or flight. JR

Polly Apfelbaum
American, born 1955
Wallflowers (Mixed Emotions),
1990
Mixed media, wire, paper, tacks,
pencil, glitter
Diameter: 69³/₄ in. (177.2 cm)

Purchased with funds from the New Art
Collectors and the Alice Speed Stoll
Accessions Trust 2004.9.3

▼ **W**hile Hodgkin's paintings tend to be compact in size, his prints instead explore the boundaries of both scale and technique. *Venice, Morning* is one of a series of four large-scale printed works aiming to express the artist's feelings at different times of day. Its dense surface results from a layering of printing techniques, which are subsequently over-painted by hand. Using a restricted range of colors and simple marks to create a variety of moods, Hodgkin strives to recollect poetically his experience of Venice and to pin down what he calls "the evasiveness of reality." JR

Howard Hodgkin
British, born 1932
Venice, Morning, 1995
Hand-painted etching and
aquatint on paper
62³/₄ × 81¹/₁₆ in.
(159.4 × 205.9 cm)

Gift of Sheila M. and Paul W. Chellgren
2002.22.20 a–p

◀ Influenced by the 1960s sculptor Eva Hesse, Traylor accommodates the sensual and tactile within an abstract aesthetic. Here her voluptuous shapes evoke swollen fruit or vulvular forms. On closer inspection, however, one sees that the sculpture's fluid volumes are encased within hard metal skins. The contrast between metal and glass introduces a string of opposites: rigid versus fragile, vulnerability versus strength, shelter versus exposure, literal meaning versus veiled evocation. Such dichotomies define much of Traylor's recent work. SE

Pamina Traylor
American, born 1964
Swells, 2003
Glass, metal
Each: 11³/₄ × 7 × 4 in.
(29.8 × 17.8 × 10.2 cm)

Partial and promised gift, Adele and
Leonard Leight Collection 2004.19.7 a,b

Helen Chadwick
British, 1953–1996
Glossolalia, 1993
Bronze, fox pelts, oak table
49⁵/₈ × 83³/₈ in.
(126 × 211.8 cm)

Purchased with funds from the Alice Speed
Stoll Accessions Trust 2001.17 a–c

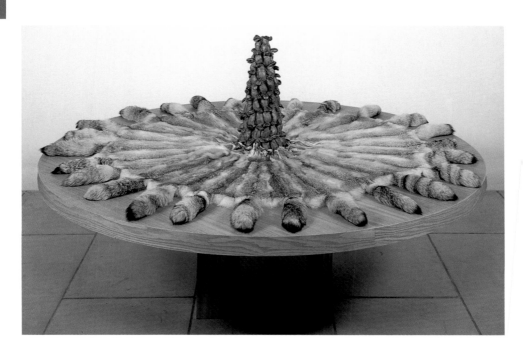

▼ **A**t first glance *The Big Red Rose* has the look of spontaneity associated with Abstract Expressionism, but on closer inspection what seem to be only gestural marks reveal themselves as a filigree of overlaid images of women's nude bodies meticulously embroidered on the canvas. Beneath this needlework the artist has painted three roses, depictions of a flower that for centuries has been venerated as a symbol of love, affection, and fertility. Fashioning a mediating context for the images of female bodies, the painted and embroidered lines interlock in a dense and active abstraction that communicates the tension between the immediacy of the brush marks and the time-consuming craft of embroidery. In this mix Amer transforms images derived from pornography into a poetic and provocative examination of art, labor, and self-love, at once teasing, humorous, and contemplative. JR

Ghada Amer
Egyptian, born 1963
The Big Red Rose—RFGA,
2004
Acrylic, embroidery, and gel
medium on canvas
72 × 64 in. (182.9 × 162.6 cm)

Purchased with funds from the
New Art Collectors and the
Alice Speed Stoll Accessions Trust
2004.9.1

◀ **C**hadwick's work abstracts the sense of herself as a woman into visual archetypes of the female experience, and her use of beauty, almost always derived from the body, continually flips between pleasure and taboo. "A hundred tiny penises" is her own description of the fleshy lambs' tongues that she stitched together and cast in a bronze pillar encircled with a luxuriant fringe of fox pelts. While referring to the phenomenon of "speaking in tongues," *Glossolalia* also displays an operatic sensuality that reverberates with theatrical excess and abounds with symbolic and mythical references. This is Chadwick at her most baroque, exploring desire through a celebration of pleasure while enveloping it in a multiplicity of meanings. JR

▼ **K**ruger derives her style, which juxtaposes newspaper and magazine images with slogan-like texts, in part from her early career as a designer and photo editor for Condé Nast publications. In *Untitled (Talk Like Us)*, an image of a tongue sticking out of a mouth is overprinted with phrases that are both declarative and accusative in tone. The two boxes of text juxtapose phrases using the reflexive pronoun "us" and the possessive pronoun "your" to create uncertainty in the viewer as to whose voice is actually being represented. In a purposeful departure from the categorical messages of popular advertising, Kruger uses ambiguity to expose the media's deployment of words and images to manipulate our view of the world. JR

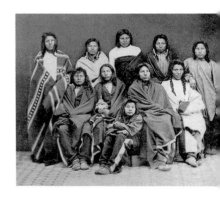

Barbara Kruger
American, born 1945
Untitled (Talk Like Us), 1994
Photographic screenprint on
Plexiglass
55 × 55 in.
(139.7 × 139.7 cm)
Gift of Mrs. Hattie Bishop Speed,
by exchange 1994.3.2

Carrie Mae Weems
American, born 1953
The Armstrong Triptych, 2000
Ink on canvas, three parts
Overall: 68 × 246³/₄ in.
(172.7 × 626.7 cm)
Gift of the New Art Collectors 2001.9 a–c

▲
Weems's primary source for this work
is an album of photographs by Frances
Benjamin Johnston (1864–1952) of the
Hampton Normal and Agricultural Institute.
Founded in Virginia by Union General
Samuel Chapman Armstrong shortly after
the Civil War, the institute provided an
education to blacks and Native Americans
in trades and academic subjects. While
the two side panels here show a group
of Native Americans before and after their
schooling, the central panel is a portrait of
Armstrong's own family. Over this image
Weems has printed, "With your missionary
might you extended the hand of grace
reaching down and snatching me up and
out of myself," a simple juxtaposition of
word and image that grounds the work
in issues of individual identity, class,
assimilation, and education. JR

Jennifer McCoy
American, born 1968
Kevin McCoy
American, born 1967
How I Learned, 2002
Metal suitcase, foam rubber,
video monitor, DVD player,
four painted wooden shelves,
261 DVDs in cases
Overall: 40 × 64³/₄ × 6 in.
(101.6 × 164.5 × 15.2 cm)

*Gift of the New Art Collectors
2002.12.3 a–i*

▲

Jennifer and Kevin McCoy produce multimedia works that combine the languages and techniques of digital production with the realm of television viewing. *How I Learned* uses clips from the popular 1970s television series *Kung Fu*, reassembled on DVDs as an archive of actions. Beside a video monitor on which they can be played, the DVDs are displayed on shelves in four groups: *How I Learned about Religion*, *How I Learned about Nature and Society*, *How I Learned about Capitalism and Violence*, and *How I Learned about Filmmaking*. This reassembling of *Kung Fu* fractures its storyline, and what at first seems like a humorous play on narrative subsequently sparks reflection about how the popular media create meaning and how one learns their habits. JR

Tony Oursler
American, born 1957
MMPI (I Like to Watch), 1995
Video installation with video
projector, VCR, videotape, small
cloth figure, metal chair
Overall: 24³/₄ × 55 × 25 in.
(62.9 × 139.7 × 63.5 cm)

*Promised and partial gift of Laura Lee
Brown and Steve Wilson 1998.16 a–e*

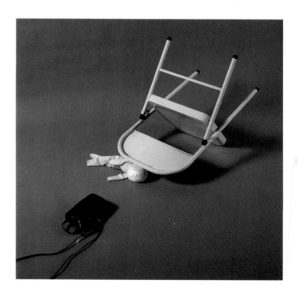

▼ In Greek mythology, Prometheus creates mankind from clay but is then condemned for also revealing fire. He is tied to a rock for eternity as an eagle consumes his regenerated liver anew each day. In Wallinger's *Prometheus*, the central figure of the artist/creator, strapped into an electric chair, sings "Full Fathom Five," an ode to metamorphosis and death from Shakespeare's play *The Tempest.* The song is mechanically slowed to a low-pitched dirge that renders the words indecipherable, then rewound at a high-pitched screech. Repeated endlessly, the video mirrors the fate of the mythical Prometheus while suggesting electricity's resonance with the divine spark of life, as well as death. JR

Mark Wallinger
British, born 1959
Prometheus, 1999
Continuous-loop video projection
Maximum projected width:
157½ in.
(400 cm)
Gift of the New Art Collectors 2002.5

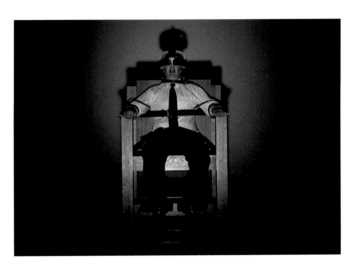

◄

Oursler is best known for sculptures in which he brings inanimate dolls and mannequins to life by projecting video images of talking faces on to them. In *MMPI (I Like to Watch)* the artist projects his own face on to a rag doll and recites statements from the Minnesota Multiphasic Personality Inventory (MMPI). A diagnostic tool developed in the 1950s, MMPI is a test for mental health based on the discovery that individuals with similar mental disorders frequently answer the same questions in similar ways. Its head trapped under a folding chair, Oursler's hapless rag doll delivers the statements in the MMPI in a droll, monotonous voice, suggesting a mindless self-absorption that is both witty and unsettling. JR

▼ **D**inh Q. Lê's meticulous artistic process involves slicing two photographs into thin strips and then weaving them together into a single work, counterpointing the fleeting glimpse of the camera with the long, patient labor of the hand. In this work he focuses on two major events in Cambodian history: the building and later abandonment of hundreds of temples during the Angkor period (ninth to twelfth centuries) and the autogenocide committed by the Khmer Rouge between 1975 and 1978 under the dictatorship of Pol Pot. Weaving together images of the Angkor temples and portraits of the victims of the Khmer Rouge, Lê's work gestures subtly at themes of history, memory, and loss. JR

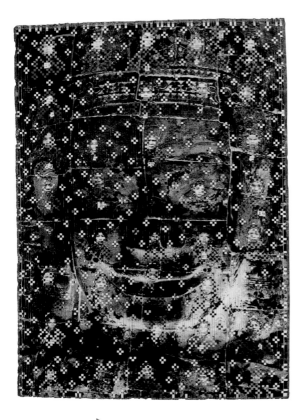

Dinh Q. Lê
American, born Vietnam 1968
Untitled #12, from the series
**Cambodia: Splendour and
Darkness**, 1999
C-print, linen tape
58¹/₈ × 40 in.
(147.6 × 101.6 cm)
Gift of the New Art Collectors 2000.14.1

▶

Dealing with issues of race, class, and gender, Searle places her own body at the center of her works. *Home and Away* is a dual-screen video projection set in the sea between Spain and Morocco, a body of water that has always been a place of migration. Searle's body floats in and out of the camera's vision, but as this continuous shot starts to widen toward the coastline, we become aware that she is alone and vulnerable. The artist's voice begins to articulate the verbs "to love," "to fear," and "to leave," enunciations that become ambiguous; while at first the viewer tends to associate them with her floating figure, one soon senses that they could also be the utterances of those left behind. JR

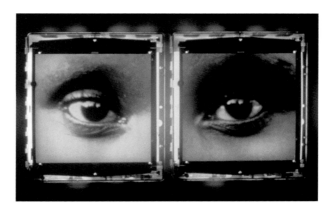

Alfredo Jaar
Chilean, born 1956
The Eyes of Gutete Emerita,
1996
Two quad-vision light-boxes,
two transparencies, two masks,
synchronizing cable
Each light-box:
25$\frac{1}{2}$ × 22$\frac{3}{4}$ × 5$\frac{1}{4}$ in.
(64.8 × 57.8 × 13.3 cm)

*Purchased with funds from the
New Art Collectors and the
Alice Speed Stoll Accessions Trust
2003.9 a–g*

▲ **J**aar has focused increasingly on the invisibility of suffering in the developing world and especially the Rwanda genocide. *The Eyes of Gutete Emerita* consists of two light-boxes with a switching mechanism that allows the image to change. Three texts appear successively on this pair of screens and then, for a fraction of a second, the eyes of a woman, Gutete Emerita, are projected, one in each light-box. The texts describe how Gutete Emerita watched her family being brutally murdered and how she survived, and as we face Jaar's narration, the woman's gaze, like lightning, flashes into being and disappears. This process is repeated over and over again, reinforcing the import of the text and the emotional power of Emerita's eyes, and symbolizing the intermittent Western attention to the African tragedy. JR

Berni Searle
South African, born 1964
Home and Away, 2003
Two-channel video projection:
6 minutes
Each, maximum projected width:
157$\frac{1}{2}$ in. (400 cm)

*Gift of the New Art Collectors 2005.9.1
Commissioned by NMAC Montenmedio Arte
Contemporáneo, Vejer, Spain*

Selected Glossary

abstract (abstraction): Refers to subject matter that has no recognizable form, or to a simplified or altered representation of form.

Abstract Expressionism: Movement in American painting in the 1940s and 1950s based on the depiction of direct emotion through nonrepresentational forms, incorporating diverse styles, including spontaneous gesture and color-field painting.

academic: Referring to the traditions and teachings of the official academies of painting and sculpture that flourished in Europe from the seventeenth to the nineteenth centuries.

action painting: Style used by some **Abstract Expressionists** in which a medium is deposited on to the support by energetic or impulsive means, reflecting the physical act or performance of painting.

Adam (style): Style associated with Scottish architect Robert Adam (1728–1792), fashionable in Great Britain in the mid- to late eighteenth century. Its characteristic symmetry and geometric design were inspired by ancient Greek and Roman sources.

Art Deco: International style prevalent in the 1920s and 1930s characterized by streamlined forms, geometric patterning, vibrant color, and the use of extravagant materials and textures.

Art Nouveau: International style that flourished from the 1880s until World War I, and featured decorative, sinuous curves based primarily on plant forms.

Arts and Crafts: International nineteenth- to twentieth-century movement focused on the revitalization of decorative arts and design, and characterized by fine craftsmanship and simple, functional forms as well as an opposition to industry, mass production, and opulent historicism.

avant garde: Term that often refers to various nineteenth- to mid-twentieth-century art movements that departed from existing norms in new and experimental ways.

Barbizon School: Informal group of nineteenth-century French painters named for the village of Barbizon, near Paris, who rejected idealized landscapes in favor of naturalistic, rural landscapes and representations of humble peasant life.

Baroque: Style in art and architecture prevalent from about 1600 to 1750, characterized by exuberant forms, intense drama and emotion, and monumentality.

biomorphic: Two- and three-dimensional forms that are nonrepresentational yet suggestive of living organisms.

broadside: Sheet of paper with a printed notice or advertisement for distribution or posting.

cabinet pictures: Small paintings intended for display in a residential setting.

cameo: Small **relief** sculptures made of gems, hard stones, or other materials with layers of contrasting colors, carved so that the image stands out against the background layer.

Caravaggesque: Painting style influenced by the dramatic **Realism** and intense contrasts of light and shadow characteristic of the artist Caravaggio (Michelangelo Merisi da Caravaggio, 1571–1610).

Classicism (Classical): Stylistic qualities inspired by the art and architecture of ancient Greece and Rome, characterized by idealized figures, symmetry, and simplicity.

Conceptualism: International art movement rooted in the 1960s, emphasizing the artist's idea or concept, rather than the making of the artwork itself, and often rejecting the use of traditional media and composition.

cope: A long mantle worn by ecclesiastics.

Cubism: Initiated by Pablo Picasso and Georges Braque around 1908, a movement that rejected the traditional idea that art should imitate nature, and instead depicted objects broken into multiple facets and seen from different viewpoints simultaneously.

diptych: A work made up of two hinged panels, which close like a book.

emblem: An image, sometimes accompanied by explanatory text, with a symbolic meaning.

enamel: A material made of ground glass (frit) fused to a metal surface with heat.

engraving: An **intaglio** printmaking technique in which an image is incised into a metal plate with a V-shaped metal tool called a burin; a print made from an engraved plate.

Eucharist: A Christian sacrament and act of worship in which consecrated bread and wine are consumed in commemoration of the Last Supper and death of Christ, symbolizing Christ's sacrifice.

Expressionism: International style prevalent in the early twentieth century, particularly in Germany, prioritizing emotional expression over traditional representation. Form and color were distorted and intensified in order to capture an impulse or state of mind.

Fauvism (Fauve): Movement in French painting early in the twentieth century marked by the use of vibrant, pure color, tactile brushstrokes, and spontaneous, simplified forms.

film noir: Literally "black film"; motion-picture genre that emerged in Hollywood in the 1940s and 1950s, typified by a dark, cynical tone, urban setting, and disillusioned characters.

fleur-de-lis (pl. *fleurs-de-lis*): Literally "flower of the lily"; a lily motif, traditionally a device used by French royalty.

fresco: Painting technique in which pigment suspended in water is applied to a wet plaster wall and absorbed into the plaster as it dries, bonding the pigment to the wall; a mural painting made with the fresco technique.

frieze: In **Classical** architecture, a narrow horizontal band found above a colonnade and below a cornice, often containing figures in relief.

Futurism: Movement founded in Italy in 1909; its works emphasized the speed, motion, and technology of the modern world.

genre: Subject matter that depicts activities of everyday life; also a particular artistic category based on style or subject matter.

German Expressionism: *see* **Expressionism**.

glazier: Person who cuts and fits glass, especially for windows.

gouache: Literally "wash"; opaque, water-based paint containing a white material made from chalk, lead, or zinc oxide; a work of art created with gouache.

Grand Tour: An educational journey in continental Europe, especially France and Italy, that became popular in the eighteenth century for aristocratic young men as a culmination of **Classical** studies and an opportunity to acquire art and antiquities.

hatching: Technique using a series of fine lines to render shade or tone.

iconography: Pictorial imagery, sometimes symbolic, used to illustrate a subject in art.

impasto: Application of paint in thick, solid strokes to create a paste-like texture.

Impressionism: Nineteenth-century movement originating in France, utilizing small touches of pure, unblended color to capture fleeting effects of light and color in landscape subjects and scenes of modern life.

intaglio: In printmaking, any of several techniques in which an image is incised into a plate to hold ink for printing.

intimism (*intimiste*): Late nineteenth-century style that depicted informal, domestic scenes in an **Impressionist** manner, emphasizing pattern and surface texture.

lacquer: Shellac varnish of Asian origin applied in numerous thin coats that harden and dry with a high gloss; it is often inlaid with precious materials and used as a protective or decorative finish.

lithography (**lithograph**): Printmaking technique created by drawing on a porous surface with a greasy material, then wetting the surface and applying an oil-based ink that adheres only to the drawing; a print made using lithography.

maiolica: Tin-glazed earthenware pottery associated with Italy, featuring colorful painted decoration on a white ground, often with figurative scenes.

mandala: A geometric image, usually concentric circles, originating in Eastern cultures as a symbol of the universe and as a meditation tool.

Mezzotint: Literally "half-tone"; printmaking technique in which the surface of the plate is roughened using a tool with a serrated edge to create varying tones; a print made using the mezzotint technique.

Minimalism: Simplified, restrained style that developed in America in the 1960s and produced objects with no intended expression or illusion.

modello (pl. **modelli**): Literally "model," "pattern," or "sample"; preparatory version of a work of art made by an artist to illustrate an idea for a larger, more elaborate work.

Modernism: A succession of art movements, especially during the first half of the twentieth century, that experimented with the formal elements of painting, such as space, line, and color.

murrine: Technique in which glass canes are fused together and stretched, sliced into disks to reveal a cross-section of the fused canes, then arranged and fused again to create a decorative design.

Neoclassicism: International movement from the mid-eighteenth to the mid-nineteenth century inspired by Greek and Roman archaeological discoveries. **Classical** themes were revived in various media, with an emphasis on severe, monumental forms.

odalisque: Female slave or concubine in a harem, often portrayed by nineteenth- and twentieth-century artists as idealized female nudes lounging in sumptuous Oriental settings.

Orientalism: Nineteenth-century style influenced by European contact with present-day Turkey and Greece, the Middle East, and North Africa.

palette: Range of color utilized by an artist.

Passion (**of Christ**): In Christian belief, the suffering and death of Christ, or the events leading up to and following Christ's Crucifixion.

pastel: Medium made up of ground pigment and a binding material in solid stick form; a work of art created with pastels.

pendant: Work of art intended to be displayed with a companion piece, often having related subject matter.

Photorealism: International movement in the 1960s and 1970s characterized by the exact representation of subject matter, often based on photographs.

plein-air: Literally "open-air"; the practice of painting out of doors, as opposed to inside an artist's studio.

Pop art: International movement in the 1950s and 1960s making use of familiar imagery, such as consumer packaging and mass-media icons. Commercial techniques were common and contributed to the ironic and witty openness of the artwork.

porte-crayon: Metal instrument that holds crayon, chalk, charcoal, or **pastel** and is used for drawing.

Post-Impressionism: Movement in late nineteenth- and early twentieth-century painting that followed **Impressionism** and disregarded its principles; umbrella term that applies to several disparate styles developed by French painters, each seeking an independent formal approach to painting.

Precisionism: Loosely organized movement in American painting beginning about 1915; its artists favored smoothly and precisely rendered subjects selected for their geometric qualities.

ready-made: A mass-produced everyday object presented and viewed as a work of art, a practice invented by the twentieth-century artist Marcel Duchamp.

Realism: Nineteenth-century movement, particularly in France, focused on truthfully depicting un-idealized scenes of peasant and working-class lifestyles; also used

generally for any work of art portraying representational subject matter as it appears to the eye.

relief: Type of sculpture in which an image projects from a background plane.

Renaissance: Style originating in fourteenth-century Italy characterized by greater accuracy in anatomy and perspective and a revived interest in **Classical** Greece and Rome.

Rococo: European style that emerged in France at the turn of the eighteenth century, characterized by sumptuous and ornate taste, frivolous subject matter, and an abundance of naturalistic and nonrepresentational ornament.

samovar: Metal urn, or vessel, of Russian origin used to boil water for tea.

screenprint: Printmaking technique in which ink is forced through an open-weave screen traditionally made of silk. A masked design on the screen, made from a cut stencil or reproduced photographically, creates the printed image. Also a print made using a screenprint technique.

Second Empire: French style during the reign of Napoleon III (1852–70); it spread throughout Europe and America and was characterized by lavishness and flamboyance.

terra-cotta: Literally "baked earth"; a type of clay, usually brownish-red in color, fired and used for sculpture, pottery, and architectural elements.

tusche: Oil-based liquid used in **lithography** to create an image that is receptive to printing ink.

Picture Credits

Photography credits

Photography by M.S. Rezny, with Richard Bram, David Harpe, Kenneth Hayden, John Nation, and Bill Roughen

Additional photography

Ghada Amer, *The Big Red Rose— RFGA*, 2004. Courtesy Gagosian Gallery, New York. Photo by Robert McKeever

Los Carpinteros, *Edificio Jerez*, 2003. Courtesy Anthony Grant Gallery, New York

Chinese, Eastern Han dynasty, Tower, AD 25–220. Courtesy J.J. Lally and Co., New York

Chinese, Tang dynasty, Foreign man, about AD 700–756. Courtesy of Eskenazi Ltd, London

John DeAndrea, *Manet: Déjeuner sur l'herbe*, 1982. Photo by D. James Dee

Alfredo Jaar, *The Eyes of Gutete Emerita*, 1996. Courtesy Galerie Lelong, New York

Berni Searle, *Home and Away*, 2003. Courtesy Michael Stevenson Gallery, Cape Town, South Africa

Yinka Shonibare, MBE, *Three Graces*, 2001. Courtesy Stephen Friedman Gallery, London. Photo by Stephen White

David Teniers I, *The Raising of Lazarus*, 1630s or later. Courtesy Alex Wengraf Limited. Photo by Prudence Cuming Associates Ltd

Mark Wallinger, *Prometheus*, 1999. Courtesy Anthony Reynolds Gallery, London

John Wesley, *Golden Horde*, 1966. Photo by Douglas M. Parker Studio

Catherine Yass, *Descent: HQ5: 1/4s, 4.7°, 0mm, 40mph*, 2002. Courtesy Alison Jacques Gallery, London, and Galerie Lelong, New York

Copyright credits

These works have been reproduced courtesy of the credited artists and organizations:

Ghada Amer, *The Big Red Rose— RFGA*, 2004. © 2006 Artists Rights Society (ARS), New York/ADAGP, Paris

Hans Arp, *Awakening*, cast 1953 after 1938 plaster original. © 2006 Artists Rights Society (ARS), New York/VG Bild-Kunst, Bonn

Hans Arp, *Constellation of White Forms on a Violet Form*, 1953. © 2006 Artists Rights Society (ARS), New York/VG Bild-Kunst, Bonn

William Bailey, *Still Life of 10 Eggs, White Vase, Blue and White Vase and Enamel Cup*, 1971. © William Bailey, courtesy Betty Cuningham Gallery, New York

Giacomo Balla, *Line of Speed (Linea di velocità)*, 1913. © 2006 Artists Rights Society (ARS), New York/SIAE, Rome

Constantin Brancusi, *Mademoiselle Pogany I*, 1913. © 2006 Artists Rights Society (ARS), New York/ADAGP, Paris

Los Carpinteros, *Edificio Jerez*, 2003. Courtesy of Sean Kelly Gallery, New York

Henri Cartier-Bresson, *Hyères, France*, negative 1932. © Henri Cartier-Bresson/Magnum Photos

Helen Chadwick, *Glossolalia*, 1993. © The Helen Chadwick Estate

Marc Chagall, *Waiting (L'Attente)*, 1967. © 2006 Artists Rights Society (ARS), New York/ADAGP, Paris

Tony Cragg, *New Figuration*, 1985. Courtesy the artist and Lisson Gallery, London

Jean Dubuffet, *Appeal for Calm (Appel au calme)*, 1962. © 2006 Artists Rights Society (ARS), New York/ADAGP, Paris

Max Ernst, *Are You Niniche?*, 1955–56. © 2006 Artists Rights Society (ARS), New York/ADAGP, Paris

Sources

The direct quotations in this book have been taken from the following sources:

Page 15: "Value of Art Galleries," *The Louisville Times*, Louisville, Ky., December 28, 1926

"A Beautiful Memorial," *The Courier-Journal*, Louisville, Ky., February 8, 1925, section 5, p. 6

Page 16: "Death Takes James B. Speed," *The Courier-Journal*, Louisville, Ky., July 8, 1912, p. 5

Page 72: Susan J. Barnes, et al., *Van Dyck: A Complete Catalogue of the Paintings*, New Haven, Conn. (published for the Paul Mellon Centre for Studies in British Art by Yale University Press) 2004, p. 592

Page 83: Jan Sysmus, quoted in Walter Liedtke, *A View of Delft: Vermeer and His Contemporaries*, Zwolle (Waanders Publishers) 2000, p. 136

Page 105 (top): Philip Thicknesse, quoted in Walter Armstrong, *Gainsborough and His Place in English Art*, London (William Heinemann) and New York (Charles Scribner's Sons) 1899, p. 66

John Hayes, *The Landscape Paintings of Thomas Gainsborough: A Critical Text and Catalogue Raisonné*, 2 vols., Ithaca, NY (Cornell University Press) 1982, I, p. 44

Page 105 (bottom): Leslie Stephen and Sidney Lee (eds.), *The Dictionary of National Biography* [1885–90], 22 vols., Oxford (Oxford University Press) 1959–60, VIII, p. 980

Page 107: Nicholas Goodison, *Matthew Boulton: Ormolu,* London (Christie's) 2002, p. 64

Page 110: *Portraits and Figures in Paintings and Sculpture 1570–1870*, exhib. cat., London, Heim Gallery, June–August 1983, n.p.

J. Tripier Le Franc, *Histoire de la vie et de la mort du Baron Gros, le grand peintre*, Paris (J. Martin) 1880, p. 89

Page 114: *Kentucky Gazette and General Advertiser*, Lexington, Ky., February 28, 1807

Page 118: Samuel D. Baldwin, *Life of Mrs. Sarah Norton; An Illustration of Practical Piety*, Nashville (J.B. M'Ferrin, for the Methodist Episcopal Church, South) 1858, p. 39

Page 125: *Bulletin of the American Art Union*, II, no. 2, 1849, p. 10

The Literary World, April 14, 1849, p. 339

Page 127: William Cullen Bryant, "A Forest Hymn," in *Yale Book of American Verse,* ed. Thomas R. Lounsbury, New Haven, Conn. (Yale University Press) 1912; bartleby.com, 1999. bartleby.com/102 [September 13, 2006]

Page 128: A.J. Webster, "Louisville in the Eighteen Fifties," *The Filson Club History Quarterly*, IV, no. 3, July 1930, p. 134

Page 135: Ann Edwards and Deirdre Windsor, "The Virginia Ivey Quilts: Nineteenth Century Masterworks," *Needle Arts*, XVIII, no. 3, August 1987, p. 18

Page 140: J.C.C. Mays (ed.), *The Collected Works of Samuel Taylor Coleridge*, 16 vols., Princeton, NJ (Princeton University Press) 2001, XVI, no. 1, part 2, pp. 605–10

Page 146: William H. Gerdts, "The Influence of Ruskin and Pre-Raphaelitism on American Still-Life Painting," *The American Art Journal*, I, no. 2, Fall 1969, p. 86

Page 150: Peta Tait, *Circus Bodies: Cultural Identity in Aerial Performance*, London and New York (Routledge) 2005, p. 40

Page 154: Avril Denton, "W.A.S. Benson: A Biography," in *W.A.S. Benson: Arts and Crafts Luminary and Pioneer of Modern Design*, ed. Ian Hamerton, Woodbridge, Suffolk, England (Antique Collectors' Club) 2005, p. 50.

Page 158: Bailey Van Hook, *The Virgin and the Dynamo: Public Murals in American Architecture, 1893–1917*, Athens, Oh. (Ohio University Press) 2003, p. 48

Page 159 (top): Julia Rowland Myers, "The American Expatriate Painters of the French Peasantry 1863–1893,"

PhD diss., College Park, University of Maryland, 1989, p. 203

Page 159 (bottom): *Edward W. Redfield: Just Values and Fine Seeing*, exhib. cat. by Constance Kimmerle, New Hope, Pa., James A. Michener Art Museum, May 2004–January 2005; Dover, Del., Sewell C. Biggs Museum of American Art, January–April 2005, p. 27

Page 160: *The Courier-Journal*, Louisville, Ky., July 23, 1888, p. 2

Page 162: "A Few Words from Mr. Remington," *Collier's Weekly*, March 18, 1905, quoted in Alex Nemerov, "Frederic Remington: Within and Without the Past," *American Art*, V, nos. 1/2, Winter–Spring 1991, p. 36

Page 165: Charles Caryl Coleman to Hattie Bishop Speed, August 25, 1922, archives of the Speed Art Museum, Louisville, Ky.

Page 166: John Rewald (ed.), *Paul Cézanne: Letters*, New York (Hacker Art Books) 1984, p. 261

Page 167: F.T. Marinetti, "The Founding and Manifesto of Futurism," February 20, 1909, quoted in Umbro Apollonio, *Futurist Manifestos*, New York (Viking Press) 1973, p. 21

Page 171: *The Armory Show Years of E. Ambrose Webster*, exhib. cat., New York, Babcock Galleries, November–December 1995, p. 9

Page 173: Edwin Murtha, *Paul Manship*, New York (Macmillan Company) 1957, p. 160

Page 175: Louis Bouché, "Preston Dickinson," *Living American Art Bulletin*, October 1939, p. 3

Holger Cahill and Alfred H. Barr, Jr. (eds.), *Art in America in Modern Times*, New York (Reynal and Hitchcock) 1934, p. 37

Page 176: Maria Jawlensky, Lucia Pieroni-Jawlensky, and Angelica Jawlensky, *Alexej von Jawlensky: Catalogue Raisonné of the Oil Paintings, II, 1914–1933*, London (Sotheby's Publications) 1992, p. 14

Page 179: *Henri Cartier-Bresson, Photographer*, Boston (New York Graphic Society) 1979, jacket notes

Page 184: Carter H. Harrison, quoted in Stephen L. Good, "Walter Ufer: Munich to Taos, 1913–1918," in *Pioneer Artists of Taos*, by Laura M. Bickerstaff, rev. ed., Denver (Old West Publishing Co.) 1983, p. 126

Page 188: Max Ernst, in *Beyond Painting, and Other Writings by the Artist and His Friends* (New York, 1948), quoted in M. Gee, "Ernst, Max(imilian), Section 2: Working Methods and Technique," in *The Dictionary of Art*, ed. Jane Turner, 34 vols., New York and London (Grove and Macmillan Publishers Ltd) 1996, X, p. 470

Page 192: Nicholas Nixon, *Family Pictures*, Washington, D.C. (Smithsonian Institution Press) 1991, p. 6

Page 198: Bruce Glaser, "Questions to Stella and Judd," in *Minimal Art: A Critical Anthology*, ed. Gregory Battcock, New York (E.P. Dutton) 1968, pp. 157–58

Page 200: Donald Kuspit, "Elmer Bischoff: Californian Intimist," in *Elmer Bischoff: Paintings from the Figurative Period, 1954–1970*, exhib. cat., San Francisco, John Berggruen Gallery, 1990, p. 8

Page 201: Patricia Hills, *Alice Neel*, New York (H.N. Abrams) 1983, p. 105. Originally published in Alice Neel, "A Statement," in *The Hasty Papers: A One-Shot Review*, New York (A. Leslie) 1960

Page 202: John Hollander, "Artist's Dialogue: William Bailey—An Extreme and Abstract Clarity," *Architectural Digest*, XLIII, December 1986, p. 48

Page 204: Quoted in Kate Kleinert, "Interview with Arturo Alonzo Sandoval," *The Alliance for American Quilts Q.S.O.S.: Center for the Quilt Online* (centerforthequilt.org), Project: The Kentucky QSOS, tape number: KY40205-005, April 5, 2006

Page 205 (top): Lloyd E. Herman, *American Glass: Masters of the Craft*, Washington, D.C. (Smithsonian Institution) 1998, p. 31

Page 205 (bottom): Sol LeWitt, "Sentences on Conceptual Art," in *Theories and Documents of Contemporary Art: A Sourcebook of Artists' Writings*, ed. Kristine Stiles and Peter Howard Selz, Berkeley (University of California Press) 1996, p. 826

Page 216 (top): Neal Benezra, "DIRECTIONS", exhib. brochure for *Juan Muñoz*, Washington, D.C., Hirshhorn Museum and Sculpture Garden, March–April 1997. Originally published in *Juan Muñoz: Monologues and Dialogues*, exhib. cat. by James Lingwood, Madrid, Palacio de Velázquez, Museo Nacional Centro de Arte Reina Sofía, October 1996–January 1997

Alexandre Melo, "Some Things that Cannot Be Said Any Other Way," *Artforum International*, XXVII, May 1989, p. 121. Originally published in "A Conversation (Interview with Jean Marc Poinsot)," in *Juan Muñoz: Sculptures de 1985 à 1987*, exhib. cat., Bordeaux, CAPC Musée d'Art Contemporain, September–November 1987, p. 15

Page 216 (bottom): Robert Storr, *Elizabeth Murray*, New York (The Museum of Modern Art) in assoc. with London (Thames & Hudson) 2005, p. 74

Page 217: David Frankel, "Interview," in *Kiki Smith*, Boston (Bulfinch) 1998, p. 32

Page 219: Nancy Hynes, "Re-dressing History," *African Arts*, XXXIV, no. 3, Autumn 2001, p. 64

Page 221: Andrew Graham-Dixon, *Howard Hodgkin*, London (Thames & Hudson) 2001, p. 214

Page 223: Marjorie Allthorpe-Guyton, "A Purpose in Liquidity," in *Effluvia*, exhib. cat. by Helen Chadwick, Essen, Barcelona, and London, 1994, p. 10

Index